CLIVE BARKER

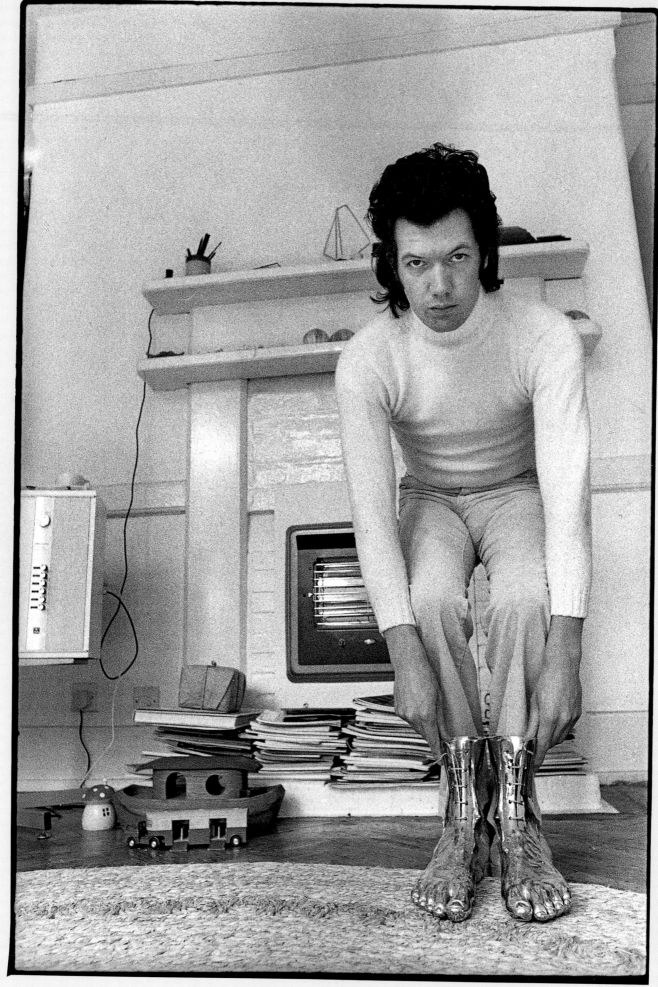

Clive Barker, London, 1969

An Jo Fermon

CLIVE BARKER

SCULPTURE

Catalogue Raisonné 1958-2000

Essay
Marco Livingstone

SKIRA

Editor
Paola Gribaudo, Studio Gribaudo, Torino, Italy

First published in Italy in 2002 by
Skira Editore S.p.A.
Palazzo Casati Stampa
via Torino 61
20123 Milano
Italy

Printed and bound in Italy. First edition

ISBN 88-8491-380-2

Distributed in North America and Latin America by Rizzoli International
Publications, Inc. through St. Martin's Press, 175 Fifth Avenue, New York,
NY 10010.
Distributed elsewhere in the world by Thames and Hudson Ltd., 181a
High Holborn, London WC1V 7QX, United Kingdom.

Contents

Lessons in Art Appreciation:
The Sculpture of Clive Barker

Marco Livingstone

From the beginning of his career, Clive Barker has found himself categorised alternately as both a latter-day Surrealist and as a Pop artist – or as something of an intruder in both movements. This confusion about where he belongs is appropriate. He has affinities in both directions but has insisted on going his own way and on deliberately neglecting to maintain his membership subscription to clubs he has no need to join.

Although Barker's debt to Marcel Duchamp's invention of the sculptural ready-made is incalculable, he himself has steadfastly refrained from presenting manufactured objects as he finds them. Instead, he has consistently preferred to have them remade in often glamorously alluring materials of his choosing, using factory-made consumer items (among other things) simply as a point of departure. Likewise, his early friendship with Peter Blake, and his admiration for the work of Americans such as Jasper Johns and Jim Dine, linked him directly to the artists who had helped establish the movement by the mid-1960s, when he was just beginning to make his mature work. Yet he has always maintained a distance from the public mass-media derived vocabulary of Pop, electing instead to leave himself open to inspiration wherever he may find it. In any case, Barker's aesthetic was rooted not in theory or in art-world discussions but in personal experience and a strongly developed formal sense and response to powerful images. His education took place less at art school (where he spent only two years) than on the factory floor of the Vauxhall car factory at Luton, where he witnessed the precision and beauty of the freshly fabricated automobiles clad in gleaming metal and upholstered in sensuous leather.

One of the great paradoxes on which Barker's work rests is that it questions and at times mocks many of the premises of both traditional and early modernist art, while at the same time layering itself with affectionate references to a great variety of art from all periods. Barker rejected the received wisdom that art had to be handmade, or at least physically constructed by the artist himself, judging the end to be more important than the means or the hands used to effect them. Moreover, he saw no need to abandon his sense of humour or his appreciation of the absurd just to lay claim to the seriousness of his intentions. Like others of his generation, he left room for irony, playfulness and a sense of fun – but not for cynicism. His art has always been predicated on a sense of wonder about the world and the objects (both functional and artistic) with which we fill it and by which we seek to make sense of it. And it is this amazement at the beauty of the ordinary and familiar, sincerely expressed, which gives all his art its life-enhancing quality.

Although Barker's work was highly visible during the 1960s through to the mid-1970s, when he exhibited at such high-profile London galleries as the Robert Fraser Gallery, Erica Brausen's Hanover Gallery and the Anthony d'Offay Gallery, his natural reticence about putting himself in the limelight and his resistance to the practicalities of making a career have pushed him unfairly towards the margins. Groups of early works and certain key pieces have continued to feature in books and survey exhibitions of Pop Art, and solo shows in museums have allowed fragmentary glimpses into certain peripheral aspects of his art, such as the boxes and his portrait drawings and sculptures. Yet his main work as a sculptor has remained more than half-hidden, with pieces often sold directly to collectors from the studio and never put on public display.

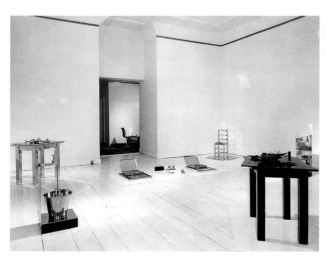

Fig. 1
Scene from first one-man show at
Robert Fraser Gallery, London
17 Jan. - 14 Feb. 1968
(Photograph John Webb)

Even those of us who have visited Barker at irregular intervals over the years would have obtained a very partial and misleading picture of what turns out in retrospect to have been a remarkably coherent development. Seeing pieces emerge one by one, it was not always possible to appreciate how they related to each other or to earlier works. It is only now, with the publication of this catalogue raisonné, that the continuities and connections will finally begin to be understood. With this evidence one will at last be able to appreciate how his mind works, how he responds when inspiration strikes from observations of even the most modest objects because of their place in the rituals of daily life. Instead of plotting his subject matter or the processes and materials in which he will clothe his imagery, he leaves himself always open to the prospect of seizing upon the sculptural possibilities presented to him by chance encounters and visual stimuli. Rather than mapping out a group of works in advance, he allows one work to lead naturally to the next, sometimes creating an explosion of works around a particular idea, at other times abandoning it until years later, when he might (sometimes literally) stumble upon an unfinished work or idea and take it up again with a new vigour. During the course of a day, most of us will have many apparently disconnected thoughts, but through habit and predisposition we will come back to some of them more than to others, refining and redefining them as we revisit them. This is how Barker's work, over almost four decades, is beginning to look to me: different strands of thought and practice interweaving in unexpected but fascinating ways.

Barker started as a painter and his love of painting from all periods has continued to inform his sculptural practice. In the late 1950s, under the influence of American Abstract Expressionists such as Clyfford Still, he briefly made richly textured abstract paintings (fig. 2). By British standards of the time, they were extreme in their physical handling, monochromatic and uningratiating colour schemes and elimination of all references to the visible world. Like many ambitious young artists, he was keen to challenge the assumptions and sensibilities of the period

with a radical statement. He quickly discovered, however, that he found abstraction wanting and developed a distaste for most of it that lasts to this day. Like other artists who were to find themselves grouped together under the Pop label, he longed for a more intense contact between the art he made and the world in which he moved. Free of the prejudices that might have been instilled in him if he had further training as a sculptor, he decided to incorporate aspects of the contemporary urban environment in the most direct way, by pouncing upon found objects that caught his eye and then presenting them, at first with minimal or no alteration, as sculptural objects in their own right. Certain formal qualities of his abstract paintings – the strong physical presence and monochromatic tendency – were now transferred to objects that any person untutored in art could recognise and relate to without the benefit of theory and complicated explanations. At a single stroke, he began to produce some of the most radical works of the time: revolutionary not only in their hands-off quality and in their apparent banality, but also in their courageous questioning of their own status as works of art.

Duchamp's first ready-mades were of course nearly half a century old by the time Barker began making sculpture in the early 1960s. But the Dadaist had insisted upon the object being selected more or less at random and with a studied neutrality, 'never dictated by esthetic delectation', as he explained in a talk delivered at the Museum of Modern Art, New York, on 19 October 1961.[1] For Duchamp, moreover, the work was done with the mere selection of the object and its redesignation as a work of art. Barker, on the contrary, chose his objects with care for their associations or because he liked the look of them, and they were then subjected to further alterations (which by Duchamp's definition would make them 'assisted ready-mades').[2] Barker was just 21 when he made *Black Dartboard* 1961-62 (cat. 9) and *Billiards Scoreboard* 1961-62 (cat. 7). Both are made from found objects that would have been familiar to most young men who frequented pubs and entertained themselves playing such competitive games of skill. Perhaps unintentionally, they also suggest an element of sexual swagger proper to men of that age, voiced in the bantering language of 'scoring'. Rather than leave the artefacts as he found them, however, Barker selectively covered the scoreboard in black paint and coated the dartboard entirely in the same colour, thus removing them from the 'real' world and relocating them to the sphere of art. Until he began making sculptures from shiny metals that reflected the environment in which they were placed, sucking it into their surface, black remained his favourite colour: a 'non-colour' which in its density also seemed to soak in everything around it.

Abacus 1963 (cat. 11) is as close as Barker would get to Duchamp's presentation of the unmodified found object. In this case a found object, already black, was turned into sculpture simply by being placed on a wooden base. But Barker, although he had no desire to involve himself in traditional ways of making sculpture with his own hands,

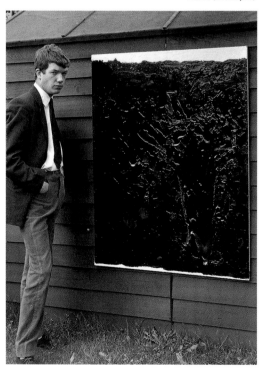

Fig. 2
Luton c. 1960:
Clive Barker with his painting
Black on White 1, 1958-59
bitumen on white emulsioned
board (destroyed)

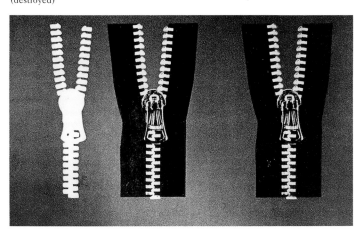

was not to remain satisfied with such a simple solution for very long. He wanted to impose himself more on the object, to transform it and to make it his own. On the shop floor he had witnessed the possibility of bringing into being a beautiful object like an automobile almost magically through the specialist labour of other people; the designers remained the authors of these works, even though they were not involved physically in the process of their manufacture. So it is that Barker began to seek out specialist craftsmen who could fabricate objects to his design, things that looked like functional items but that had no existence other than as works of art. It was this thinking, too, that led him by the mid-1960s to begin casting replicas of real objects which he then subjected to startling transformations of surface and appearance.

In the early 1960s Barker used black leather as a favoured material, prompted by the car upholstery he had admired on the factory floor and perhaps also by the masculine 'biker' look (popularised by rockers and by Marlon Brando in *The Wild Ones*) as the sign of a sexy, youthful independence from inherited standards of polite behaviour. *Dick's Jacket* 1963 (cat. 12) was made in reference to the American leather jacket owned by the painter Richard Smith, who had just spent two years in New York and whose studio was in the same building as Barker's at that time. The leather is stretched over a wooden frame like a canvas and presented as a kind of found painting.

References to painting have continued to abound in Barker's work, taking precedence over sculpture as a source of inspiration. He continued making paintings based on found objects as late as 1965, when he made *Vest – Orange*, *Pants* and *Pants – Red, White & Blue* by spraying aerosol paint through real underclothes used as stencils to create actual-size replicas (fig. 3). As with his sculpture, it was a way of taking a found object as a starting-point from which to produce a credible stand-in for it. From 1962 to 1964, he produced a series of monumentally enlarged zips silkscreened onto canvas (fig. 4), but it was in the series of *Zip Boxes* of 1963-64, and in *Seat* 1964 (cat. 24), that he found a way of using such object imagery in three-dimensional form, which suited him better. All these works – made from black leather and zippers on wood – were fabricated to his designs by a carpenter and an upholsterer on the efficient principles of the division of specialist labour that he had witnessed on the assembly-line. Though *Seat* might appear to be an oddity among the other objects created by Barker at the time, the subject was of course ideally suited to take full advantage of the skills of the upholsterer with whom he was collaborating. Having decided that he did not need to make the

things himself, he always sought out the highest level of craftsmanship in others. The chrome-plating of his sculptures of the late 1960s was carried out, literally, by the Rolls-Royce of chrome-platers: at the Juno Plating Company, a subsidiary of Rolls-Royce.

One might refer to works such as *Tall Exit* 1963-64 (cat. 14) as 'pseudo-found objects'. They are fabricated to look as though they might have been removed simply as the artist had discovered them, and made in response to things he had observed in the everyday environment, such as the exit signs in cinemas, using the same materials (such as neon light to spell out the letters of the word 'EXIT') to represent them. By 1966, however, he came to prefer more physically direct ways of dealing with items of daily use that caught his attention, such as the Coca-Cola bottles of which he had become so acutely aware during a three-week visit to New York in April. When his first son, Tad, was born that May, he created *Coke with Teat* 1966 (Plate 2, cat. 37), memorialising both his visit and his joy in parenthood through a makeshift milk bottle suitable for the son of a leading Pop artist. The pleasure he experienced in converting a transparent glass object into one made from dense and impenetrable solid bronze was compounded by the paradox of the reflective polished surface that visually dematerialised it before one's very eyes. It was not until 1968, however, that he returned to the Coke bottle as a subject for a period of two years, when he subjected it to numerous permutations: a single bottle with cap on; bottles in pairs or groups of three, with and without straws, upright and on their side, with caps on, off or in the process of being removed; cut into sections and reassembled as a *Coca Cola Puzzle* (cat. 68); and even two bottles screwed together to make a table lamp (at the request of his wife). These variations attest to the variety of themes that Barker was able to address through a single object. The title of *PPSSST* 1969 (cat. 109) refers to the sound of a cap being pulled off, releasing some of the pressure contained within a bottle of carbonised drink. Time, movement, physical force and sound are all thus introduced into an object whose form as a metal sculpture will remain forever fixed, humorously demonstrating that (all appearances to the contrary) it can continue to be thought of as a transparent vessel containing a drink. Such is the power of suggestion in the way we experience works of art as surrogates for the things they represent.

The simple expedient of direct casting was surprisingly full of possibilities, and Barker wasted no time in exploring them. If the Coke bottles played on the issue of transparency and opacity, creating a kind of alchemical distance between the model and its double, other works sought to minimise the difference between the 'original' and the 'copy' to such an extent that one would be hard-pressed to tell the difference between the two. Some of the first objects replicated in bronze or other metal were themselves made of metal, so that the remade object is visually virtually indistinguishable from the readymade manufactured object from which it has been cast. Only by trying to play the chrome-plated steel *Zip Mouth Organ* of 1966 (cat. 41 and cat. 42) could one be absolutely sure that it was not the real thing.

11

Reflective metal soon proved so seductive in itself that Barker used it to accord an unaccustomed glamour and preciousness to a variety of ordinary everyday objects, cladding them in plated surfaces of gleaming chrome, gold and silver, or obtaining a similar effect more easily by casting them in aluminium that was simply polished.[3] *Painted Dartboard* (Plate 7, cat. 58) and *Dartboard* (cat. 57), both of 1967, return to the subject of the sculptures he had presented six years earlier as found objects; now cast in aluminium and then painted or polished, they are closer in spirit to the *Target* paintings by Jasper Johns to which they allude in that they have been completely remade in the materials of art. Just as Johns posed the question 'Is this a flag or a target, or a painting, or both?', so Barker's works asked viewers to consider whether they were to respond to them as they would to other sculptures or to functional objects. Of course their original function is denied now that they have been remade in a surface impervious to being punctured by even the sharpest pointed missiles.

Despite the central importance of the mass-produced object to the iconography and processes of Pop Art, the movement produced surprisingly little in the way of sculpture on either side of the Atlantic. Barker's casts of the 1960s thus form a particularly important part of the story. Yet even these works are addressed only occasionally to what could be deemed pure Pop subjects from the mass media or from assembly-line production. *Newspaper* 1967 (cat. 49) makes permanent an item as ephemeral and throw-away as the front-page of a tabloid newspaper, a subject used by Andy Warhol for a few paintings before he took up screenprinting in 1962. In Barker's work, featuring the sensationalist headline 'VERDICT IS FOR HANGING', the embossed metal surface is presented as the impression of the typeset plate from which the actual page could have been printed. There is no hint in the work itself of where the artist might stand on the issue of capital punishment.

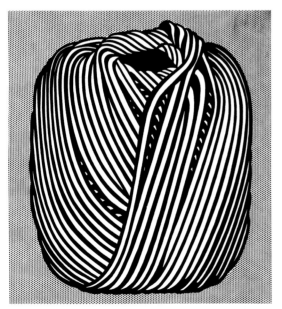

Fig. 5
ROY LICHTENSTEIN (b. 1923)
Ball of Twine, 1963
magna on canvas, 101.6 x 91.4 cm

Ball of String 1969 (cat. 107) may have been conceived in part as homage to another leading American Pop painter, Roy Lichtenstein, who six years earlier had made a painting of a *Ball of Twine* (fig. 5). Barker, as usual, gives the image his own twist, according an almost comical dignity to the banal and mundane. He followed it in 1970 with *Piece of Old Rope* (cat. 124), the title of which plays self-deprecatingly on the expression for profits easily made from work already done: 'money for old rope'. It consists of a bigger piece of string, cast in metal so that its twisting form resembles a Baroque Solomonic column, carried to a more absurd length through its transformation from a floppy object into one that is hard and absolutely erect: all phallic connotations accepted playfully and with a mock innocence. Barker may also have had an amused eye on the type of material then being adopted for sculptural purposes by artists associated with Arte Povera and Process Art, notably in works made between 1967 and 1969 by Barry Flanagan. When looking at Barker's work,

one can see reflected in it – as is literally the case when it is presented in group shows – the work of other artists, sometimes turned on its head or twisted almost beyond the point of recognition. The running commentary on aesthetic solutions proposed by others, encompassing the extremes of respectful homage and ridicule, critically contextualises his own production and provides one of the avenues by which his sculptures can be considered lessons in art appreciation.

In his later work, Barker has continued to employ both casts from found objects and fabricated replicas of recognisable things for everyday use. Although a pure Pop aesthetic has resurfaced during the 1990s in polished pieces that return to some of his favoured subjects of the 1960s, he has never hesitated about breaking his own rules if an idea for a sculpture presents itself. *Tea Time Table* 1981-90 (cat. 425) is a rare case in which an unadorned found object appears in the final form of the sculpture. The title, which can be heard ambiguously as a table for tea-time or as a timetable pointing to an assignation for tea, alludes to the conflation of form and function by which a large public clock has been severed from its moorings and turned on its side. In its quiet way, this unusual piece restates some of the governing principles of Surrealism that continue to guide Barker's imagination. *Dartboard Table* 1995 (cat. 440), which takes as its top a cast of the same dartboards by which he announced his arrival as a sculptor in the early 1960s, offers no logical explanation for the new function proposed for an object whose original purpose has in the process been denied. It can perhaps best be thought of in the spirit of Duchamp's 'reciprocal ready-mades', which he exemplified with the outrageous proposal that a Rembrandt painting be used as an ironing board.

Barker's readiness to act on the external provocation of something seen in passing has continued to motivate him in the 1990s as it did three decades earlier. When he saw that a local cafe that he had frequented near his home in Hampstead was closing down, he grabbed the opportunity to buy a group of cast iron tables from them, as he had always wanted to make some still lifes with only one or two objects on them. Finding them was a gift, and the time was right to make the pieces he had long had in mind; the personal associations he had with the cafe became an unexpected part of the process. The resulting works, such as *Table with Yellow Jug* 1992 (cat. 238), *Table with Bottle and Glass* 1992-93 (cat. 239) and *Table with Brushes (F. B.)* 1992-93 (cat. 240), a tribute to the recently deceased Francis Bacon,[4] treat the conventions of still-life painting with a simplicity that borders knowingly on a perilous banality. The tables are ordinary (found) objects surmounted with equally familiar (representations of) things from the home and studio. In each case the table-top acts as a ready-made plinth but is also an essential component of the sculpture as both form and image.

Art objects and artists' tools feature prominently in the vocabulary of Barker's sculpture and were of central importance to the work through which he established his identity from the mid to the late 1960s. The equation appears straightforward, but one should beware of a simple

identification between the artist and his tools, and not just because Barker has so fundamentally redefined the notion of the artist as 'maker' of his works. The references are almost always to the medium he had left behind, painting, rather than to his own métier as a sculptor. *Yardstick I* and *II* of 1968 (cat. 74 and 75), with their overtones of Duchamp's standard stoppages and of the rulers glued onto the surface of Johns's paintings, and *Blowlamp* 1968 (cat. 73), with its reference to the welding tools employed by the macho metal sculptors of the 1950s, are rare exceptions to this rule. This constant emphasis on painting leads to psychological resonances, even to a sense of loss, that have to be taken into account. The very first such work, *Two Palettes for Jim Dine* 1964 (Plate 1, cat. 27), initiated a series of homages to painters. Although Dine had begun to make his

Fig. 6
JIM DINE (b.1935)
Two Palettes (Sears, Roebuck; Francis Picabia), 1963
oil on two canvases
237.5 x 152.4 cm
(Metropolitan Museum of Art, New York)

own sculpture by then on principles compatible with those employed by Barker, it was only the paintings, drawings and collages by the American that were known to him at the time;[5] the paired palettes were based on a painting by Dine which in turn had alluded to the Dadaist Francis Picabia (fig. 6).[6]

Among other early works referring to the tools of a painter are *Table with Drawing Board I* and *II*, both of 1966 (cat. 35 and 36), *Art Box I* 1966 (cat. 39), *Art Box II* 1967 (Plate 4, cat. 44), *Art Box* 1970 (cat. 121), *Palette & 2 Tubes* 1967 (cat. 53) and *Palette and Tube* 1967 (Plate 6, cat. 52). In each of these, the paint tubes and other materials have been rendered inert, embalmed in their cast metal casings. Why, one might ask, would a sculptor refer to 'my' palette, a utensil for which he would no longer have much use except – perhaps on a very rare occasion – to apply a bit of colour to the surface? Of course, because of his training as a painter he continued to have a great fondness for painting. Works such as these, even if they do present a kind of sidelong glance at a medium that was no longer his prime form of expression, have a respectful and even joyous air in their celebration of the beauty of art. *Palette for Rose* 1966 (cat. 40), festooned with hearts for his wife, who had just given birth to their first son, conforms to a particular category in Barker's work: that of a personal memento recording an important occasion or bond with a loved one or friend.

For Barker, an undeniable love of art in its many guises goes hand-in-hand with a questioning of its privileged status. By presenting his own art as a manufactured commodity, he likens it to functional, mass-produced, factory-made objects destined for sale, but with a nod to the precious *objet d'art* in the gleaming surfaces that seductively coat these casts of real things. Some of the objects are editioned, usually in small numbers,[7] although many others that could have been made as multiples exist as unique objects. (This is particularly the case when he made something with a particular person in mind.) The casting process itself of course acknowledges the potential for endless replication, directing attention to the common, but usually discreet, artistic practice of creating multiple casts of a bronze or other sculpture.

Barker, moreover, has used the casting process to raise the issue of the 'original' versus the 'copy' and to question the notions of 'authenticity', 'the handmade' and 'invention' as operating principles.[8] In his work the act of creation is equated with the replication of an object already in existence, or with the fabrication of a familiar type of object from cut-out sheets of metal. Technically speaking, therefore, the source object is the original, and the cast or constructed imitation made from it is the replica. But the source was merely a functional object, certainly one that had been designed by someone but not intended to be appreciated primarily for aesthetic reasons. Only by remaking it and presenting it as an object for visual delectation does it become a work of art. The process of transformation thus necessitates a redesignation of the object from which he had started. Viewed this way, it is not the original at all but simply the subject of the final work, just as, for example, the actual apples painted by Cézanne were dignified as art only through the act of being painted.

Barker's relationship to painting is most clearly expressed in the 'homages' that he created during the 1960s. By transforming flat images into insistently physical, three-dimensional objects, he created sculptures that can best be understood as monuments to painting, as celebrations of their timelessness and quality of invention. The very first of his object-based works, a series of corrugated cardboard targets on wood, painted in black gloss in 1961, had been inspired by the mid-1950s target paintings of Jasper Johns. *Van Gogh's Chair* 1966 (Plate 3, cat. 32, 33 and 34), taken from one of the most famous paintings by an artist with an inestimable popular following, places the viewer inside a pictorial space made real, as if the illusion of the two-dimensional image had been used as a blueprint for the construction of the actual objects in three dimensions (fig. 7). It was followed by *Morandi Still Life* 1966 (cat. 38) and *Homage to Morandi* 1969 (cat. 108),[9] *Magritte's Pipe* 1968 (cat. 76)[10] and *Homage to Magritte* 1968-69 (Plate 9, cat. 71),[11] *Homage to Soutine* 1969 (Plate 12, cat. 83),[12] *Homage to Picasso* 1969 (cat. 84),[13] *Van Gogh's Hat with Candles 1* and *2* 1969 (cat. 79 and Plate 8, cat. 80) and *Van Gogh's Sunflowers* 1969 (cat. 78). All make explicit reference to specific works by artists that Barker counted among his favourites, and all play on the physical materialisation of motifs that had previously existed as flat representations of three-dimensional objects.

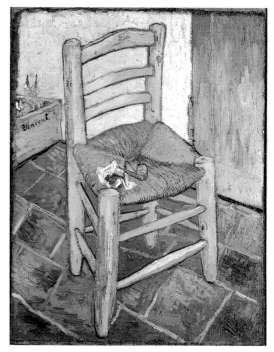

Fig. 7
VINCENT VAN GOGH (1853-1890)
Van Gogh's Chair, 1888
oil on canvas, 91.8 x 73 cm
(National Gallery, London)

Portrait of Madame Magritte 1970-73 (Plate 16, cat. 122), among the two or three largest sculptures yet made by Barker, was cast from a leather chesterfield sofa. It was not based on a particular painting by Magritte, nor was Barker paying tribute to a large bronze sculpture made by Magritte only a few years earlier, *Madame Récamier de David* 1967, which itself had been based on earlier paintings by him and in which the seated figure of the famous society hostess immortalised in Jacques-Louis David's portrait is represented as an L-shaped coffin placed on a lifesized bronze replica of a late 18th-century chaise longue.[14] In this case, Barker

started with the idea that he wanted to make another work inspired by Magritte, this time relating to his wife Georgette. It was entirely his invention, though prompted in part by the sculpture he had already made of the boots turning into human feet. The idea was 'to make a portrait that wasn't there but was there, if you know what I mean': as if the figure had just vaporised. He first found a pair of shoes, which he cast. Then, while looking for a suitable chair to place next to them, he chanced upon a beautiful leather chesterfield sofa in Camden Town. He bought it for £600 and had it delivered to the foundry, where he had it cast in three sections, the largest they could accommodate; the separate pieces were then welded together.

In 1988 Barker made a series of violins from sheets of steel, as silenced objects for formal invention as in Cubist painting, to which he paid direct homage in the title of the first one.[15] In these he was left more to his own devices than in the works based on specific sources in painting, inventing his own variations on Cubist forms from a generalised notion of Cubist vocabulary. Such is the case, too, with *Cubist Still Life 2* 1995 (cat. 256), which includes a siphon bottle borrowed from Fernand Léger[16] and a single die as a joke that takes literally the notion of the cube. This increasing emphasis on pictorial problems posed by different types of painting, rather than with specific sources, reached a peak in *Vase of Flowers in a Frame* 1995 (cat. 250 and 251). Produced in bronze and aluminium versions, it is a wonderfully light and graceful essay on the pictorial illusion of representational painting measured against the physical reality of the sculptural object. It consists of a vase with tulip poised on the lower edge of a freestanding frame, at the juncture between the 'real' world and the world of the imagination defined by the borders of the picture frame.

Compared to the proliferation of references in Barker's art to 20th-century painting, allusions to modern sculpture are rare. *The Critic Writes* 1970 (cat. 123) was a typically good-natured response to a series of comments on art critics by his peers. Johns had made *The Critic Smiles* 1959 (a sculptural representation of a toothbrush with the bristles replaced by teeth) (fig. 8) and *The Critic Sees* 1961 (with mouths in places of eyes in a pair of spectacles).[17] Richard Hamilton had countered with *The Critic Laughs* print of 1968 and multiple of 1971-72 in which a replica set of dentures was grotesquely poised on the pointed end of an electric toothbrush (fig. 9). Barker's contribution is stripped of the acerbic distrust of the art writer displayed by his colleagues, yet it still has a sting in the tail because of his choice of such a wilfully old-fashioned object as a quill pen to represent the métier of the contemporary art critic.

A slightly later work, *Mr and Mrs Iron* 1972 (cat. 139), provides almost the only other instance in Barker's art in which he has acknowledged the work of 20th-century sculptors. It makes oblique allusion to Man Ray's *Cadeau (Gift)* 1921, a Surrealist

masterpiece known from its author's contemporaneous photograph and from the replicas he produced as an editioned multiple in 1963, towards the end of his career: an 'assisted ready-made' consisting of an upraised iron to whose heatable surface he applied a row of menacingly sharp nails.

If the history of sculpture had not featured large as a topic in Barker's art, in the early 1970s he introduced playful allusions to the classical tradition of sculpture. *Chained Venus* 1971 (cat. 131), with its overtones of sadomasochism tempered by a humorous recognition that it is we rather than she who remain in bondage to inherited notions of beauty, was the first of what was to prove many uses by Barker of the Venus de Milo. It was followed by *Aphrodite* 1972 (Plate 18, cat. 138), a classical head ominously enclosed in a gas mask, and by *Portrait of an Unknown Beauty* 1973 (cat. 141 and 142), with the head of the Venus de Milo still recognisable by its characteristic tilt in spite of the face being mysteriously shrouded like the drowned or suffocated figures pictured in paintings by Magritte.[18] Just over a decade later, *Venus Escargot* 1987 (Plate 28, cat. 211) [19] was the first of a new group of lighthearted, even comic, Venus de Milo heads including *Venus with Butterfly* (cat. 232) and *Venus with Tongue in Cheek* (cat. 231), both 1990.

Tang Horse (Plate 20, cat. 143) and *Tang Chariot* (cat. 144), both dating from 1973 and cast from authentic Chinese antiquities lent to him by the dealer and collector Giuseppe Eskenazi, were made during the same period that Barker was examining the Western classical tradition. In their straightforward celebration of beauty and refinement, however, they are very different in tone from the frequently mocking and iconoclastic remakes of Greek, Roman and Renaissance art to which Barker devoted himself with the Kitsch fervour of a Hollywood film producer. In *Chariot* 1974 (cat. 154) a winged messenger of the gods is brought down to earth on an ordinary roller skate that serves as her chariot, while in *Charioteer* 1974 (cat. 155) the Michelin Man is poised comically, and in typically ungainly fashion, on the axle joining a pair of metal wheels. Most insolent of all is *Classical Sculpture Being Laughted At* 1972 (Plate 17, cat. 137), based on a small cast of a famous and popular Renaissance bronze,[20] itself endlessly replicated in different sizes long before Barker's birth; this figure has been impertinently placed on a base of later design and his back even more disrespectfully covered with cartoon laugh-words.

Before addressing himself to the classical tradition that had been implicitly challenged by the premises of his early work, Barker directed his attention to much more fundamental issues about what kind of object could be said to constitute a piece of sculpture. Beginning with the *Zip Boxes* of 1963, and then in 1967 with the paint boxes and the buckets used in *Splash* (Plate 5, cat. 46), *Drips* (cat. 47) and *Bucket of Raindrops* (cat. 45), he produced ingenious variations on one of the most basic kinds of object known to humanity: the container. In some of these, such as *Nuts* 1967 (cat. 48) and *Parcel* 1970-71 (cat. 126), the spectator is presented with nothing but the exterior of the receptacle, and is asked to visualise the presumed contents concealed from view. Even more

extravagant in this playing on expectations is *Object to be Shipped Abroad* 1971-73 (cat. 136), a large piano-shaped crate identified through its stencilled lettering as 'WORK OF ART' and containing a grand piano. Since the crate is sealed shut, this is a fact one must take on trust. The idea for this work, which is at once highly conceptual and insistently physical, depends for its frisson on the knowledge that a beautiful and valuable object has been rendered useless, if not destroyed, by being turned into an invisible component of the sculpture. It is close in spirit and form to *Cremated Richard Hamilton Painting* 1971 (cat. 133), *Cremated Joe Tilson Painting* 1971 (cat. 134) and *Cremated David Hockney Painting* 1973 (cat. 146), each of which consists of a casket containing the remains of important paintings by artist friends. Following the iconoclastic example of Robert Rauschenberg's *Erased de Kooning Drawing* 1953, Barker asked friends whose work he admired to choose a picture they liked and willingly sacrifice it in the name of (Barker's) art.

Quite apart from the extended series of small boxes initiated in 1972, somewhat in the spirit of the Surrealist assemblages of the American Joseph Cornell,[21] Barker in his sculptures has continued to examine the many different kinds of objects that could be defined as containers.[22] Among the most imposing of these are reinforced receptacles for protecting perishable goods, *Meat Safe* 1978 (Plate 24, cat. 169) and the well-stocked *Fridge* 1999 (Plate 31, cat. 391), which is not only his largest sculpture in many years but also the most complex in the number and disposition of elements. Similar in form is *Bullion* 1981 (cat. 198), a safe filled with gold, the ultimate commodity. More unexpected are *Dead Bird* 1981 (cat. 191), in which the cast corpse of a budgie lies at the bottom of a real birdcage, and the outrageous *Penis Vase* 1994-98 (cat. 438), a vessel for holding water in the shape of a body part used for passing water. In 1990 Barker made *Box Camera* (cat. 235), the very name of which alludes to its function as a container for capturing images; like the other cameras that followed in 1999 (*Falcon* (cat. 350), *Agfa* (cat. 349) and *Kodak* (cat. 351)), it serves as a compelling image in itself. Jewel boxes are called to mind by *Snail Ring No. 1* 1987-88 (cat. 429), its preciousness accentuated through being presented in a silver-leaf box, and *Polo Box* 1998 (cat. 303), a polished aluminium larger-than-life representation of a Polo mint, housed like a finely crafted ring or brooch in a cushioned box. Among the wittiest of all these variations are *Tad's Castle* 1969 (cat. 105) and *Castle for Ras* 1976 (cat. 168), metal casts of plastic containers used for making sand castles. Objects designed to be filled with wet sand in order to produce a temporary cast of their interior shapes were instead replicated as permanent metal objects by means, appropriately enough, of the process of sand-casting. They are dedicated to his two sons, who had loved playing with these toys, and made as unique sculptures because he thought of them as *their* objects.

The toys that appear intermittently in Barker's art are among his most Pop pieces in combining the operating principles of play and pleasure. Similar in spirit are the food sculptures that he

started making in 1969, including *Three Peking Ducks* (cat. 101) of that year, a suitably expensive-looking trio of silver-plated bronzes commissioned by the upmarket Chinese restaurant Mr Chow. The pastries, cakes and biscuits, among the most decoratively appealing of all Barker's works, are closer in form and in their means of production to Robert Watts's chrome-plated actual-size replicas [23] than to the expressionistically painted hand-made plaster sculptures produced in the early 1960s by Claes Oldenburg. The very choice of high-calorie sweets and pastries, for all but the first of Barker's food sculptures (*Bagels* 1969), speaks of the illicit thrill of giving into temptation: *Iced Cherry Cakes* 1969, *Jam Tarts* 1969, *French Fancies* 1969, *One Cake Left* 1969 (cat. 89-94 and cat. 100). Several of the works cast in 1969 were completed only three decades later when he came across them again and sought out suitable receptacles in which to present them: *Cakes and Tarts* 1969-97 (cat. 96), on a tripartite cake stand of the kind placed on the tables of hotels and tea-rooms serving a superior cream tea; *Biscuits* 1969-97 (cat. 95); and *Jammie Dodgers* 1969-98 (cat. 97), laid out on a pewter tray. As any good cook or restaurateur knows, an inviting presentation is as essential as a good-tasting recipe, since the eyes as well as the taste-buds have to be pleasured. So it is that beginning with *Bagels* he presented items on a stand with a transparent cover. Though these covers have a practical function in keeping food fresh, they act also as a teasing way of presenting to view an item ultimately withheld from our touch and – of course, since they are sculptures – from our consumption.[24]

Soda Bread 1998 (cat. 310) marks Barker's return to food as subject three decades later, and finds him exchanging the scrumptious tarts and fancies of the 1960s for the altogether less inviting prospect of a dry piece of soda bread. Consciously or not, the relationship of the new image to the old indicates an awareness of how his own life and position have changed: first as a man in his twenties on the glamorous centre stage of the art world of 'Swinging London', now choosing as a middle-aged man to live quietly, almost hermit-like, out of the limelight and simply to carry on making his work with humble dedication. In another work of the same year, *Happy Birthday* (cat. 319), a single candle has been plunged roughly into a small cake, creating something of a crater in its surface; it looks more like a bullet that has just been shot through it from the back. All these signs point to this not as an image celebrating the first birthday of an infant, but as a single person's blackly humorous way of marking the passage of another year alone. (I hasten to add that this is my own projection: Barker is quick to insist that he loves living on his own and appreciates the peaceful pleasures of solitude).

By contrast with the reflective mood of those pieces, *Lollipop* 1998 (cat. 316) and *Painted Lolly – Red* 1998 (cat. 317), in their straightforward replication of a child's fantasy of a pretty object consisting of 100% sugar, return to the spirit of the early food sculptures as representing an extremely palatable if prohibited pleasure. *Concorde Lolly* 1999 (cat. 370) and *New York Lolly* 1999 (cat. 371) place the accent on a child's fantasy on imbibing a substance that will turn him or her into a super-hero or villain: the

idea of slowly consuming a supersonic airplane or the Statue of Liberty suggests that the eater has grown to monstrous size or assumed an awesome and unaccustomed power. The 1998 *Mars Bar* (cat. 334), already half out of its wrapper, ready to be eaten, and the *9 Walnut Whips, Blueberry Flan* and *Apple Flan* of 1999 (cat. 375, 376 and 377) also take up where Barker had left off in the late 1960s, providing a vivid instance of his ability to slip effortlessly back into his youthful work not as a formula to be copied but as a spur to new invention. In *3 Apples* 1998 (cat. 308) he brings together nature and art, arousing associations with painting traditions and especially with Cézanne's still lifes.

Notions of the consumer society addressed by much Pop Art were given a particular twist by Barker in the equation he made between two types of consumption: the acquisition of factory-made goods made to appear unbearably seductive and desirable, and the ingestion of food that looks equally irresistible but may be as bad for your health as shopping is for your wallet. Pleasure in itself is understood as a form of escapism. So it is that the hedonistic side of Barker's art has been linked from the beginning to the exotic, the unattainable, the erotic and the romantic. The allure of Hollywood and images of sexy masculinity are manifested in *Cowboy Boots* and in *Rio – Homage to Marlon Brando*, both of 1968 (cat. 69 and 70), while in *American Beauty* 1969 (cat. 113) and *A Lovely Shape* 1970 (cat. 130), Barker returns to an icon of contemporary mass consumption, the Coke bottle, now surmounted by shapely female bodies reminiscent of car hood ornaments and Playboy bunnies: trophies of desire and unrestrained libido that exude the joyful sexuality of the 1960s but also, in their literal objectification of the female body, act as provocations to the emerging women's movement. *Heart Box* 1969 (Plate 11, cat. 81), yet another of Barker's beloved containers, is more openly romantic in its inclusion of the cast hearts first used in *Palette for Rose* 1966 (cat. 40); in this case, 29 polished aluminium hearts, one for each year of his wife's age, are encased in an ornate jewel box in celebration of her birthday.

Given the somewhat brutal, matter-of-fact method of production employed by Barker, and the shiny, new look of his sculptures, his choice of pretty 19th-century objects and his occasional reference to outmoded styles attracts attention by its very incongruity. Years before Barry Humphries' alter-ego Dame Edna Everage coined the catch-phrase 'Call me old-fashioned', Barker was challenging his audience's expectations by asking them to appreciate such an impossibly sentimental, Kitsch arrangement as that suggested by *Victorian Fruit* 1969 (cat. 88). In *Victorian Couple* 1971 (cat. 135) an ornate knife and fork are placed side by side on a silver platter whose oval shape suggests the format of a conventional family portrait. Nothing could have been so abhorrent to the taste of that time for sleek, modernist objects as the kind of decorative Victoriana and anthropomorphic cuteness memorialised here. Yet Barker retrieves them through the affection, gentle humour and loving care lavished on his parody. *Erotic Still Life* 1972 (cat. 140) provides a stark contrast of mood: by Barker's standards, this is an unusually bawdy and direct representation of male genitalia, presented on a dark furry base openly suggestive of pubic hair.

Another comic catch-phrase popularised on British television – Dick Emery's 'You *are* awful – but I like you!' – would be a suitable epitaph for the sneaking admiration shown in Barker's work for the most appalling Kitsch. If Kitsch manifests itself as a misguided and pretentious bid for good taste characterised by its vulgarity, sentimentality and ersatz emotion, surely the ultimate Kitsch object in British terms would be the flying ducks once so commonly displayed on the walls of working-class homes. Such fowl trios – like bad luck, they always seem to come in threes – are the ultimate debased popular expression of the romance of wild nature. So how could Barker resist making replicas of the plaster cast *Flying Ducks* that he had seen in his mother's sitting room for so many years, and which he finally turned into a sculpture in 1995 (cat. 259), long after her death, when he found them in storage? For another artist, this might have been cause for pure mockery, but Barker remembers growing up with them. Like so many of the objects that have ended up as the subject of his sculpture, including the many children's toys which he has cast in bronze or aluminium long after his boys had grown up, the *Flying Ducks* must be understood as autobiographical fragments, as a means of coming to terms with his own past. It is not ridicule but acceptance – of the vagaries of popular taste and of the circumstances of one's own life – that emerges as the abiding emotion and operating principle of Barker's work.

Barker's imagination continues to be triggered by the most ordinary objects, which lead him into the realm of dreams and fantasy. In *For Cinderella* 1997 (cat. 286) he conceives of the cast of a single woman's high-heeled shoe, poised on a polished platform, as representing the shoe dropped by Cinderella as she hurried home from the ball. In so doing, Barker, ever the romantic, places himself and the male viewer alike in the role of the lovelorn prince in search of his perfect mate. In the spirit of Hollywood remakes, *Maltese Falcon* 1999 (cat. 356) is a replica of the rare and valuable object at the centre of intrigue in one of Humphrey Bogart's most enduring movies.[25] By making a whole edition of these rather than a unique sculpture, Barker of course subverts the whole idea enshrined in that object as a rare and unobtainable original work of art.

Barker's sculptures, though generally small, can be surprisingly heavy when cast in solid metal, but one can never be quite sure just by looking at it. Appearances can be deceptive: a bronze will naturally be much heavier than a piece cast in aluminium, but when the surfaces have a similar mirror-like shine it is not always possible to tell at a glance what material has been used. In *Parcel Post* 1975 (cat. 158) and *Nearly Five Pounds of Pears* 1981 (cat. 196), Barker responds to this natural curiosity by resting the objects on traditional scales, using the actual things rather than cast replicas of them. These scales thus take the place of conventional plinths and at the same time record the weight of the sculptures resting on top of them.

Weight and density are normally verifiable properties of objects. When confronted by works of art, however, we have been taught to refrain from touching, and as a result are forced to rely on

the evidence presented to our eyes. This perhaps accounts for the dialogue in Barker's art between the fragile and the indestructible, and between the ephemeral and the permanent. As early as *For Jacqueline* 1968 (cat. 72), in which a leaf is cast in brass, he has made sculptures representing delicate organic forms destined to grow and die. *Vase of Flowers* 1981 (Plate 22, cat. 187), in painted wood, and *Black Vase of Flowers* 1983 (cat. 200) (a bronze variant on the carved wood version), *Roses* 1983 (cat. 202) (a unique painted bronze), *Study for Ice-Bucket Stand for Ivy Restaurant, London* 1990 (cat. 436 and 437) (in which metal ivy leaves climb up a stand in a matching material), *Vase and Thistle* 1995 (Plate 27, cat. 257), *Vase of Flowers in a Frame 1* and *2* 1995 (cat. 250 and Plate 29, cat. 251) and *Posy* 1998 (cat. 320) are among the numerous sculptures in which Barker has made use of such imagery at intervals over the years. If all of these allude to the passage of time and thus to mortality, another work, *Linda's Clock 7 P.M. 30th January 1988* 1988 (cat. 226), shows time stood still, memorialising the consummation of a relationship with a woman he loved. Rather than experiencing any embarrassment at making public such a private and intimate moment, he draws attention to it by placing a pair of copulating frogs on top.

Much more sober in its allusion to time and the passage of life is *Candle in the Wind* 1997 (cat. 290), a memorial to Princess Diana conceived through the image of Elton John's song of that title. As witnessed by millions of television viewers, the words sung by the composer had been rewritten by the lyricist Bernie Taupin for her funeral service so that they referred to her rather than to Marilyn Monroe, as in the original recording of the early 1970s. Appropriately for a public figure with such a large popular following, Barker conflates the imagery of a familiar pop song with the symbolism of Old Master painting, in which an extinguished candle signifies mortality. Representing the strong flame by means of an upside-down heart, he identifies her spirit with the power of love; the result is all the more touching and intimate for the simplicity and small scale of the solution.

If *Candle in the Wind* provides a metaphorical stand-in for a person, the human figure has customarily entered Barker's art more directly in the form of body parts. As the very idea of a 'body part' suggests, such forms are often accompanied by an element of the grotesque. (This is true even in the case of *Ouch* 1999 (cat. 366), a rare foray into comic narrative, which records an everyday incident at home or in the studio: the dropping of a hammer on an unprotected toe.) The very first such fragments suggest amputations and damaged or incomplete bodies. Both are housed in containers. *Van Gogh's Ear* 1967 (cat. 54), placed in a box, alludes to one of the most infamous episodes in the biography of modern artists, when the lovelorn Post-Impressionist genius severed one of his own ears in despair at being rejected. *Tom Bruen's Teeth* 1967 (cat. 55), in which the dentures of the artist's father-in-law are placed, as at bed-time, in a pair of drinking glasses, is more openly comical, but it is still comedy of a rather black dimension. If dentures strike us as funny, it is because they play on our nervous fear of growing old, losing our looks and eventually disintegrating – as we must – to dust.

Like *Van Gogh's Ear* and the two *Van Gogh's Hat with Candles* of 1969, *David Hockney's Glasses* 1970 (cat. 127) brings to mind an admired artist – in this case also a friend – through a kind of trademark image of a particular part of the body or item of clothing. By contrast with this portrait quality, *Heart* 1969-96 (cat. 116) is a more general evocation of the human body through the organ responsible for sustaining life. The heart itself was sand-cast in aluminium in 1969 from a plastic model of the human heart made as an educational toy, which the sculptor Eduardo Paolozzi had glued together and just given to Barker's son Tad, then aged three, who had picked it up out of curiosity. Barker did nothing more with it until he found it again in 1996, when he made the base for it and produced a small edition of them.

The link with Paolozzi through *Heart* is an appropriate one. Paolozzi's sculpture, like Barker's, makes much use of casts from existing objects and is rooted as much in Surrealism as in Pop concerns.[26] *Foot Stool* 1983 (cat. 427) provides another vivid example of Barker's occasional return to a classic and somewhat grotesque Surrealist image, on this occasion involving the literal visualisation of the title not as a low stool for resting one's feet but as a stool-like object consisting of nothing more than lifesized bronze casts of a pair of human feet holding aloft a small circular top. This provides yet another instance of his inventive questioning, even overturning, of the conventional relationship between a piece of sculpture and its pedestal. While other sculptors of his generation, from the Minimalists to the Constructivists to those engaged in casting the human figure from life,[27] all sought to eliminate the pedestal altogether so that the sculpture and the viewer shared the same space, Barker was happy to align himself with a more traditional conception of the sculptural object as a discreet form existing within its own space – if only for the opportunities this gave him to subvert expectations.

Beginning in 1969 with *Life Mask of Francis Bacon* 1969 (cat. 85 and Plate 14, cat. 86), made first in plaster from the celebrated painter's face and from this in bronze coated in gold leaf, Barker has also sought many ways – from the extremely literal to the stylised and abstracted – of representing human heads and figures. *Head of Jean* 1974 (cat. 157) translates the dome shapes of his food sculptures into brass, identifying the otherwise smooth geometric form as human only by means of the Surrealistic protrusion of a pair of lips. As in certain paintings by Magritte, such as *Le Viol* [*The Rape*] 1934, *Torso of Marianne Faithfull* 1975 (cat. 159) – a portrait of a voluptuous woman known to Barker not only as a singer but as a friend – functions simultaneously as both head and nude torso, with the two circular forms appended to the impeccable surface of a perfect cylinder reading either as a pair of erect nipples or as eyes open wide-eyed in amazement (fig. 10). *Tits (M.F.)* 1975 (cat. 161) is another portrait of Marianne

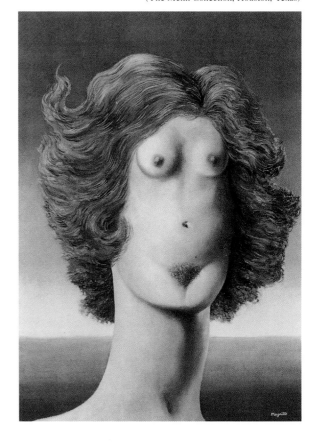

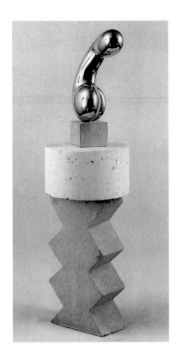

Faithfull, represented this time by conical wooden domes peaking in nipples, suggesting the aroused breasts of a woman lying on her back; it is echoed by another wood sculpture, *Helen* 1980 (cat. 186), which consists of spheres similarly brought to life as breasts by the addition of nipples.

Man from N.Y.C. 1981 (cat. 189) (in pitch pine), *Head of Eduardo Paolozzi* 1981 (Plate 19, cat. 188) (in wood), *Head of Jo House* 1981 (cat. 195) (cast in bronze) and *Man from New York City* 1987 (cat. 216) (a polished bronze) form part of this animated series of real and fictional portraits from the 1980s. Perhaps most successful of all is another *Head of Marianne Faithfull*, from 1981 (Plate 25, cat. 194), in polished bronze. Redolent of pioneering Modernist works by the Rumanian Constantin Brancusi, polished bronzes such as *Mademoiselle Pogany* 1916 (fig. 11) or the even more daringly reductive *Princesse X* 1916, this streamlined egg-shaped form is recognisable as a representation of a human head thanks to the prominent pouting lips thrust forwards towards the viewer into the shape of a kiss or a voice raised in song. Inevitably one thinks of the even more famous, oversized lips of her ex-boyfriend, Mick Jagger, bringing into the equation her initial incarnation as the supreme rock-star chick of the 1960s. But by this date, two years after the release of her LP *Broken English*, Marianne Faithfull was reestablishing herself as a powerfully affecting singer in her own right.

The 1969 life mask of Francis Bacon was followed up nearly a decade later by an extraordinary series of portraits of a painter who had become such a close friend. Viewed together, they form Barker's most extended homage to the work of another artist. The 1978 *Studies of Francis Bacon* (cat. 170-181) comprise a series of unique objects, mostly in polished brass, rich in allusions to some of the most memorable inventions by the leading figurative painter. In *Study of Francis Bacon, No. 3* 1978 (cat. 172) severely distorted forms are shown as if melting into pure matter, the equivalent in bronze of Bacon's characteristic smearing of facial features into almost abstract brushwork. *Study of Francis Bacon, No. 7* 1978 (cat. 176) depicts Bacon as literally seeing the world through the lens of a camera, transformed into his eyes and nose: an acknowledgment of the immense influence that the photographic image had on his painted depictions. The eyes in *Study of Francis Bacon, No. 8* 1978 (cat. 177) are closed as in a life mask, prompting memories of the life mask of William Blake, which Bacon took as the subject of a series of paintings called *Study for Portrait (After the Life Mask of William Blake)* in 1955-56. *Study of Francis Bacon, No. 11* 1978 (cat. 180) takes its cue from Bacon's *Painting* 1946, another key early work, in which a man's tormented head is shown half-swallowed into the dark recess of a black umbrella, while *Study of Francis Bacon, No. 12* 1978 (cat. 181) makes reference to the small heads presented by Bacon in triptych format. Perhaps the most extreme of all these portraits – and portraits they certainly are in the complexity of mind, character and appearance they summon forth – is *Study of Francis Bacon, No. 9* 1978 (Plate 23, cat. 178). Here the tube from a gas mask is transformed into an ambiguous anatomical part which could be read as the spine or as the breathing system (the

throat and windpipe) of the figure. In this case the configuration of the form as an enormously elongated arched neck, leading directly to a mouth opened wide as it releases a piercing howl, serves as a powerful reminder of the chilling animal mutants featured in the triptych that kick-started Bacon's career, *Three Studies for Figures at the Base of a Crucifixion* 1944 (fig. 12).

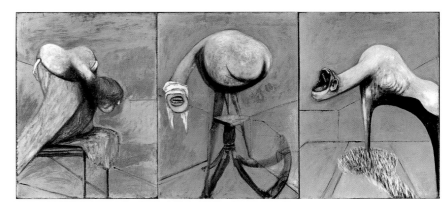

Fig. 12
FRANCIS BACON (1909-1992)
Three Studies for Figures at the Base of a Crucifixion, 1944
oil and pastel on hardboard
each panel, 94 x 73.7 cm
(Tate, London)

The violence integral to Barker's portraits of Bacon chimed naturally with the symbols of violence with which he had first concerned himself in 1969, the year of the inaugural Bacon portrait, in his series of *Hand Grenades* (cat. 102-104). These works, followed in 1973-74 by a group of 'war heads' in the form of helmets and skulls, were made during the final stages of the increasingly unpopular Vietnam War, seen nightly on the television news. Barker maintains, however, that he has always been apolitical and that he did not make these out of a conscious intention to comment on the war and its rights or wrongs. He thought of the hand grenade, without a trace of irony, simply as 'a nice object, something that fit in the hand'. The later series of skulls, made from helmets and from gas masks that he discovered after his father's death in 1970 in a cupboard in his father's home, were for him not about war but about the loss of his father, which he says 'affected me more than anything.'[28]

More than 20 years on, Barker returned to images of combat in works such as *Space Pilot X-Ray Gun* (cat. 330), *Head of Darth Vader* (cat. 336) and *Bomber* (cat. 329), all of 1998. This time the violence is conceived through casts of children's toys, prompted by the imminent release of a new *Star Wars* Hollywood spectacular. This new group includes another agent of destruction that fits nicely into the hand, but that remains a fairly benign fantasy object in comparison to the *Hand Grenades* of 1969: *Small Ray Gun* 1998 (cat. 331), made in polished aluminium in an edition of 50. In a similar vein, *Bomb* 1998 (cat. 328) – a spherical object with a prominent curved wick – is a shorthand representation of an incendiary device as depicted in the comical violence of a cartoon such as 'Roadrunner' rather than in a more threateningly realistic form. And of course the subject allows him to return in yet another unexpected guise to a favourite subject, the container. For what is a bomb if not a container filled with explosives?

Bomb serves as a timely reminder that the initial impact of Barker's sculptures can obscure the fact that many of them burn on a slow fuse. Precisely because they can seem thunderingly obvious on first sight as straightforward replications of familiar objects, one might miss the more subtle inflections that counter that literalness with a use of visual pun,

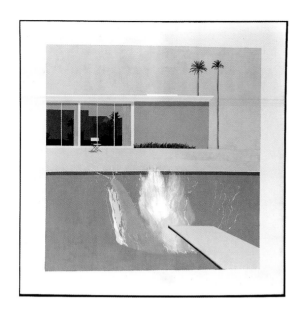

Fig. 13
DAVID HOCKNEY (b.1937)
Bigger Splash, 1967
acrylic on canvas, 244 x 244 cm
(Tate, London)

metaphor and rather magical forms of metamorphosis. In *Splash* 1967 (Plate 5, cat. 46), for example, chrome-plated ball bearings are transformed into larger-than-life drops of water, their undisguised static spheres fused through accumulation into a stylised but credible depiction of a quantity of fluid; the elongation of a few cast shapes in the centre creates the splash alluded to in the title, as witty in form as the foam represented in the *Bigger Splash* painted by Barker's friend David Hockney in the same year (fig. 13).

A pair of much later works, *Jack's Plane* 1987-95 (cat. 217), constructed mainly in wood from found objects, and *Jack's Plane – 2* 1995 (cat. 260), the same assemblage cast in polished aluminium, reveals how Barker has continued to allow his imagination to be stimulated by chance encounters with ordinary objects, playing on their function, identity and name. In this case he has been led to transform a rudimentary carpenter's 'jack plane' for shaving wood into the body of an equally basic but unmistakable representation of an airplane. The wings, found some years earlier by a friend, were from a broken model airplane, and the propeller was from a toy boat. Brought together with the carpenter's tool, the components all seem in perfect proportion with each other, as if they had been waiting only for that 'eureka' moment to be married together. In ancient Greek myths, the gods reinvented themselves in whatever guises were necessary to achieve their ends. Barker reveals that with the Surrealist heritage at his disposal, the modern artist is free to reinvent the world, with the unfettered innocence of a child's vision, to make unexpected connections by which a whole universe can be created from the most ordinary materials close to hand. *Riding Along in my Automobile* 1998 (cat. 339) features a similar carpenter's plane, to which Barker has added metal wheels and into which he has inserted an artist's lay figure as the driver of a classic racing car. The title is a line from a Chuck Berry song of the 1950s, 'No Particular Place to Go', suitably applied to a nostalgic and carefree image of the days (now long gone) when motoring was associated with the freedom of the open road.

In *Self-Portrait with Bananas* 1987 (cat. 212) several huge bunches of bananas are held aloft on Barker's head, not in emulation of Carmen Miranda's preposterous hats but as a substitute for his own long wavy hair. The result is self-deprecating not just in its plain silliness, with the artist presenting himself as a kind of jester entrusted with the task of entertaining the public, but also in its use of such a juvenile phallic substitute as an allusion to masculine self-esteem and concern with sexual potency.

Such transformations have animated Barker's sculptural inventions, even the most modest in size, for almost forty years. A recent work, *Champagne Ring* 1990 (cat. 435), celebrates this very quality of the creative act, the poetry of making art from whatever happens to be at hand. The felicitous

simplicity of the idea for this tiny piece – cast from a champagne cork into which a circular hole has been drilled so that it could be worn as a ring – is wholly appropriate to the subject. In a single act, the lightheadedness and celebratory mood induced by the consumption of champagne is associated with the spontaneous gesture of a declaration of love accompanied by the exchange of impromptu engagement rings. It works as a sculpture precisely because it is so unforced, like a passing thought suddenly drifting through the mind when one's defences are down. The object becomes a testament to a moment of relaxed reverie. Who could have predicted that such a modest object, subjected to such simple transformations – pierced, then cast in aluminium and polished till it gleams – could come to represent a state of mind? It would be almost impossible to will oneself to come up with such an idea. The beauty of it, and of Barker's art in general, is that it seems to have been called into being at a single stroke by a man gifted with the Midas touch.

NOTES

1 The text of Duchamp's lecture was not published until 1966, when it appeared in *Art and Artists* (London), vol. 1, no. 4, p. 47.

2 A rare exception to Barker's reluctance to use ready-made elements were the buckets used in *Splash*, *Drips* and *Bucket of Raindrops*, all of 1967. Even here, however, where he used store-bought steel buckets, he took pains to make successive alterations to them, stripping off their galvanised surface and then chrome-plating them.

3 In an interview with the author on 1 December 1999, Barker explained: 'My first cast was a bronze one, and my second cast was an aluminium one. They were the first two I ever did. And then I went on to chromium-plating bronze and steel or whatever. Now I've gone back to aluminium again because it's so much easier; you can polish it and then you've got that shine. Chromium-plating is okay when it's just a flat surface, but if there's any kind of deviation, you can't throw it; you can't throw it into a right angle, for instance, so that is a problem. Because you have to copper plate, nickel plate, and then chrome-plate. With aluminium, once it's polished you don't have to do anything more to it. It might get tarnished if people handle it too much, and of course if it's left outside, but you then just polish it up again.'

4 Bacon, whom Barker had counted on as a close friend, especially from the late 1960s through to the late 1980s, had died on 28 April 1992. The stilled brushes, forever locked in place into a tin for cleaning them, are strongly reminiscent of Jasper Johns's sculpture *Painted Bronze* 1960, but the table-top is painted the shade of orange used so often by Bacon to create the atmosphere of anxious emotion at which he excelled.

5 Dine's work was seen in London through the Robert Fraser Gallery, where Barker participated in group exhibitions and had his first solo show in 1968.

6 The painting referred to was presumably *Two Palettes (Sears Roebuck; Francis Picabia)* 1963.

7 *Small Ray Gun* 1998, of which he made 50, is by far the largest edition; it has to be viewed almost as a commission, however, as someone had offered to buy half the edition in advance if he produced that number.

8 *50 Francis Bacon Signatures* 1969 provides a caustic comment on the faith invested in the authenticity of the artist's signature and in his 'signature style'. It bears interesting comparison with the *Signatures* made between 1965 and 1973 by the American Robert Watts (an artist he admires, but little of whose work he has seen) and the young English artist Gavin Turk's use of his own signature as the subject matter of many of his own works during the 1990s.

9 Barker had made only one cast from a bottle, *Coke with Teat* 1966, before making the first of these homages to Morandi, both of which were based on reproductions in a lavish monograph on his work that had just been published.

10 This is an allusion to paintings such as *La Trahison des images* 1929, bearing the inscription 'Ceci n'est pas une pipe' below a very clearly delineated image of a smoker's pipe.

11 One of Barker's most reproduced sculptures, this is a faithful rendition in three dimensions of the alarming image proposed in Magritte's painting *Le Modèle rouge* 1935 of a pair of unoccupied lace-up shoes metamorphosing into human feet.

12 Based on a reproduction of Soutine's *Hare Against Green Shutter* c. 1925-26.

13 As usual for Barker, who normally has taken paintings as his point of reference, in this case he has quoted Picasso's canvas *Goat's Skull, Bottle and Candle* 1952, which had entered the collection of the Tate Gallery in 1957. One could be excused, however, for thinking that he has reinvented a Picasso sculpture, *Goat's Skull and Bottle* 1951-53, in his own terms while keeping very close to the imagery and composition of the older work, so closely related are the Picasso painting and sculpture in both their imagery and their compositions. This sculpture by Picasso, fittingly, is an example of his metamorphic assemblages incorporating found objects: a painted bronze from a plaster maquette that used a set of bicycle handlebars as the goat's horns. It has been in the collection of the Museum of Modern Art, New York, since 1956. For a reproduction and analysis of the painting and sculpture by Picasso, see Elizabeth Cowling and John Golding, *Picasso: Sculptor/Painter* (exh. cat., Tate Gallery, London, 16 February - 8 May 1994), pp. 152-3 and pp. 280-81, cat. nos. 133 and 125.

14 This and other sculptures by Magritte, made right at the end of his life, were shown by Erica Brausen at the Hanover Gallery by the time she had become Barker's dealer, and he saw them there. He asserts, however, that he never liked Magritte's sculptures, which he found old-fashioned and which had that 'brown stuff [the look of patinated bronze] I always hated'.

15 The final work in the series, *Red Violin for Linda Kilgore* 1989, was dedicated to the woman with whom he was in love, who had been forced by circumstances to return to her home in the United States. The whole series was made during the time that he was involved with her, suggesting that it was conceived as a kind of love song to her and completed as a respite from the sadness of the situation and as a kind of elegy or lament to the relationship that had just ended.

16 *Le Siphon* 1924.

17 Johns employed the same motifs from these two sculptures in three prints made in 1966 and 1967.

18 See such works as *L'histoire centrale* 1928 and *Les Amants* 1928.

19 The snail was also used in a group of small sculptures, including *Snail Ring No. 1* 1987-88, associated with Linda Kilgore, from which one might safely conclude that this return to the Venus motif was also prompted by his appreciation of the beauty of a particular woman at a time that he was deeply in love. For all the apparent detachment of the means and processes employed by Barker, he continues to demonstrate his willingness to make art out of even the most personal and private circumstances.

20 *Mercury* c. 1565 by Giambologna.

21 For a selection of these works dating from 1972 to 1984, see *Clive Barker: Boxes* (exh. cat., Wolverhampton Art Gallery and Museums, 13 April 18 - May 1985).

22 He still has in mind the possibility of making a cast from a large cardboard tube in which Jasper Johns sent him a signed poster in 1971. This would not be the first time that many years have passed between the idea and the execution.

23 See such works by Watts as *Whitman's Assorted Chocolates* 1963 and *Shrimp and Clams* 1964, reproduced in *Robert Watts* (exh. cat., Leo Castelli Gallery, New York, 27 November - 20 December 1990), pp. 9 and 10 respectively. Barker saw works by Watts in 1966, when he visited New York for the first time, but he thinks it was only on his next visit, in 1971, that he saw chrome-plated cast pieces. He did eventually meet him, but although he admires his work he has still seen little of it except in reproduction. As he explained to the author on 1 December 1999, 'Even now I've probably seen only about five things of Bob's, and only two or three in reality in New York. I didn't see much, but what I saw I liked. I think I've seen a cabbage, a lead hot dog, two sandwiches (the plexiglass ones), and a stamp machine. I can't think of anything else.'

24 The use of glass domes had a precedent in a work by one of Barker's favourite artists, Magritte: *Ceci est un morceau de fromage* 1937, in which a painting representing a generous slice of Camembert or Brie is displayed, like a real piece of cheese, inside a glass dome placed on a glass pedestal.

25 The Maltese Falcon was an object made by the Knights Templar at the time of the Crusades and stolen en route to the ruler for whom it was intended as a gift. In the popular imagination, however, it is the rare and precious object sought by the heroes and villains alike in the Hollywood film of that name. Twelve plaster cast reproductions had been produced as a promotional tool on the publication of a book about the film; Barker borrowed one of these and made a cast from it. Eventually, in order to achieve a better degree of detail, he made a mould from the object, coated the interior of it with clay and then carved into it in order to accentuate the relief.

26 Paolozzi, along with Barker's friend Colin Self, was also one of the few sculptors working in the 1960s who shared Barker's love of chrome-plated surfaces.

27 The Americans George Segal (from 1961) and, later in the 1960s, the hyper-realists Duane Hanson and John De Andrea.

28 It was the tubes of these same gas masks that featured in the 1978 portraits of Bacon.

Barker's Practice: Materials, Method, Techniques and Production

Materials

Barker's choice of materials and their finishes was largely determined by his experience of working with leather and chrome at Vauxhall Motors during 1960-61.

> 'Mostly, I suppose, I worked on seats, and a bit on the chromium stuff. I was on seats for about six months. Behind me, and a bit further down from me were great skips, full of Lucas lamps. Chromium-plated on the inside. Those skips, filled up like that, seemed fantastic objects. (…) Looking back, the leather and chrome was very important. But at the time I didn't think it.'[1]

Whereas the leather directly inspired a group of work during a relatively short period 1963-65, the influence of chrome was a lasting one, leading Barker not only to apply chrome finishes but also to work primarily in polished cast metals.

Prior to the influence of leather and chrome becoming manifest during 1963-64, Barker worked with low cost materials, inevitably suggesting a lack of financial means.[2] The result is a group of nine works fabricated from corrugated cardboard or found objects. With the exception of *Little Neon* 1962 (cat. 10), all are covered with paint and all but one, *Black Sculpture* 1961-62 (cat. 8), are quasi two-dimensional and intended to hang on the wall. As such, they relate more to painting than to sculpture. Barker's use of paint to black out representation can already at this stage be traced to a conscious wish to transform a found object by changing its physical appearance, a practice inspired by his confrontation with rusty sheets of steel being renewed through the process of chrome-plating at the Vauxhall car factory.

Whereas the use of corrugated cardboard was restricted to the targets, Barker has continued to use found objects throughout his career.

Whilst having settled into his job at a pawnbrokers in Portobello Road, during 1963, Barker began working with leather.

> 'I started thinking about the seat that I had made at work, and the fact that they had a certain quality about them. (…) Portobello Road was an exciting place to be in the early Sixties. I used to cross the road at lunchtime and walk around. There were lots of little workshops there. Among them was a leather man's place. He did upholstering: that sort of thing. I walked in and talked to him one day. I asked him if he would stretch leather over a box for me if I brought it in. Of course he thought I was a bit crazy. 'What's it for? A seat or something?' he asked. I told him that it was just something that I wanted to do. So I brought a little box in, and he stretched it up.'[3]

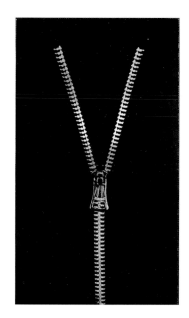

Fig. 14
Zip II, 1965, screenprint
image 762 x 470 mm
(Tate, London)

Barker made use of leather, stretched over block-board, for three years, creating relatively small-scale boxes, using zips, as well as larger structures, enhanced with neon and studs shaped into arrowheads. He favoured black leather, making *Way Out (Brown Exit)* (cat. 15) the exception, owing to the upholsterer, who, at the time, did not have in stock a piece of black leather large enough.

Finally in 1964 Barker began casting in metals. For *Zip* (cat. 23), *Zip 2* (cat. 22), and *Zip 1* (cat. 21), Barker used bronze and aluminium, the two materials which would later dominate in his work.[4] Following these initial casts, insufficient funds forced Barker back to working with leather for a time. Subsequently more cast work emerged later in 1965.

The use of cast metals accomplished Barker's transition to making freestanding three-dimensional sculptures.

During his formative period 1961-65, in addition to making objects, Barker was painting, drawing and printmaking in relatively equal quantities, a practice that persisted until the late 1960s (fig.14). When showing at the Hanover Gallery in 1969, the 19 sculptures were complemented by 5 prints and 13 drawings.

Barker's meeting with Robert Fraser put an end to his chronic shortage of money, enabling him to concentrate on casting in metals. A first meeting in the autumn of 1964 turned into a contract in November 1966. Barker was to receive a fixed monthly sum in exchange for exclusivity to sell all the work produced. If need be, extra funds would be made available for special projects. Even though the terms of the contract were not always fulfilled, due to Fraser's late payments [5], at least Fraser's commitments allowed Barker to fully realise his ideas. During the eighteen months leading up to his first one-man show at the Fraser Gallery in 1968, Barker reached a sudden maturity with the 3 versions of *Van Gogh's Chair* 1966 (Plate 3, cat. 32, 33 and 34), and with the 2 versions of *Table with Drawing Board* 1966 (cat. 35 and 36), using brass tubing, cast bronze and sheet steel, with a chrome-plated or enamelled finish. Other works involved the use of copper, lead, silver and gold.

The impeccable stark gleaming finishes of these sculptures differed from the traditional dark brown patinas, which Barker regarded as old-fashioned, dull and boring. They also contrasted with the colourful painted finishes typically used by 'The New Generation' contemporary abstract sculptors, harbingered by Anthony Caro (b.1924). For Barker the gleaming chrome communicated the spirit of post-war optimism, its appeal clearly attuned to a young and adventurous generation. It recreated the perfect surface quality of all things brand new and embodied the pride sensed by workmen upon seeing the result of their labour.

> 'My father was a coach painter, an expert. He was fantastic at it. I think that's why I've always been interested in a kind of excellence. Even if he wanted to buy a fridge, or something like that, he knew exactly how he wanted it. He would never buy anything that was shop-soiled or second-hand. He just had that sort of mentality; I've probably got a lot of things from my father. I could never possibly go out and buy something that had a scratch on it. If one of my things got scratched, I would feel that I had to redo it.'[6]

Given Barker's reluctance to attribute a particular meaning to his objects, chrome and other shiny reflective surfaces had particular appeal because they are dependent on their surroundings for their own existence.

> 'It isn't chrome as such, that interests me, but what it reflects. Chrome is nothing unless it reflects something. If it doesn't, it's dead. If you put chrome in a white room you lose it. But you put it near someone with a red dress on, someone looking at it quite closely, and you see their face. You see all sorts of reflections; that's what makes it so exciting. I have read certain things about my own work for example, which have led me to understand it better. I've often thought, well, that was an insight into what I did, even though the idea itself had not been in my mind when I did it.'[7]

Barker produced the majority of his chrome-plated work between 1966 and 1970, plating not only on bronze and steel but also on brass and copper. His use of chrome-plating diminished rapidly after 1970, when strict environmental laws and regulations concerning the health risks of chromium residue forced many chrome-plating companies out of business. By 1983 Barker's use of this material had disappeared altogether.

An obvious and cheaper alternative to chrome was polished aluminium. Barker used it in his first casts in 1964, and worked with this material regularly throughout his career. The intensive use of polished aluminium from 1992 onwards is the result of Barker employing Roseblade Foundry (London), an industrial foundry where components for aeroplanes were cast in aluminium (closed down 2001).

Barker first used bronze in 1964 and has continued using it during the span of his career. The finishes vary from plated, polished, to patinated and painted. Barker's personal preference of polished bronze over patinated bronze, instilled by his love of the surface quality of chromium-plate, distanced him from traditional sculpture. Reflective and light, this 'new' bronze was used whenever possible. Bronze sculptures with a subject matter unsuited for polishing, are patinated. Barker often opts for a light brown tone or experiments with alternative colours. To colour *Tang Horse* 1973 (Plate 20, cat. 143), Barker went to great lengths to find the bright blue patina, typical of Tang sculpture. Unknown to his foundries at the time, the desired effect was created through experimentation. Over the years however, this bright blue patina has discoloured and taken on a green tone. Whilst Barker has made use of green, black and also dark blue patinas, when a colour has altered over time, he feels that the work is taking on its own character and prefers to leave it as such. Consequently, when in 1976, Kunsthalle Mannheim purchased *Portrait of Madame Magritte* (Plate 16, cat. 122), Barker did not restore the turquoise-green colouring, which had appeared on the initial brown patina whilst remaining in storage for three years.

From 1988 Barker's preoccupation with welded sheet steel reflected a change in his personal life. Following the separation from Ro, Barker had found new love with American artist Linda Kilgore who worked solely with this material during her stay in London. Sheet steel became an option for Barker in order to spend as much time as possible with Kilgore. Unsuitable for the art he had made previously, sheet steel lent itself to fabricate the series of cubist violins,

an idea Barker had contemplated for some time. Following the break-up with Kilgore in 1989, the use of welded sheet steel disappeared altogether.

Occasionally Barker has turned to wood. A total of 7 objects in wood [8] are grouped over two specific periods: 1975 and 1980-81. Of these works, 4 are painted.

From a chronological perspective, the use of materials divides into six successive periods, in each of which the use of one particular material predominated:

1958-62: painted corrugated cardboard and painted found objects

1963-65: leather-upholstered block-board

1966-70: chrome-plated metals

1971-87: polished bronze and patinated bronze

1988-89: welded sheet steel

1990-2000: polished aluminium

Method and Techniques

Fig. 15
Vauxhall Motors, Luton
final assembly line, 1961
(Photograph Vauxhall Motors)

With the exception of the works predating the leather-upholstered pieces, each of Barker's sculptures is the result of divided labour, a practice rooted in his fifteen-month-long job at Vauxhall Motors during 1960-61. Here, whilst working on the assembly line, Barker envisaged producing art works in the same way.

'I'd always liked the idea of these great working places, like a factory… Just the thought of all those engines coming down the lines. I just thought, well, wouldn't it be fantastic if I had a studio like that, where I could have people assembling. Of course since then, several people have had a similar idea. You could say that Warhol almost put it together. But at the time – I was only nineteen – it was quite out of the question.'[9]

To Barker the appeal of the production line and the use of divided labour did not stem from a desire to mass-produce art, as opposed to the then current trend in the United States. There, the ideals of making popular and affordable art for the mass-market led to experiments with 'factory art'. Barker however used divided labour primarily as a means to manufacture high-quality unique objects. The total of 440 catalogued works includes only 78 editions.

'There are so many guys out there who can do the work better than you, who are experts at these things. I prefer to get the best guys to do it. When I was at the factory, if something went wrong with the seat, it came back to me. If something went wrong with the welding it went back to the welder. And I thought, well, if you had all these guys, you could probably produce the best work in the world. And then, when I left, and came to London, I found I was still thinking the same way.'[10]

Moreover, the use of divided labour offered a practical alternative to his aversion to physical involvement in the making of his sculptures, an attitude which became manifest during the obligatory weekly sculpting classes at art school.[11]

Barker's vision of setting up a complete studio, uniting the different specialist craftsmen involved in the making of his sculpture was never an option, considering the expense.

His 'remote control' method of fabrication, relying on out of house specialist craftsmen, set him apart from other sculptors in a time when moulding and casting had moved from the professional foundry back into the artist's studio.[12] Consequently, Barker never needed to maintain a studio or engage assistants. The leather-upholstered objects were the first works made along these principles of divided labour. Fabricated in block-board by Bird and Davis (London), these structures were then covered in leather by a professional upholsterer with a workshop off the Portobello Road.

Barker has employed several sculpting techniques including fabrication in materials other than metal, incorporating found objects, welding sheet steel and casting in metals. During the first two decades of his career Barker has often involved the use of more than one technique in making a work. The overall importance of casting however prompts further investigation, exploring Barker's creative process and casting techniques.

Fig. 16
Sketches for 'Study of
Francis Bacon' series, 1978
pencil and biro
177 x 112 mm

SKETCHES, STUDIES AND MODELS

Given his aversion to physical involvement in the manufacture of his work, Barker favours casting from found objects, frequently purchased 'off the shelf'.

Objects cast from one single model ('single model' objects) are usually replicated from ready-made models therefore making sketches and 'maquettes' or studies unnecessary as a rule. Objects that involve several models to make up a work however are often cast from a combination of ready-made models and models crafted by Barker himself. It is for these 'multiple model' objects that sketches and 'maquettes' do exist.

The sketches are quick and simple, but nevertheless accurate. They illustrate the clarity of Barker's thought process and concept, showing that most of the finished objects are exact executions of their original idea and sketch (Figs. 16 and 17). Occasionally a finished collage acts as sketch, as is the case with *MM* (Fig. 18).

More elaborate drawings of objects however do exist, both for 'single model' objects and 'multiple model' objects. They postdate the sculpture concerned and are therefore artist's drawings rather than sketches or working drawings. Instead of drawing from the sculpture itself, Barker will draw using black and white photographs, which exaggerate the shadow patterns. Occasionally Barker has used the model or the sculpture itself as a template (Fig. 19). Barker has gone through various phases where sculpting was replaced by producing 3 to 4 drawings a day. The total of drawings therefore amounts to hundreds.

The existing studies in the sense of 'maquettes' are *Portrait of Madam Magritte, Study 1* and *Study 2* 1970 (cat. 118 and 119), *Study for a War Memorial* 1974-83 (cat. 153), *Study for a Monument to Francis Bacon* 1992 (cat. 243), *Study for Monument for Luton (Elephant)* 1993 (cat. 244), *Study for a Sunbather 1* and *2* 1995-96 (cat. 264 and 265) and *Study for Trophy* 1999 (cat. 362).

Fig. 17
Sketch for *Study of
Francis Bacon, No. 6*, 1978
pencil and biro
177 x 112 mm

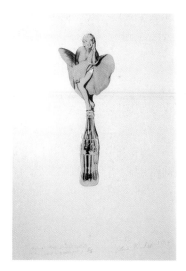

Fig. 18
*Study for Sculpture 1969
(Coke & Marilyn)*, collage
1997, paper 782 x 521 mm

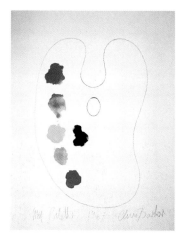

Fig. 19
My Palette, 1967, pencil and gouache
paper 655 x 500 mm

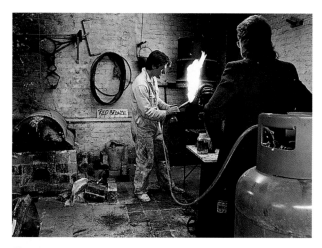

Fig. 20
Clive Barker overseeing the welding of
Self-Portrait with Bananas at Red Bronze
Studio Art Founders, London, 1987
(Photograph Eileen Tweedy)

Of these, only *Portrait of Madam Magritte* has materialised into a larger scale finished work (Plate 16, cat. 122). In *Study of Francis Bacon, No. 1-12* 1978 (cat. 170-181) Barker has applied the term 'study' in reference to Bacon's fashion of titling his own work rather than in reference to their existence as 'maquettes', which they are definitely not. *3 Cokes Study* 1967 (cat. 59), *Three Torches Study* 2000 (cat. 406) and the two versions of *Study for Ice-Bucket Stand* 1990 (cat. 436 and 437) are referred to as studies because they exist in other versions.

All 'maquettes' and works referred to as studies are cast in metal rather than remaining in clay or plaster. The term 'study' is further applied in a broader sense to objects of certain editions. This term is used fairly arbitrary and it is not unusual for the study to be identical to the edition.

With the exception of *Penis Vase* 1994-98 (cat. 438), all models crafted by Barker himself are used in multiple model objects. Barker has used clay, wood or wax to make his models. Coming to mind as examples of such works are: *Mermaid on Heart* 1987 (cat. 215) and *For Linda* 1987 (cat. 214) cast from a model carved in wood, *Penis Vase* 1994-98 (cat. 438) cast from a model in clay, and the numerous small waxes of Playboy bunnies and Marilyn Monroe figures featuring on top of bottles, or female figures posing as sunbathers or dancers. Most of these models crafted by Barker have been destroyed after being cast.

FOUNDRY

Barker employs three casting techniques: sand-casting, lost wax process and a technique where the model is burnt out of the mould. Bronze is cast using all three techniques. Brass is only cast in lost wax and aluminium is cast solely in sand.

As a rule, works cast in sand are solid. Barker rarely makes use of a core, therefore casting larger bronze works using the lost wax process.[13]

There is little continuity in the use of a particular technique when creating a series of works. Bronze Coke bottles, for example, have been cast both in sand and in lost wax.

When casting an edition in lost wax, Barker always casts the model in the required number of waxes prior to casting in metal. Even when making his largest lost wax edition, *Life Mask of Francis Bacon* 1969 (Plate 14, cat. 86 and cat. 85), Barker cast all 16 waxes before starting to cast in metal.

Based on the same principle as the lost wax process is a technique in which the model is burnt out of the mould. Covered in grog, which sets hard, the model is placed in the furnace where it is burnt out under great heat. This creates a cavity for the metal to be poured into directly. Barker used this technique in 1990 for the bird's nests in *Little Bird in his Nest* (cat. 233) and *Twins* (cat. 234) and again in 1995 for the thistle in *Vase and Thistle* (Plate 27, cat. 257).

Over the years, Barker has used many different foundries. He worked with several local London foundries before starting with Morris Singer Foundry (London) in 1966. After leaving Morris Singer in 1977, Barker changed to Burleighfield Arts (High Wycombe), set up by former employees of Morris Singer. Here, Barker started with the casting of the bronze and brass series of *Study of Francis Bacon, No. 1-12* 1978 (cat. 170-181), remaining with them until early 1984. In 1986, after a two-year break from casting, Barker started working with Red Bronze Studio Art Founders (London), until 1992. In 1987 he also started to employ Livingstone Art Founders (Tonbridge, Kent). Since none of these foundries specialised in sand-casting, Barker preferred to take objects to be sand-cast to local foundries in Islington and Peckham.

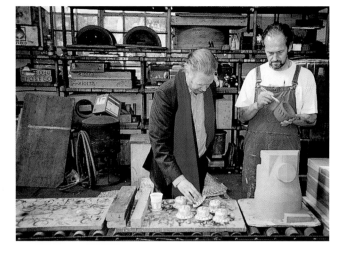

From 1992 until 1995 Barker worked with the Luton Casting Company (Luton) and from 1993 onwards also employed Roseblade Foundry (London), an industrial foundry specialising in casting aeroplane components. Both foundries specialised in sand-casting, making Barker rely on Livingstone for lost wax casting and the 'burn-out' technique.

To avoid the long waits for different parts of assembled sculptures to be cast, Barker in addition made use of various local foundries.

At the beginning of his career, Barker, trained as a painter, wasn't always aware of the limitations of certain materials and therefore the techniques sometimes proved a challenge to the foundry-men.

> 'I cast the ladder-back in bronze, and went to another workshop, and asked them to help me fabricate it (*Van Gogh's Chair*). He advised me on the best way to do it. We looked through some brass tubes and things, then I drew up the chair and he fabricated the tubes for me. We had a bit of a problem fitting the bronze and brass together: if you heat the tubes too much, they go too soft, but the bronze doesn't get soft enough. So we had a lot of trouble with that.'[14]

With time, Barker gained great insight in the technical aspects of sculpture making, partly through visiting the foundry several times during the process of moulding and casting but most certainly through his establishing a good working relationship with the foundry-men and moulders.

Fig. 22
Stamped signature details,
illustrating the use of small punches

After casting, the different parts to the sculptures remain in the foundry for fettling [15], the application of a patina, if required, and welding. Sometimes drilling holes in the different parts of assembled sculptures, usually performed by engraver Peter Reddish, takes place at the foundry.

Then, from the foundry, the different sections to the sculptures are delivered to Barker's home. Here they are collected by craftsmen to undergo the necessary processes of drilling holes, chrome-plating or polishing, and engraving, all prior to assembling.

Fig. 23
Stamped signature details,
illustrating the use of larger punches

Fig. 24
Signature details engraved by machine

Fig. 25
Signature details applied in the wax

Fig. 26
Signature details in enamel, applied
by hand

The task of polishing has been entrusted to James Ord-Hume, who has worked with Barker for many years. The polished surfaces are usually not lacquered, leaving them to tarnish over the years. The absence of lacquer has the advantage that tarnished surfaces can be re-polished without difficulty by a non-professional. The few polished bronzes that have been lacquered need to be stripped first before re-polishing is possible, a task which is better left to a professional polisher.

Chrome-plating was undertaken by Barrell and Clerkenwell (London) as well as by the Juno Plating Company (Southend-on-Sea, Essex).

SIGNATURE

The majority of works bear the artist's name, title, year and edition number where appropriate. These details appear stamped, engraved (by machine or by hand), stencilled (leather-upholstered pieces) or applied with pen, pencil or enamel paint.

The stamps are applied by Barker himself, in his home. Over the years Barker has used different sets of punches. A set of small punches was used during the 1960s and 1970s and larger punches were used during the 1990s. Early stamped details often only quote Barker's initials and the two last digits of the year, sometimes making it difficult to find the signature, especially on aluminium. Engraving, carried out since 1964 by Peter Reddish of Charles Smith & Reddish Ltd (London) is fairly uniform in style (fig. 24). During the 1990's the engraving more frequently appeared on a nameplate screwed to the sculpture.

On rare occasions, a work is signed in the wax before casting (fig. 25).

Some objects carry multiple signatures, including signatures applied by hand, in enamel paint, black felt tip pen or pencil. They are mostly found on parts to assembled works, with the purpose of being easily identified in the foundry. On black painted wood, cardboard and block-board surfaces, as a rule, the artist signs in pencil or applies a stencilled signature. A few of these early signatures in pencil were at the time inscribed by Barker's wife Ro. It is not unusual for a work not to bear any signature. Occasionally being pressed for time during his contracts with the Fraser Gallery and the Hanover Gallery, sculptures were delivered to the gallery unsigned. Once out of his hands, Barker is reluctant to make alterations to a finished work. Sometimes, for no reason other than his own casualness, few works which have been in his possession for a long time do not have signature details.

ASSEMBLY

For cast sculptures Barker employs two assembly techniques: that of welding and that of screwing or bolting together.

In general, welding is used for patinated pieces and is performed in the foundry.[16] Bolting or screwing together, on the other hand, is generally used for polished pieces and is carried out in Barker's home, after the different parts to the polished sculptures have been polished, engraved and drilled with the necessary holes. Chrome-plated works are assembled using either technique.

Production

Barker's production is characterised by a predominance of unique works and by large variations in annual production numbers.

Of the total of 440 catalogued works, only 78 are cast in edition.[17] Edition sizes are small with only 3 editions exceeding 10 in number: *Gold Coke* 1992 (cat. 242), edition of 40 (only 9 cast), *Small Ray Gun* 1998 (cat. 331), edition of 50 and *Noddy and his Car* 2000 (cat. 412), edition of 25. All three were initiated and partly funded by third parties, a practice Barker usually avoids. Barker considers these large editions, with the exception of *Gold Coke*, as non-commercial ventures, often making gifts of the works to friends.

Editions of two are usually created in a personal context, referring to a specific situation or memory shared with someone close to him.

Barker produced an increasing number of editions as his career progressed. Of the total of 78 editions, 54 were cast after 1990. This development is highlighted in a comparison between the two most productive years 1969 (40 works, 7 editions) and 1999 (50 works, 18 editions). Editions however have never outnumbered unique works in any particular year.

Barker has always cast the full number in each edition simultaneously. With the incomplete edition of *Gold Coke*, casting was halted at 9 due to lack of funding by the third party. Barker has no intention to ever cast the remaining 31 works in this edition.

The casting of a second edition has occurred once. Only because 3 waxes from the original *Life Mask of Francis Bacon*, were not cast at the time, Barker allowed Anthony d'Offay to go ahead with casting them in a second edition of 3 in 1971. Barker's natural resistance to engage himself in a work longer than necessary, prevents him from making second editions.

The decisive factor in whether to proceed with an edition or not, is the cost of the first cast. Should he decide to cast in edition, the first cast becomes either part of the edition, a prototype, a study or an artist's proof, terms the artist uses quite arbitrarily. There is no consistency in the production of artist's proofs or prototypes accompanying the editions. About half of the editions have artist's proofs, the number of which has never exceeded a total of 3 and which in most cases were destined for himself and his two sons. Over the years however, many of these proofs have been sold. Periodically throughout his career, Barker has created variations of objects. These variations differ in finish, material or the addition of further elements or different bases, and each are considered as unique works, as their numbering and titles indicate. The 'Vase of Flowers' series 1981-83, including *Vase of Flowers* (Plate 22, cat. 187), *Vase of Flowers with Brush* (cat. 193), *Black Vase of Flowers* (cat. 200) and *Roses* (cat. 202), illustrates best the variety of materials, finishes and added elements.

There are several reasons for large variations in annual numbers, the most common being variable financial situations and variable states of mind brought upon the artist by separations, death and the reception of his work.

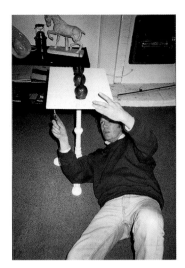

Fig. 27
Clive Barker assembling
3 Toffee Apples, at home, 1992
(Photograph Mary Beazley)

The majority of work was produced in the periods 1966-75 and 1995-99, with 1969 and 1999 as most productive years with a respective output of 40 and 50 works.

Barker's small production during the years 1958-61 was the result of his indecisive approach to choosing a career: whether to follow in the family tradition of working for Vauxhall Motors or to seek a career as an artist. During 1961-65 the little production is the consequence of his poor financial situation, rather than of any lack of ideas - *Van Gogh's Chair* and *Table with Drawing Board*, show a maturity that cannot be traced in the preceding work, illustrating that ideas had been developing in his mind in the meantime.

Following the overnight success of the exhibition of *Van Gogh's Chair* in 1966 Barker was taken under contract by Robert Fraser and immediately started preparing for a first one-man show at the Robert Fraser Gallery in 1968. This is reflected in higher levels of production. In 1969, Barker was in effect working for the Hanover Gallery.[18] This resulted in an output of 40 works, a number he had never attained previously. It was not until 30 years later that a greater production was achieved.

During 1970-74 production levels fell to an average quantity, paradoxically the result of a sense of achievement felt by Barker. Things were looking optimistic for Barker: he had been represented by two of the most prestigious art galleries in London, his work was shown on the international circuit and after the Hanover gallery had closed in 1972, he was now informally working with Anthony d'Offay. In 1974, the results of these four years formed the exhibition 'Heads and Chariots' at the Anthony d'Offay Gallery, London.

1975 is characterised by a large production. Whether or not a sense of security instilled by Fraser's return to London played a role in this is difficult to establish.

In 1976 the growing need for a larger family home diverted Barker's attention away from work. Only one work dates from 1976 (*Castle for Ras*, cat. 168) and there is no work dating from 1977. After the acquisition of the house in Malvern, Barker resumed work in 1978, with the series of portrait heads of his close friend Francis Bacon. This project was promoted by Robert Fraser in a show at the Felicity Samuel Gallery, London. Following this exhibition, refurbishing works on the house in Malvern started, absorbing Barker's attention. For a further two years no work was completed.

1981 and 1983 were productive years, with 14 and 10 works respectively. These years alternated with years of almost no production. In 1985-86, the combined effects of the final separation from Ro and Robert Fraser's deteriorating health [19] were cause to produce only two works.

Not until he met Linda Kilgore in 1987 did Barker start working again. The presence of the American artist inspired Barker to produce a large group of work. Kilgore's departure to Arizona in 1989 left Barker unmotivated.

By the early 1990s Barker was working again and reached a creative outburst during 1995, leading to a peak in 1999. The year 2000 is further characterised by a large production and by more ambitious projects such as *Alphabet* and *Van Gogh's Bed*, both unfinished in 2001.

NOTES

1 In interview with Peter Fuller, 1975.

2 Most of Barker's resources at that time went to setting up household with his new wife, in London.

3 In interview with Peter Fuller, 1975.

4 Disappointed with the casting quality of *Zip* and *Zip 2*, Barker rejected both these works and therefore considers the two variations of *Zip 1* as his first casts.

5 VYNER, Harriet. *Groovy Bob: The Life and Times of Robert Fraser*. London, 1999, pp. 170-171 and pp. 206-207.

6 In interview with Peter Fuller, 1975.

7 Ibid.

8 This excludes works incorporating wooden found objects.

9 In interview with Peter Fuller, 1975.

10 Ibid.

11 In interview with the author on 19 October 1999 Barker, referring to his sculpting experiences at art school, has commented: 'I never wanted to be involved with sculpture. And I thought that all those things were too much trouble anyway, making sculpture, mould making and all that sort of thing'.

12 KOWAL, Dennis and Dona Z. Meilach. *Sculpture Casting, Mould Techniques and Materials: Metals, Plastics, Concrete*. London, 1972, p. 3.

13 Bronze bases cast in sand however, are usually cored. *I Thought She Was a Natural Blonde* (1999-2000) is a large bronze cast in sand, for which the legs were cored.

14 In interview with Peter Fuller, 1975.

15 Fettling is the technical term for cutting and chasing the cast work.

16 Sculptures in sheet steel are welded together by John Crisfield (London).

17 This includes *Happy Birthday* (1999), unnumbered edition of 6, and *Coke with Teat* (1966 and 1973), *Candle Stick* (1986), *Mervyn's Stick* (1998) and *Light Sabre* (1999) each of which Barker cast 2 unnumbered examples.

18 Motivated by rumours of the pending closure of the Robert Fraser Gallery, Erica Brausen of the Hanover Gallery approached Barker during November 1968. Barker continued to be represented by Robert Fraser until the closure of his gallery in August 1969, but was in effect working for the Hanover Gallery.

19 Robert Fraser died of Aids in 1986.

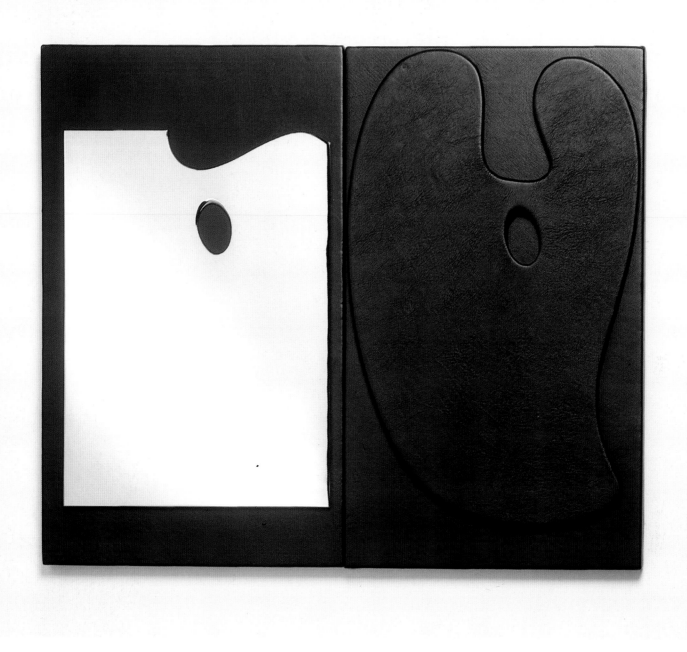

PLATE 1 (Cat. 27)
Two Palettes for Jim Dine, 1964

Leather, chrome-plated brass and wood
26 x 30 x 2 in / 66 x 76.2 x 5 cm (Private Collection, London)

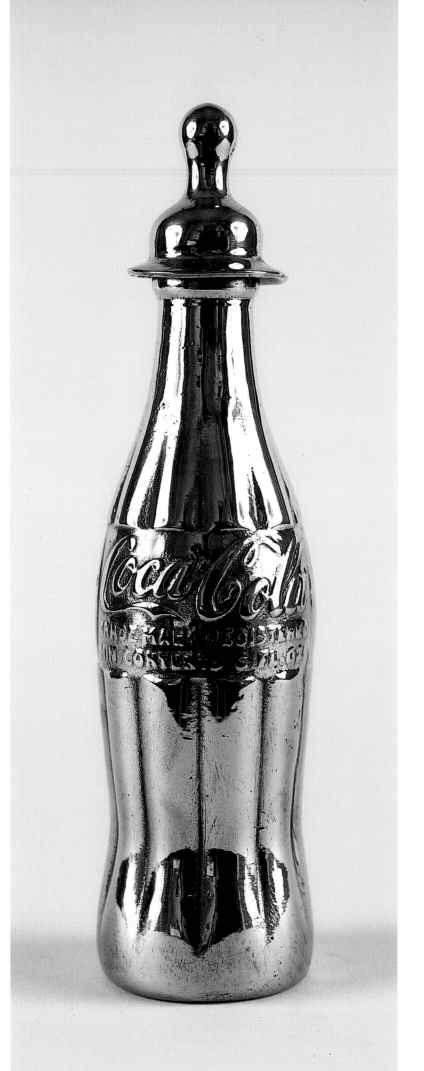

PLATE 2 (Cat. 37)
Coke with Teat, 1966

Polished bronze
8 3/4 in / 22.2 cm high
(Collection of Tad Barker)

(right) PLATE 3 (Cat. 32)
Van Gogh's Chair I, 1966

Chrome-plated steel, chrome-plated bronze
and chrome-plated brass
34 in / 86.4 cm high (Heller Collection)

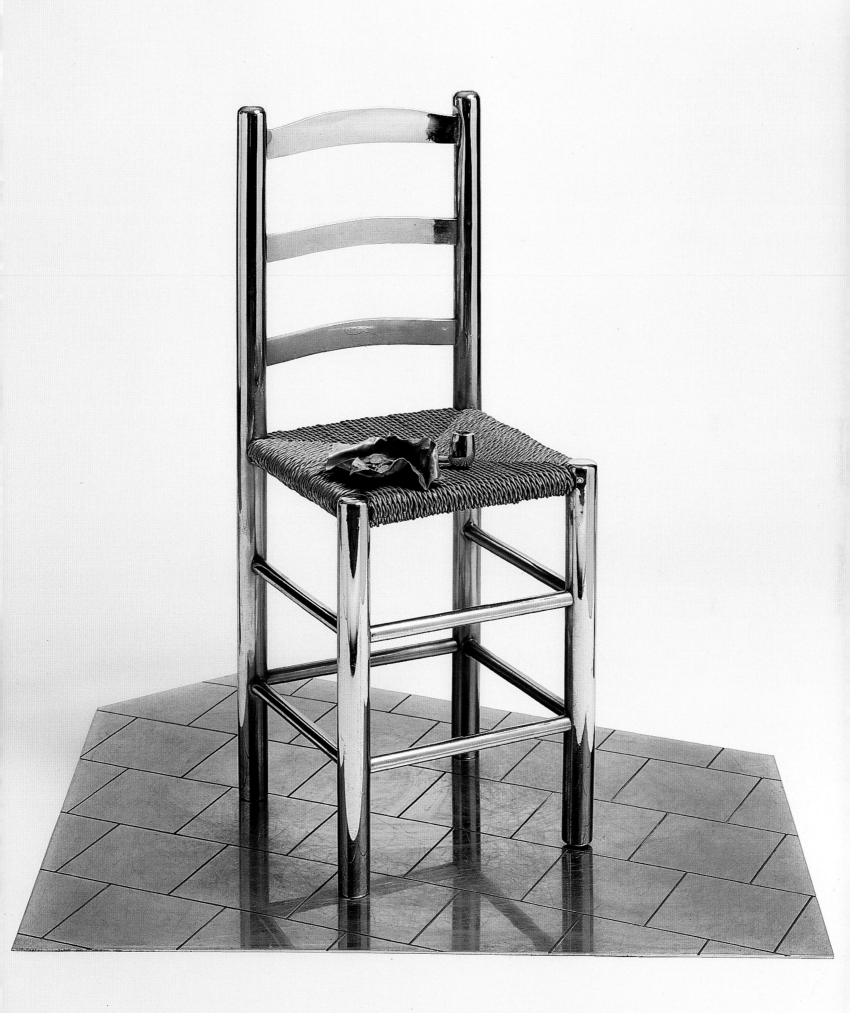

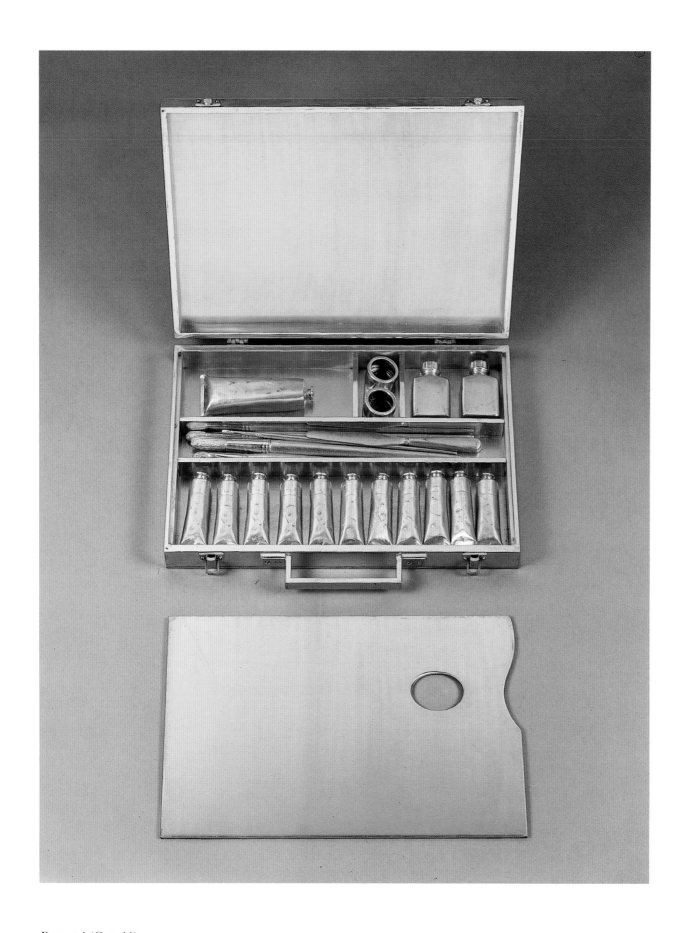

PLATE 4 (Cat. 44)
Art Box II, 1967

Gold-plated brass and gold-plated bronze
2 1/2 x 16 x 12 1/4 in / 6.4 x 40.7 x 31.1 cm closed (Collection Peter Blake)

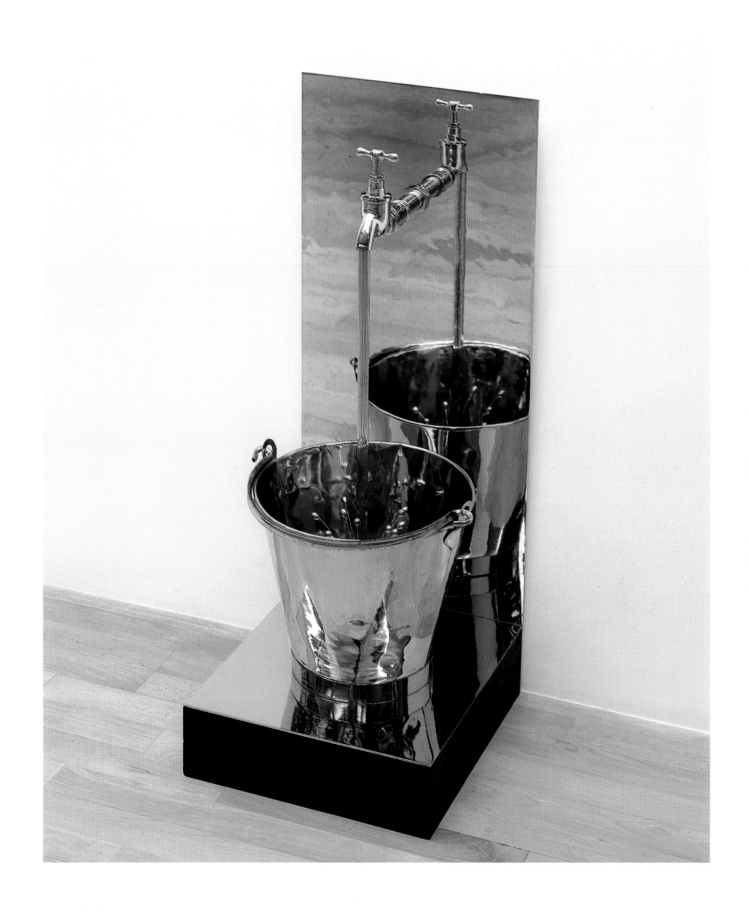

PLATE 5 (Cat. 46)
Splash, 1967

Chrome-plated steel, chrome-plated brass and painted wood
34 x 15 x 14 in / 86.4 x 38 x 35.6 cm (Tate, London)

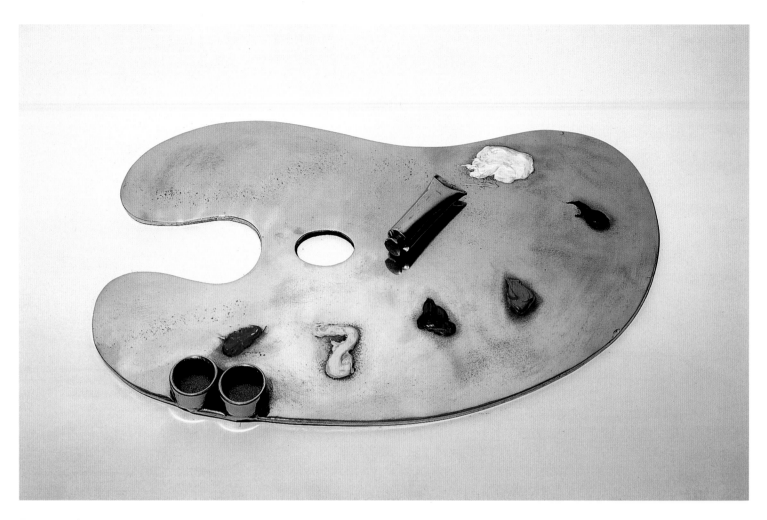

PLATE 6 (Cat. 52)
Palette and Tube, 1967

Polished aluminium, partly painted
19 1/2 in / 49.5 cm long
(Whitford Fine Art, London)

(right) PLATE 7 (Cat. 58)

Painted Dartboard, 1967

Painted aluminium
17 1/2 in / 44.5 cm diameter
(Whitford Fine Art, London)

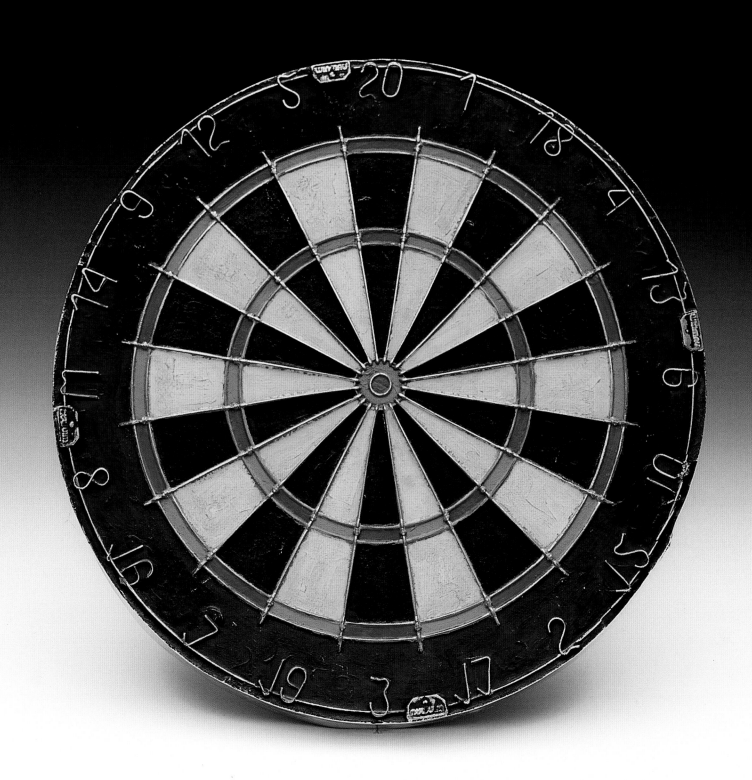

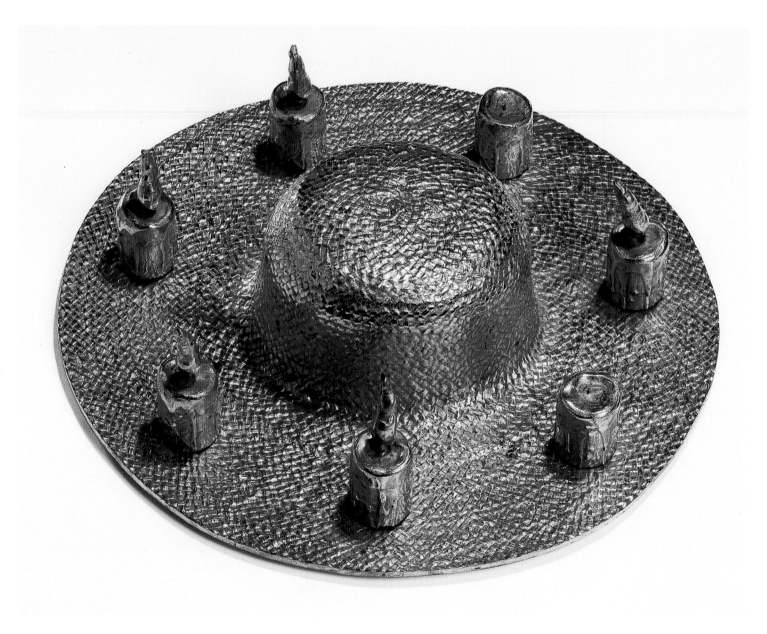

PLATE 8 (Cat. 80)
Van Gogh's Hat with Candles 2, 1969

Copper-plated bronze
4 1/2 x 17 x 18 in / 11.5 x 43.2 x 45.7 cm (Adrian Mibus, London)

(right) PLATE 9 (Cat. 71)
Homage to Magritte, 1968-69

Chrome-plated bronze, edition of 6
7 3/4 in / 19.7 cm high

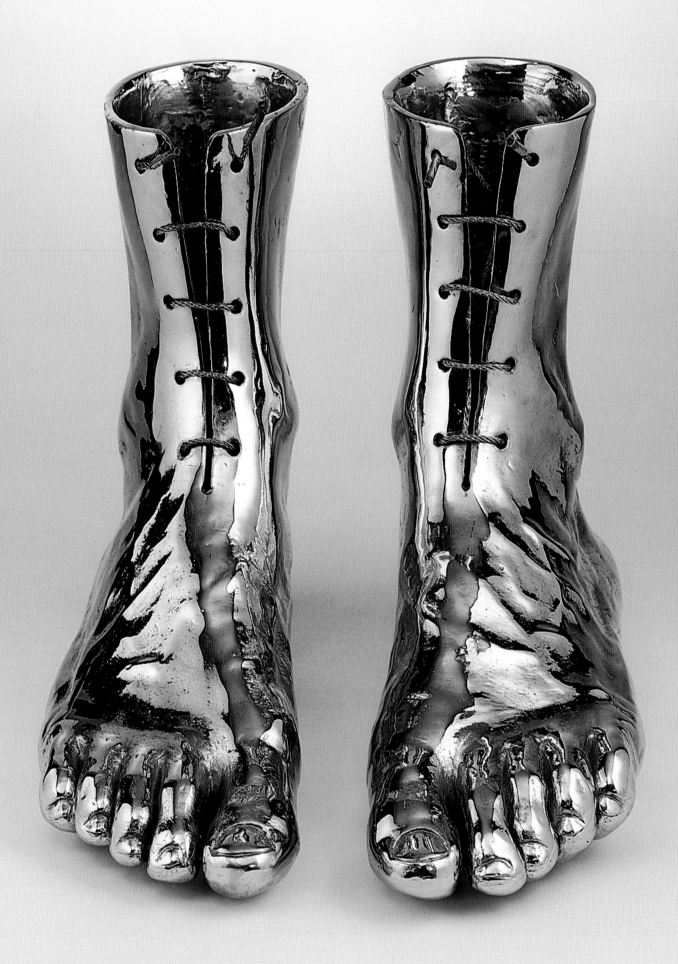

PLATE 10 (Cat. 30)
Sunbeam Shaver, 1965

Mixed media
10 1/2 x 9 1/2 x 10 3/4 in / 26.7 x 24.2 x 27.3 cm
(Collection Alan Wheatley)

(right) PLATE 11 (Cat. 81)
Heart Box, 1969

Mixed media
7 1/4 x 9 1/16 x 6 1/2 in / 18.4 x 23 x 16.5 cm
(Private Collection, Belgium)

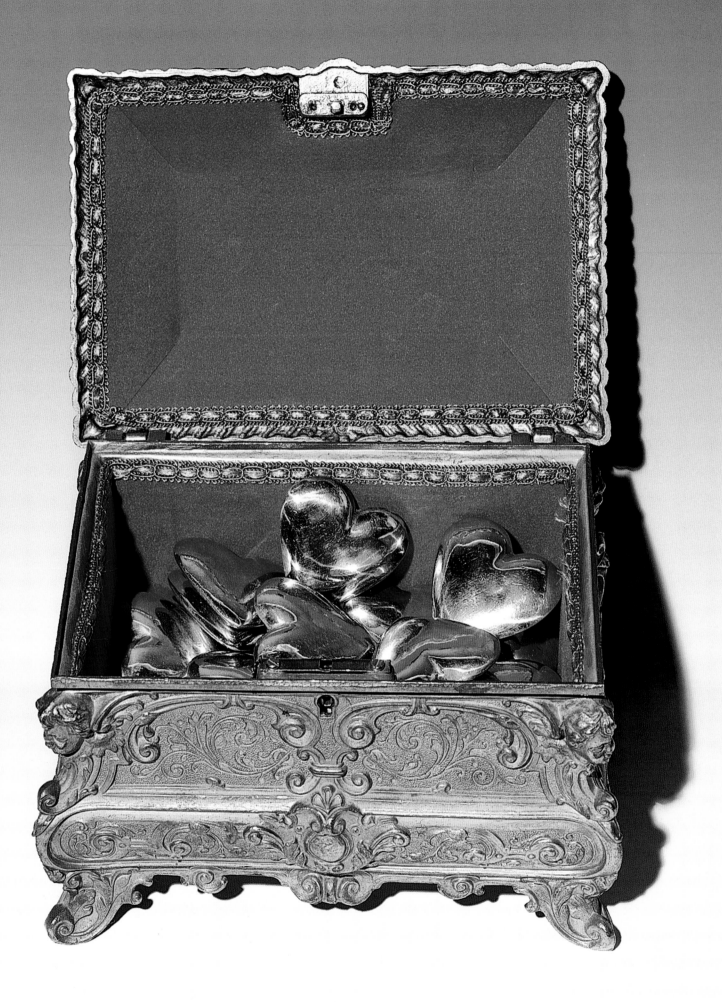

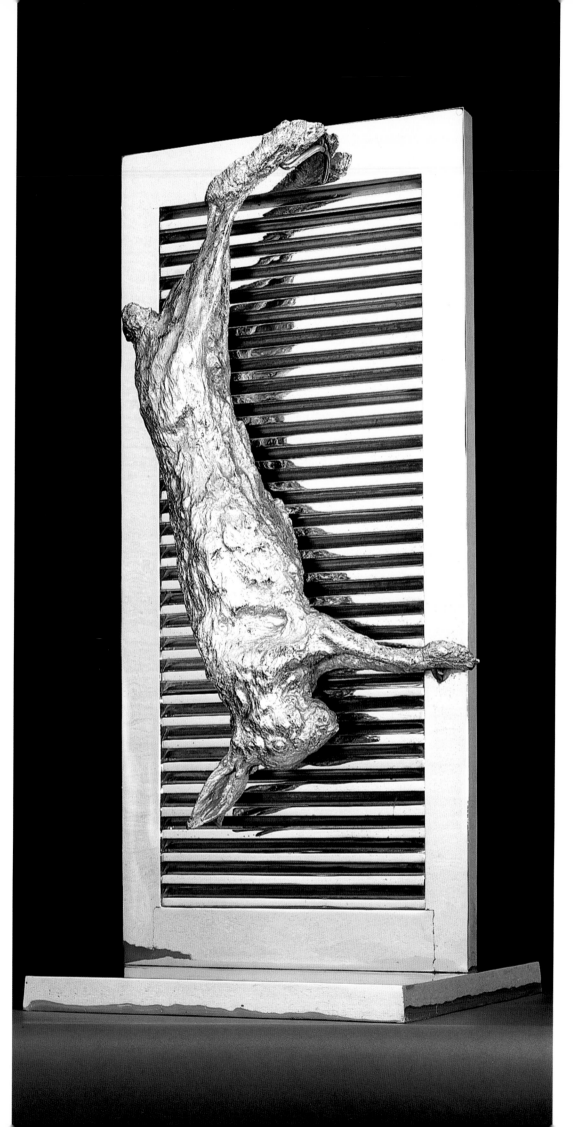

PLATE 12 (Cat. 83)
Homage to Soutine, 1969

Chrome-plated bronze
37 1/2 x 17 3/4 x 17 3/4 in
95.3 x 45.1 x 45.1 cm
(Berardo Collection, Sintra
Museum of Modern Art, Sintra)

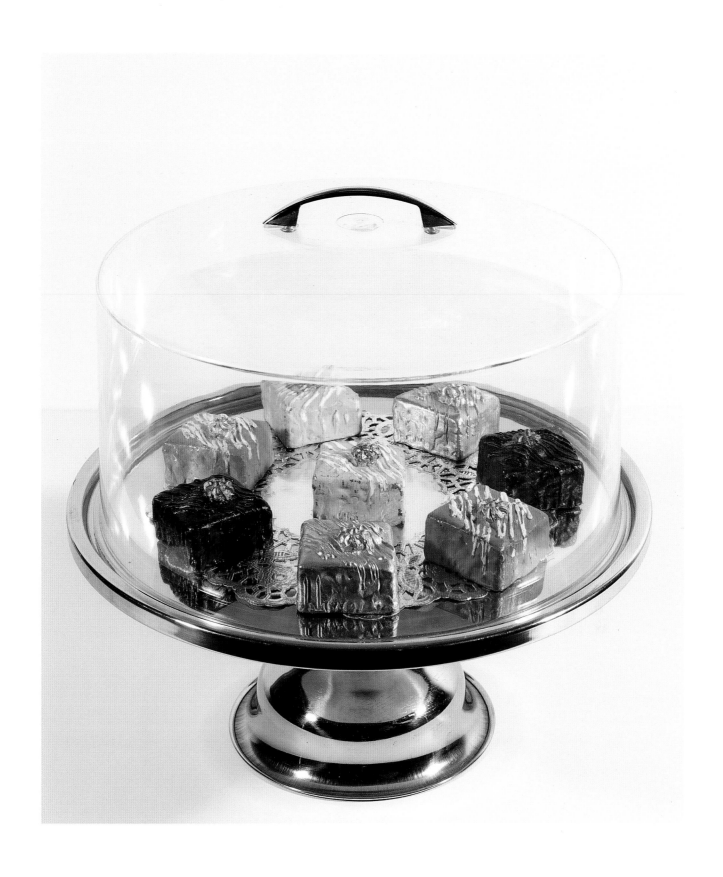

PLATE 13 (Cat. 92)
French Fancies, 1969

Mixed media, 13 in / 33 cm high; 13 in / 33 cm diameter
(Whitford Fine Art, London)

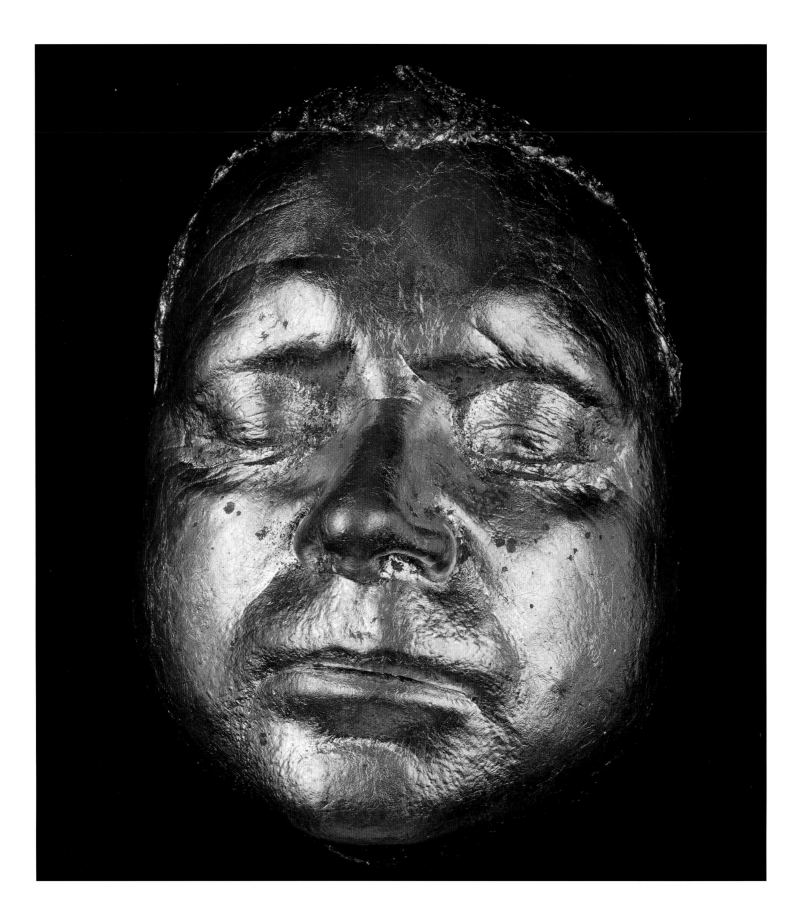

PLATE 14 (Cat. 86)
Life Mask of Francis Bacon, 1969

Gilded bronze, 8 1/4 in / 21 cm high
(National Portrait Gallery, London)

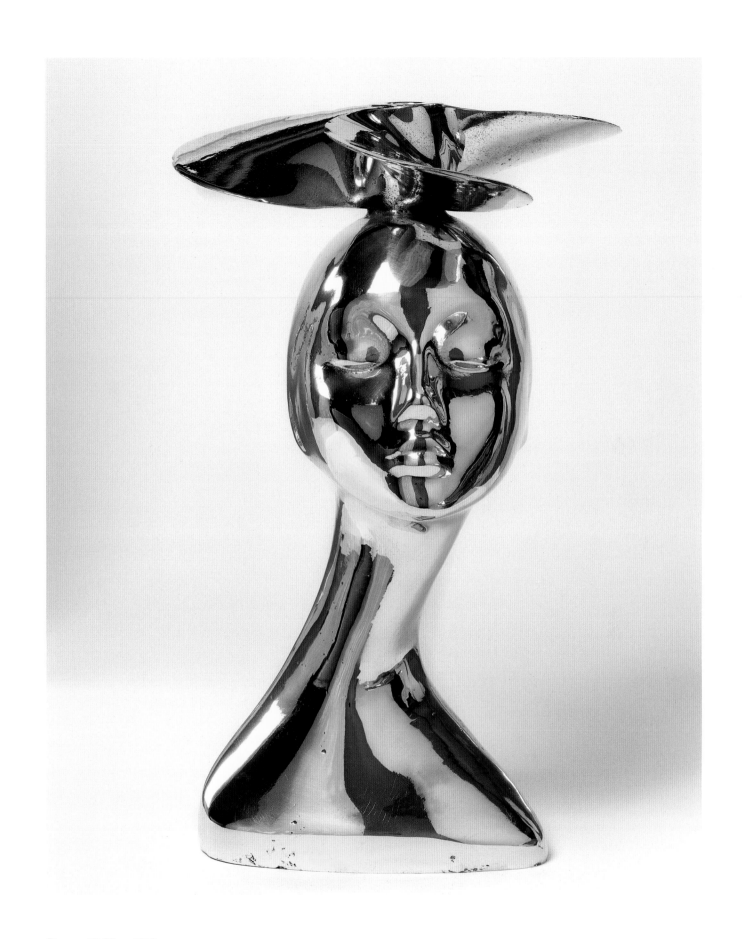

PLATE 15 (Cat. 276)
Woman with Strange Hat (Ascot), 1996

Polished brass
17 ¹/₂ in / 44.5 cm high (Private Collection, London)

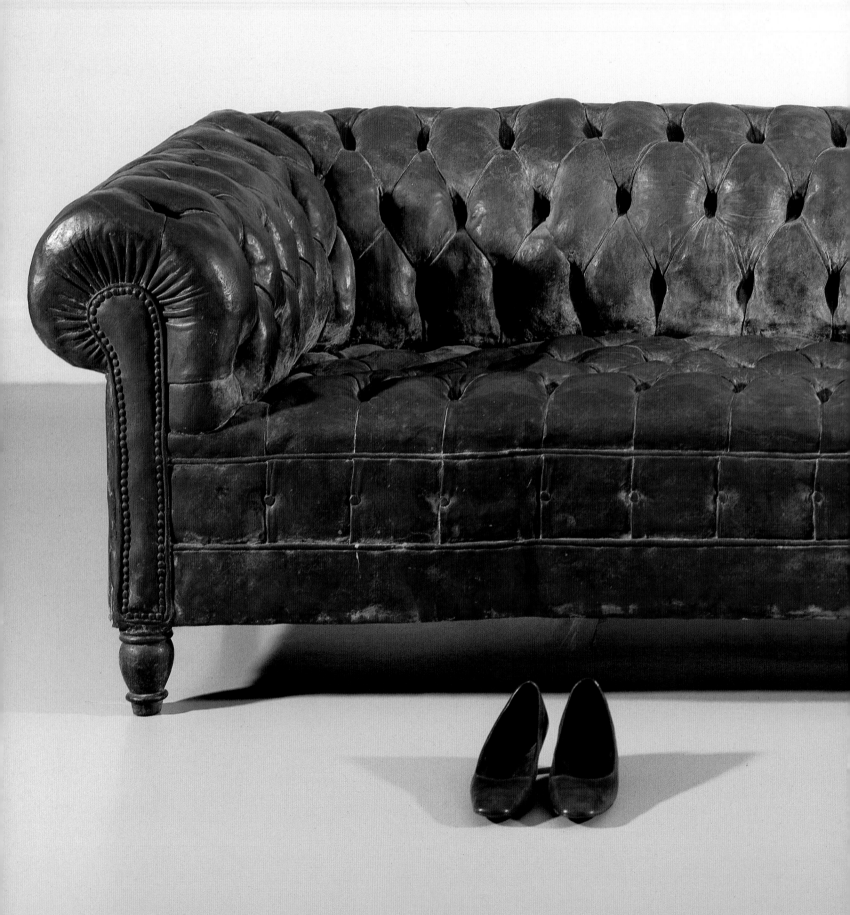

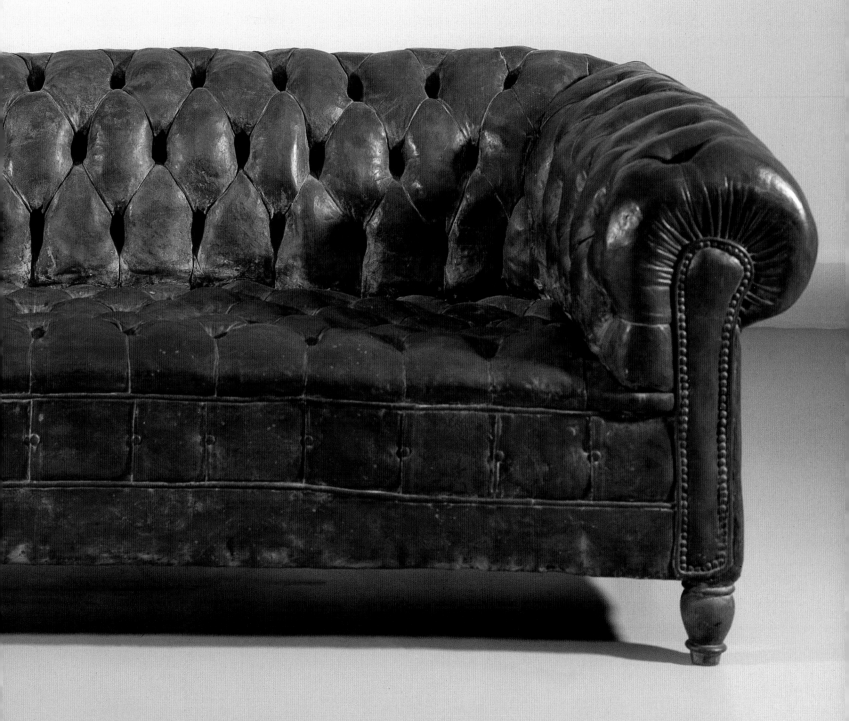

PLATE 16 (Cat. 122)
Portrait of Madame Magritte, 1970-73

Bronze with brown and green patina, 29 ¹/₈ x 89 ³/₄ x 35 in / 74 x 228 x 89 cm
(Städtische Kunsthalle, Mannheim)

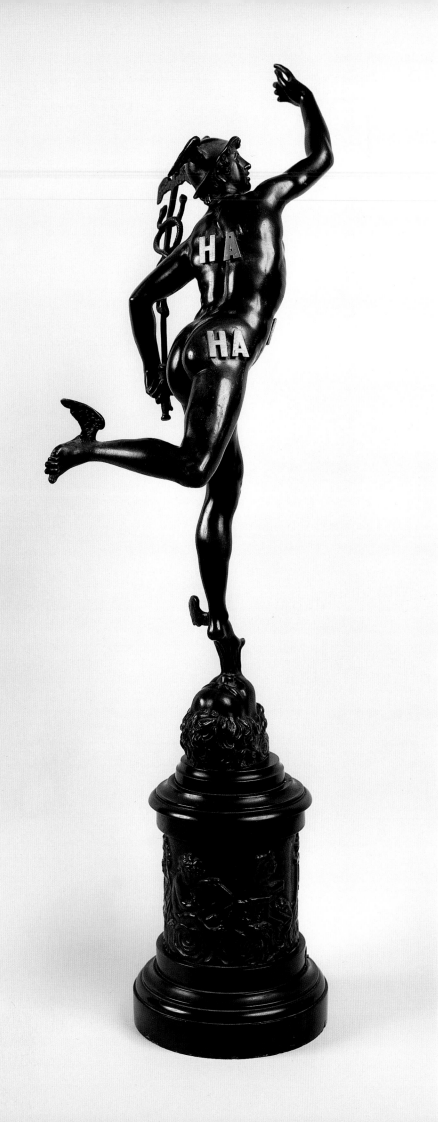

PLATE 17 (Cat. 137)
Classical Sculpture Being Laughed At, 1972
Bronze with brown patina and polished brass
33 in / 83.8 cm high
(Private Collection, London)

PLATE 18 (Cat. 138)
Aphrodite, 1972

Mixed media
30 ¹/2 x 12 x 10 ³/4 in
77.5 x 30.5 x 27.3 cm
(Whitford Fine Art, London)

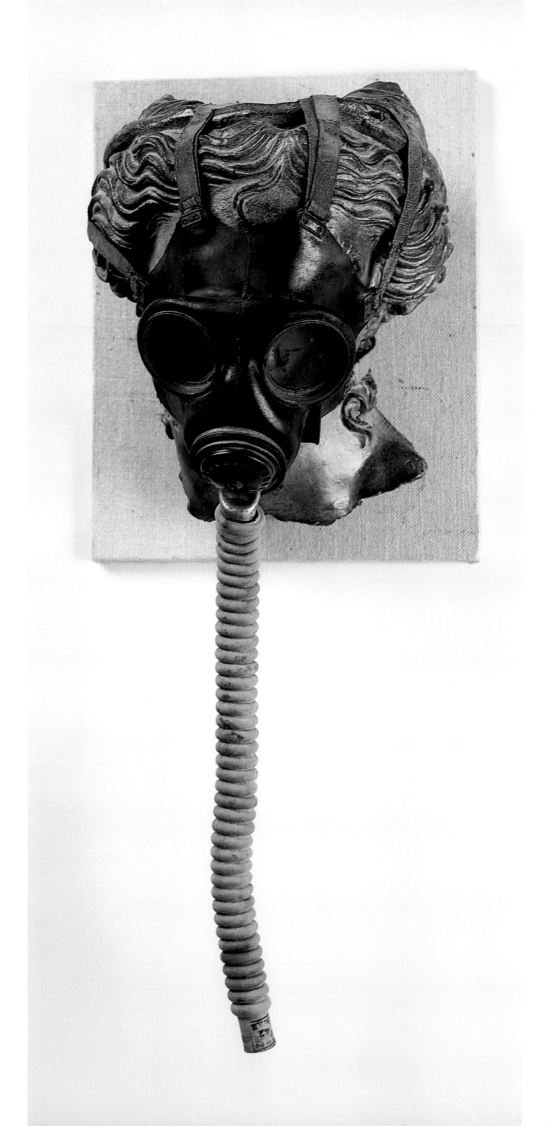

PLATE 19 (Cat. 188)
Head of Eduardo Paolozzi, 1981

Painted wood
13 ¹⁵/₁₆ in / 35.4 cm high
(Private Collection, London)

(right) PLATE 20 (Cat. 143)
Tang Horse, 1973

Bronze with brown and blue-green patina
21 in / 53.3 cm high
('Mr Chow' restaurant, New York)

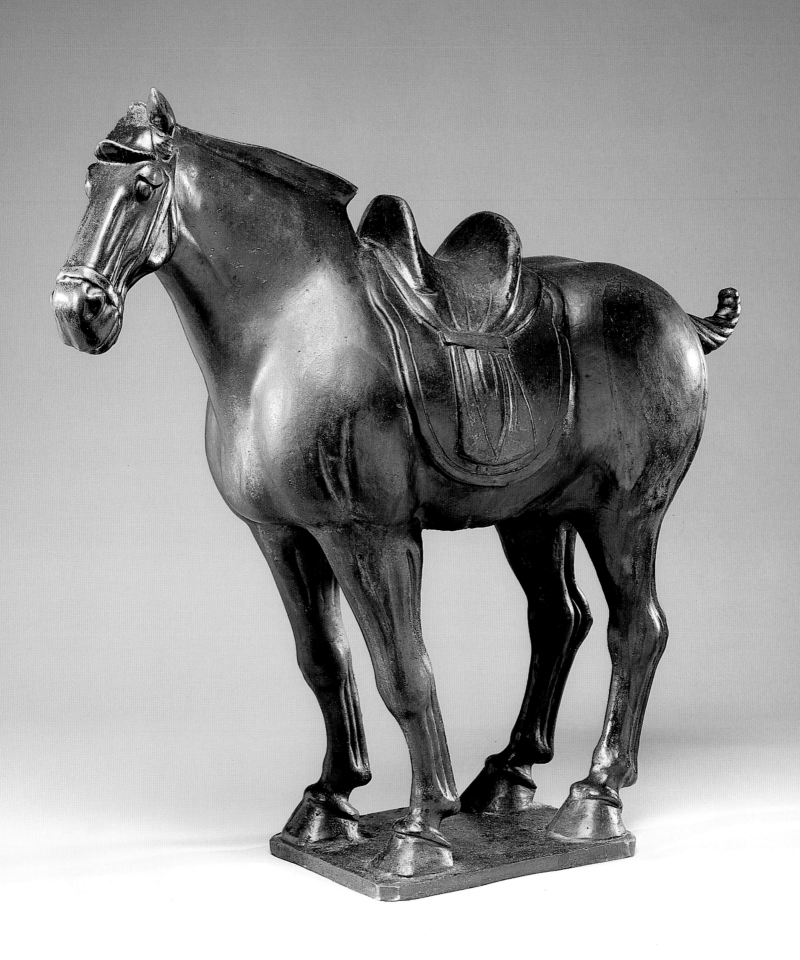

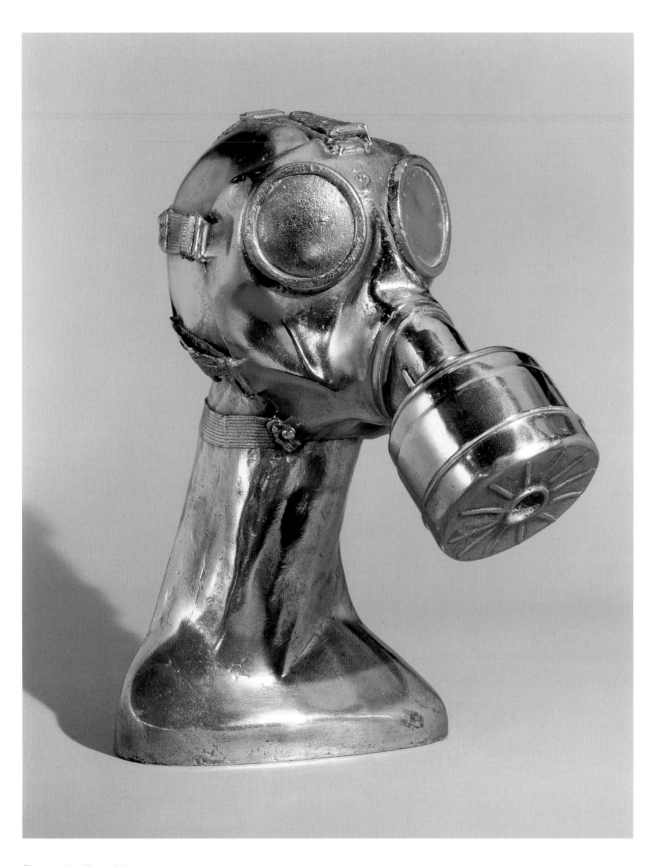

PLATE 21 (Cat.152)
German Head '42, 1974

Polished brass, 15 ½ in / 39.4 cm high
(Imperial War Museum, London)

(right) PLATE 22 (Cat. 187)
Vase of Flowers, 1981

Painted wood, 16 in / 40.7 cm high
(Collection Sir Paul McCartney)

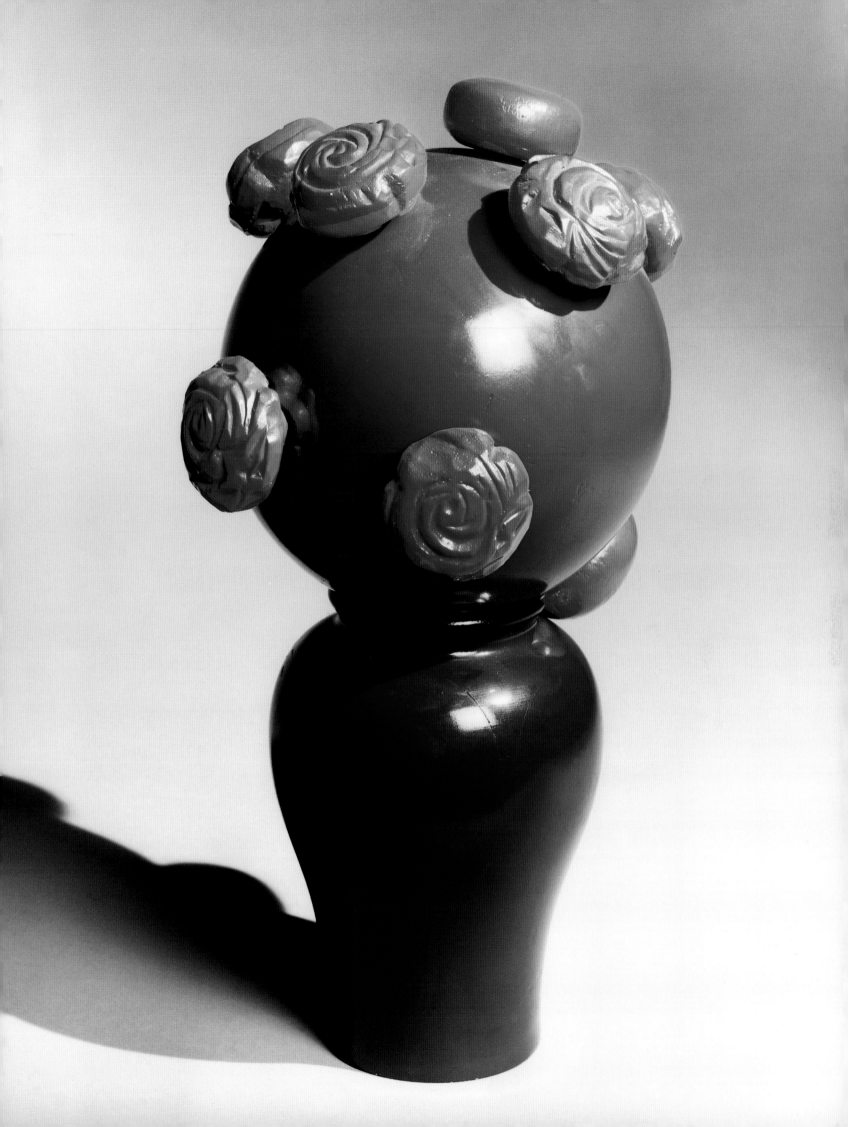

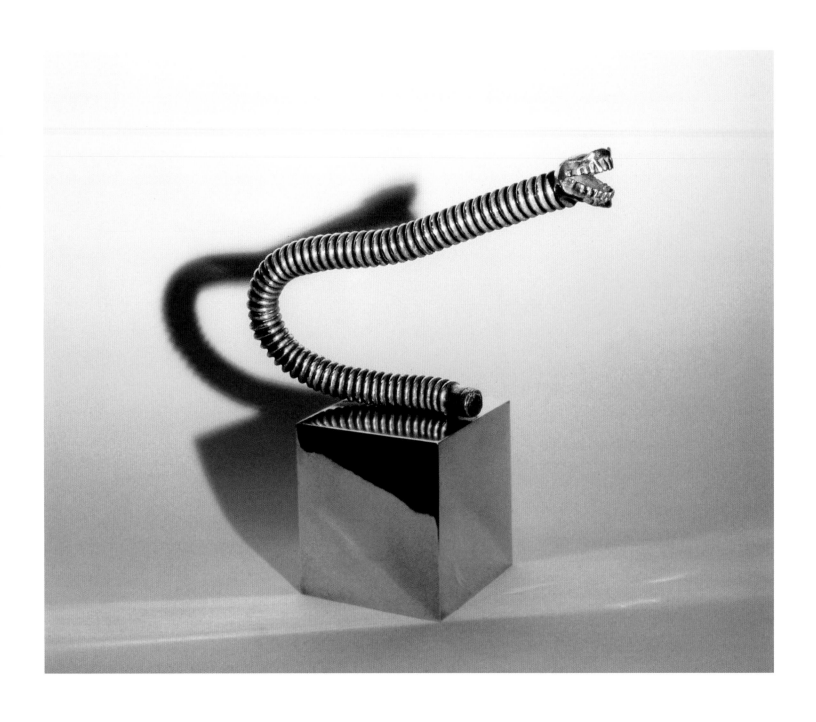

PLATE 23 (Cat. 178)
Study of Francis Bacon, No. 9, 1978

Polished bronze and polished brass
22 in / 56 cm high (Wolverhampton Art Gallery, Wolverhampton)

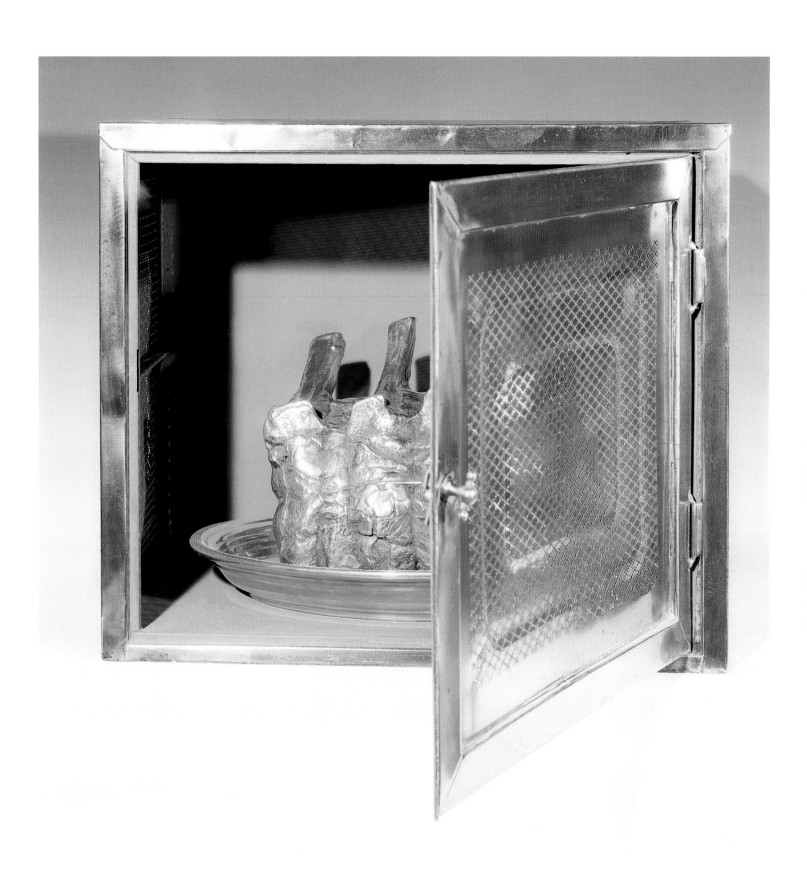

PLATE 24 (Cat. 169)
Meat Safe, 1978

Polished steel, partly painted, and polished aluminium
14 x 16 3/4 x 11 7/16 in / 35.6 x 42.6 x 29 cm
(Private Collection, London)

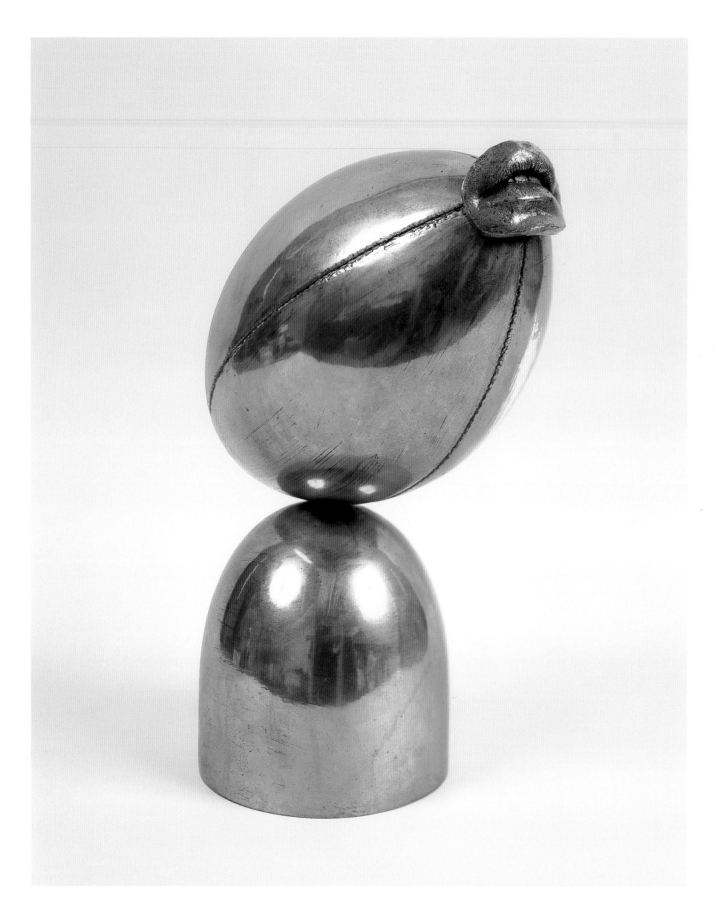

PLATE 25 (Cat. 194)
Head of Marianne Faithfull, 1981

Polished bronze, 13 1/2 in / 34.3 cm high
(Private Collection, London)

PLATE 26 (Cat. 197)
Mother and Child, 1981

Polished brass, 10 1/2 in / 26.7 cm high
(Private Collection, London)

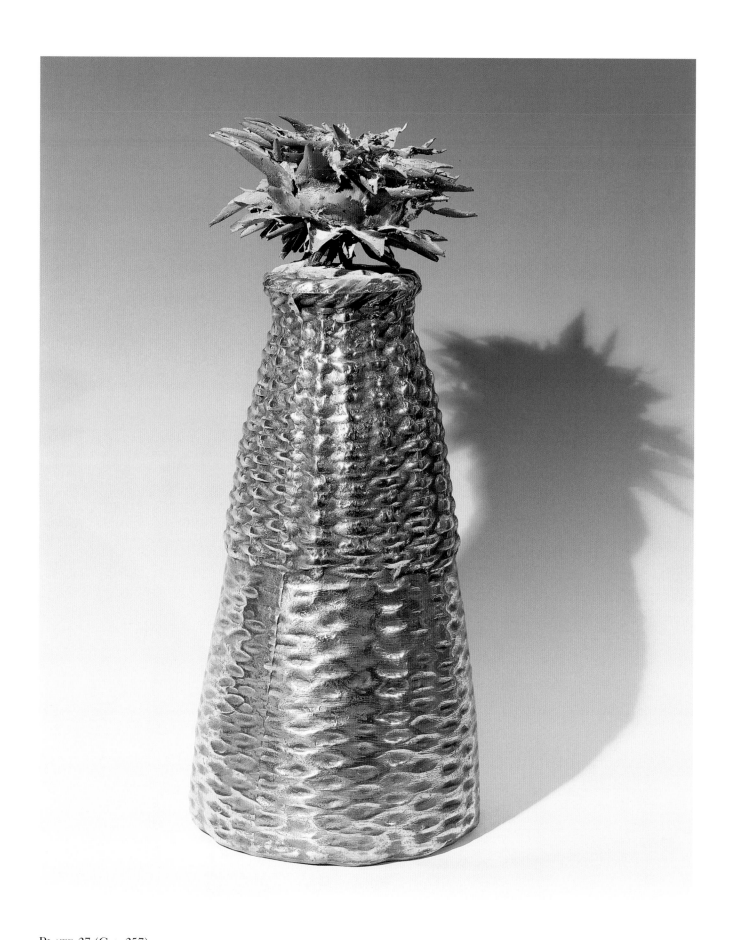

PLATE 27 (Cat. 257)
Vase and Thistle, 1995

Polished bronze and bronze ex foundry
16 1/2 in / 41.9 cm high (Private Collection, London)

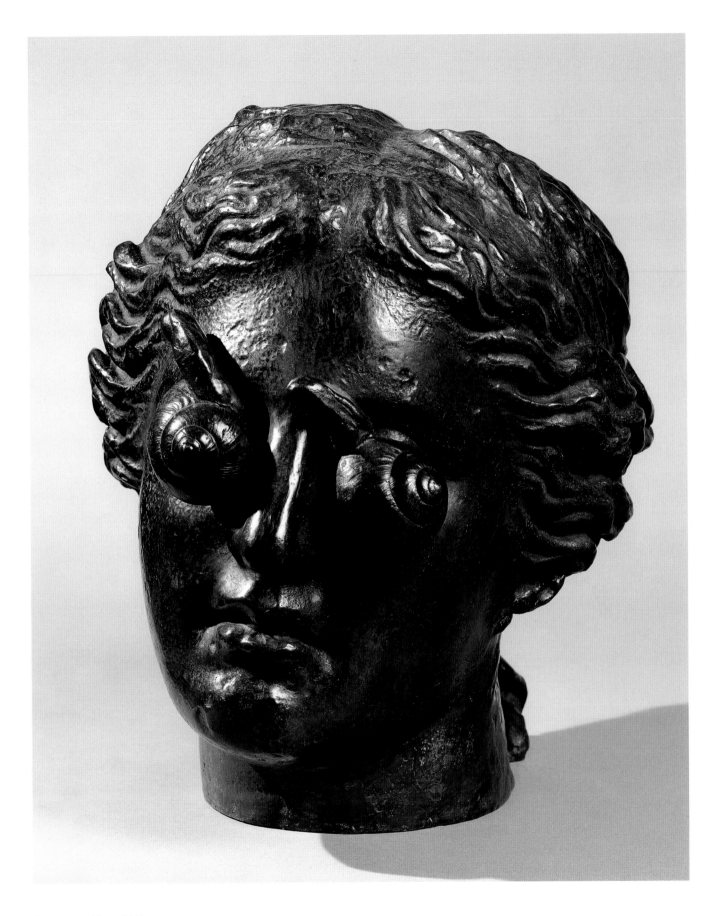

PLATE 28 (Cat. 211)
Venus Escargot, 1987

Bronze with green-black patina, edition of 3
11 1/8 in / 28.3 cm high

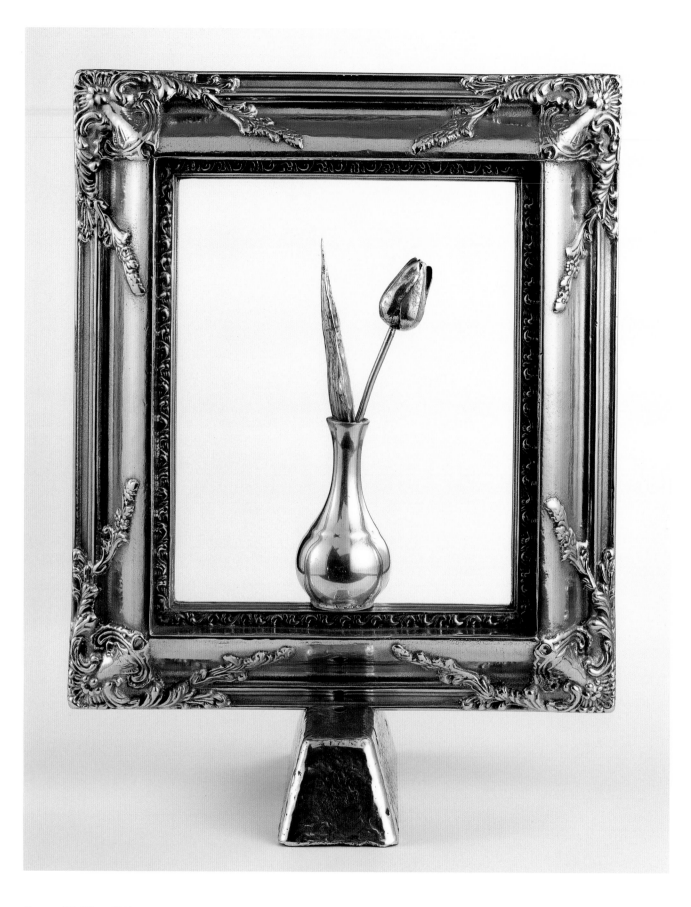

PLATE 29 (Cat. 251)
Vase of Flowers in a Frame 2, 1995

Polished aluminium
18 1/8 in / 46.1 cm high (Private Collection, London)

PLATE 30 (Cat. 289)
Stove and Coffee Pot, 1997

Polished brass, polished
aluminium and cast iron
32 in / 81.3 cm high
(Collection Alan Wheatley)

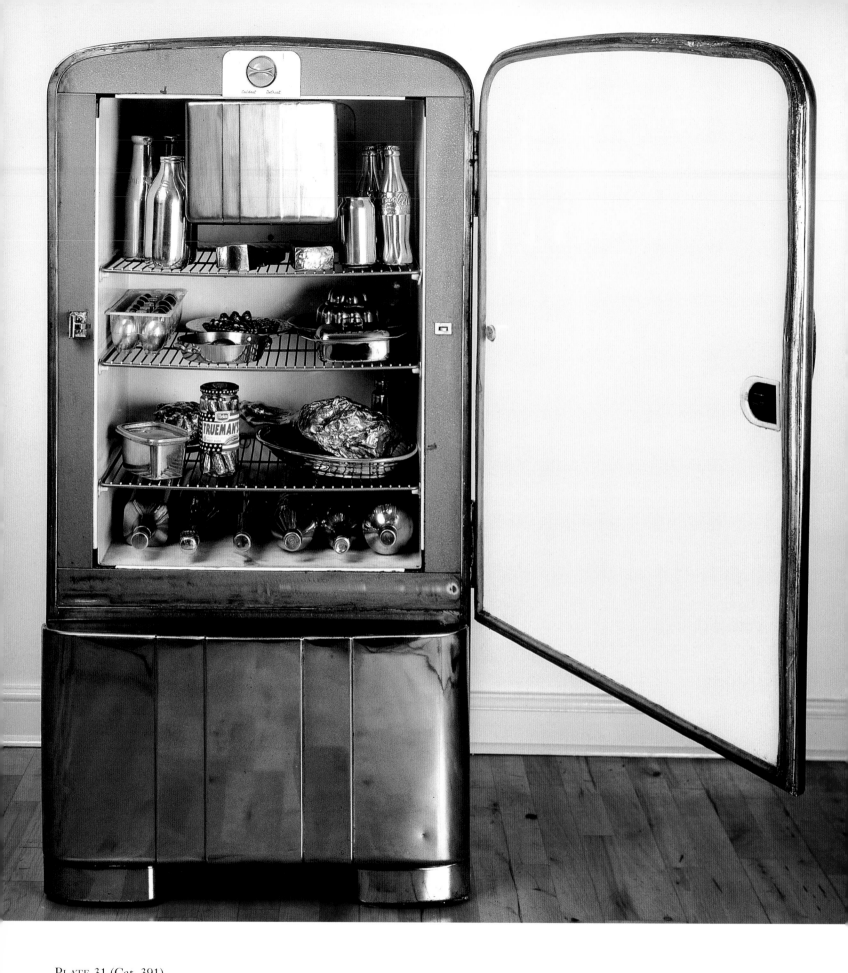

PLATE 31 (Cat. 391)
Fridge, 1999

Mixed media, 54 x 28 ¹/₂ x 23 in / 137.2 x 72.4 x 58.4 cm
(Berardo Collection, Sintra Museum of Modern Art, Sintra)

72

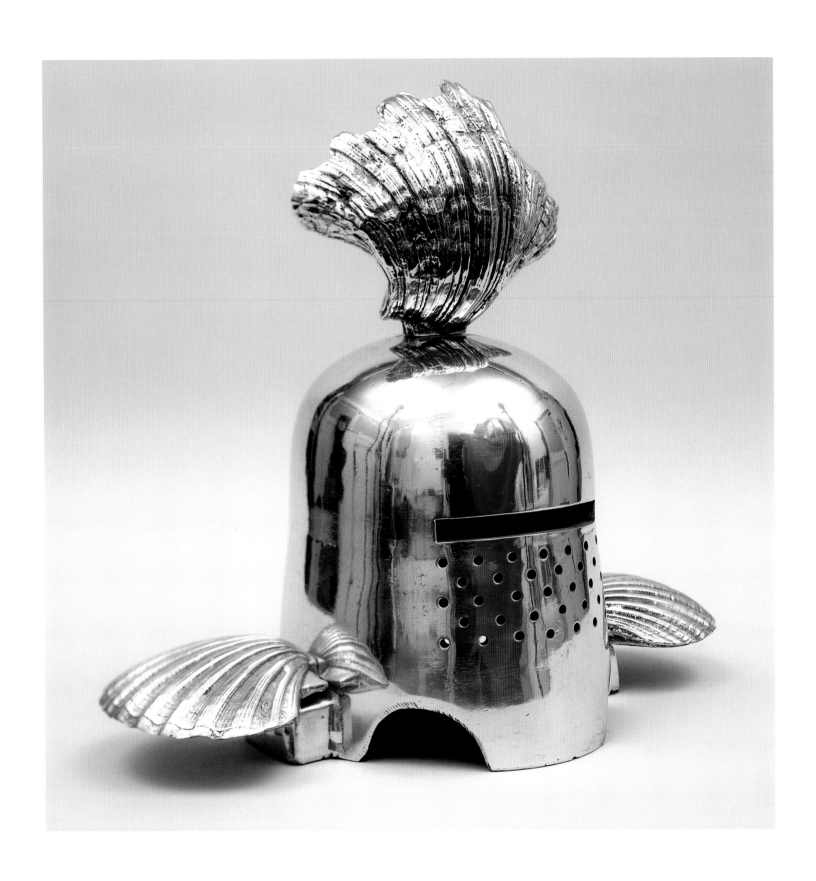

PLATE 32 (Cat. 300)
Helmet 3, 1998

Polished aluminium, 14 in / 35.6 cm high
(Courtesy of Whitford Fine Art, London)

73

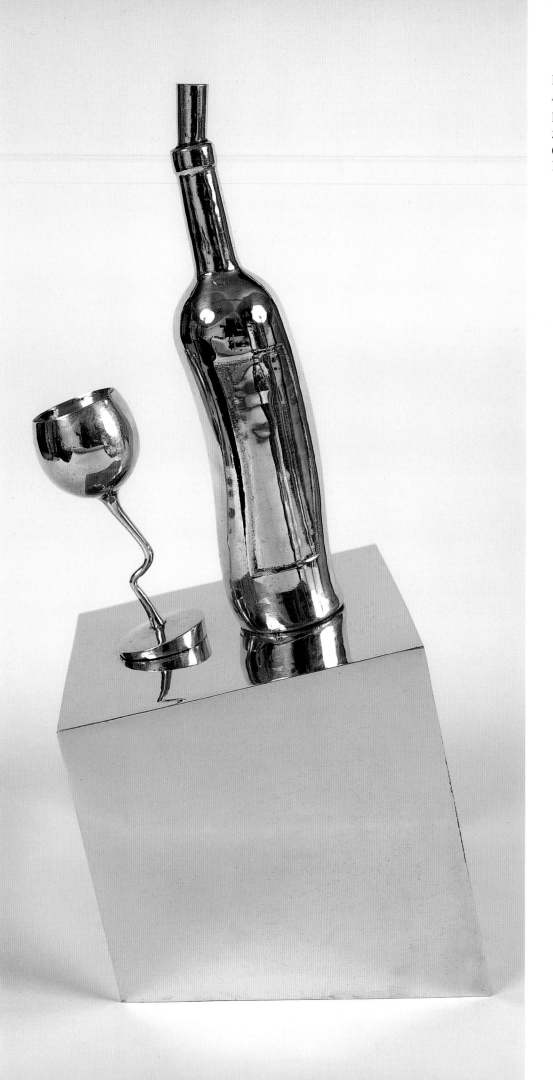

PLATE 33 (Cat. 402)
Drunken Still Life, 2000

Polished bronze
21 1/8 in / 53.7 cm high
(Courtesy of Whitford
Fine Art, London)

Catalogue Raisonné
1958-2000

Notes on the Catalogue Raisonné

Date

The catalogue gives a chronological listing of Clive Barker's sculptures until the year 2000. The date of works, which have been in progress for less than one year, reflects the year in which the work was completed. When a work has been in progress over a number of years, both dates of inception and completion are quoted. In such case the object is catalogued under its date of inception.

Dimensions

Sizes are given first in inches, as the dimensions with which the artist works, followed by centimetres. Height is given before width, before depth, unless otherwise stated.
The majority of works have been accurately measured during the preparation of the catalogue. For a few exceptions we had to rely on the artist's notes, which only quote inches, usually rounded off to the nearest 1/4 inch, as well as on estimations by the artist, in which case the measurements are placed in parentheses.

Material

As finishes are an important feature of Barker's work, the treatment of each metal has been specified.
Where a subject was produced in more than one medium, the works are listed in the same entry provided they are titled identically.

Edition

All works are unique unless otherwise stated.
All casts of each edition are actually made. Only in one case, *Gold Coke* (1992) 9 of 40 casts have been made. The artist has no intention to complete the edition.

Collection

Only works in public collections are identified.

Signature

Signature details of each work have not been quoted. In general, works are stamped or engraved in the material, quoting the artist's name, the title of the work, date and edition number, where appropriate. Some works have this information on an engraved nameplate. Early works are more often stamped than engraved and regularly have initials and date only. Few works do not bear any signature details.

With the help of the artist, we have endeavoured to make the catalogue as accurate and complete as possible, but we welcome any further information and corrections which could be incorporated in subsequent editions.

1. *Object*, 1958-59
Mixed media
18 in / 45.7 cm high
Destroyed by the artist

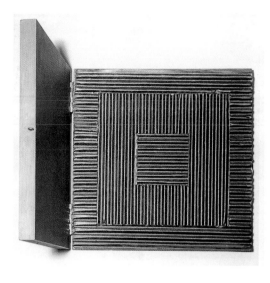

2. *Target Square*, 1961

Painted corrugated cardboard and painted wood
8 x 16 7/32 x 3/4 in / 20.3 x 41.2 x 1.9 cm (open)

EXHIBITED - 1962, *Young Contemporaries*, RBA Galleries, London,
cat.10 (together with other four targets as 'Little Quintett').

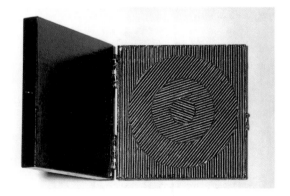

3. *Target Round*, 1961

Painted corrugated cardboard and painted wood
6 x 12 3/16 x 1 in / 15.2 x 31 x 2.6 cm (open)

EXHIBITED - 1962, *Young Contemporaries*, RBA Galleries, London,
cat.10 (together with other four targets as 'Little Quintett').

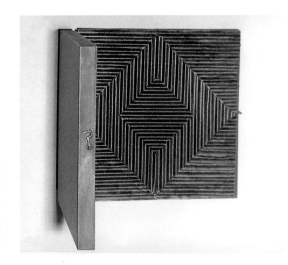

4. *Target Diamond*, 1961

Painted corrugated cardboard and painted wood
8 x 16 7/32 x 3/4 in / 20.3 x 41.2 x 1.9 cm (open)

EXHIBITED - 1962, *Young Contemporaries*, RBA Galleries, London,
cat.10 (together with other four targets as 'Little Quintett').
1981-82, *Clive Barker: Sculpture, Drawings and Prints* (retrospective
exhibition), Mappin Art Gallery, Sheffield and tour, cat.1
(as 'Black Target', 1962-63 and with erronous measurements).

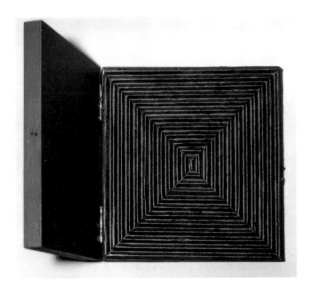

5. *Target*, 1961

Painted corrugated cardboard and painted wood
8 x 16 $^7/_{32}$ x $^3/_4$ in / 20.3 x 41.2 x 1.9 cm (open)

EXHIBITED - 1962, *Young Contemporaries*, RBA Galleries, London, cat.10
(together with other four targets as 'Little Quintett').

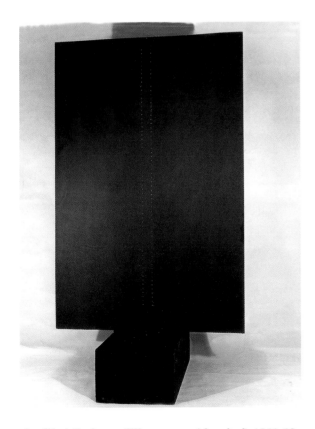

8. *Black Sculpture (Whasamattawithyoubud)*, 1961-62

Painted wood
90 x 48 in / 228.6 x 121.9 cm
Destroyed in 1965 fire in storage unit

EXHIBITED - 1962, *Young Contemporaries*, RBA Galleries, London, cat.210.

Photograph unavailable

6. *Target Painted*, 1961

Painted corrugated cardboard and painted wood
(8 x 16 $^7/_{32}$ x $^3/_4$ in / 20.3 x 41.2 x 1.9 cm)

EXHIBITED - 1962, *Young Contemporaries*, RBA Galleries, London, cat.10
(together with other four targets as 'Little Quintett').

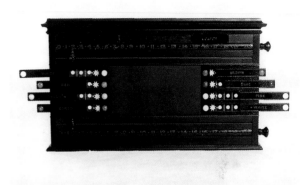

7. *Billiards Scoreboard*, 1961-62

Painted wood
18 x 30 in / 45.7 x 76.2 cm
Destroyed in 1965 fire in storage unit

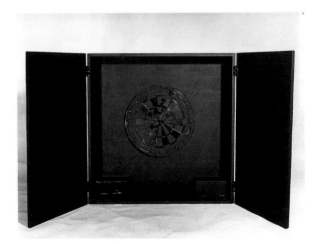

9. *Black Dartboard*, 1961-62

Painted wood
36 x 36 x (2) in / 91.5 x 91.5 x (5) cm (closed)
Destroyed in 1965 fire in storage unit

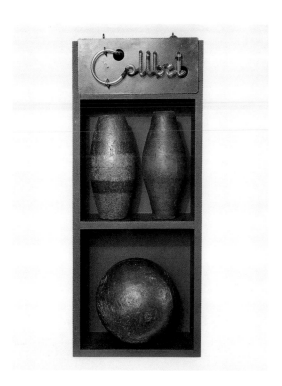

10. *Little Neon (Colibri)*, 1962

Wood and neon
28 x 12 x 6 in / 71 x 30.5 x 15.2 cm

EXHIBITED - 1964, *About Round*, Leeds University, cat.3, ill.
1967, *Englische Kunst*, Galerie Bischofberger, Zürich, cat.3, ill.

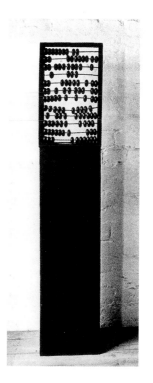

11. *Abacus*, 1963

Mixed media
48 in / 122 cm high

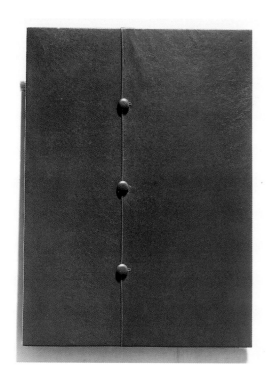

12. *Dick's Jacket*, 1963

Leather and wood
40 x 30 in / 101.6 x 76.2 cm

EXHIBITED - 1967, *Ventures*, Arts Council of Great Britain, touring
exhibition, cat.1.
1967, *Englische Kunst*, Galerie Bischofberger, Zürich, cat.1, (as 'Bick's
Jacket')

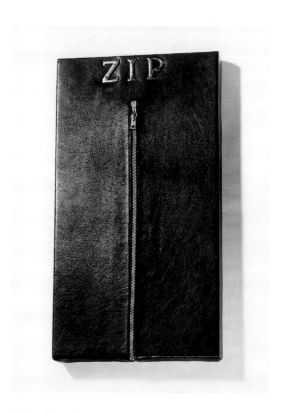

13. *Small Zip*, 1963

Leather, metal and wood
20 x 11 in / 50.8 x 27.9 cm

EXHIBITED - 1967, *Ventures*, Arts Council of Great Britain, touring
exhibition, cat.2.

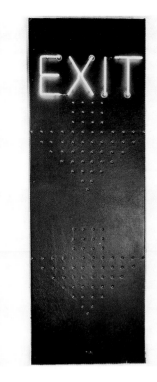

14. *Tall Exit*, 1963-64

Leather, neon, studs and wood
72 x 24 x 6 in / 183 x 61 x 15.2 cm

EXHIBITED - 1964, *118 Show*, Kasmin, London.
1967, *Ventures*, Arts Council of Great Britain, touring exhibition, cat.3, ill.
1967, *Englische Kunst*, Galerie Bischofberger, Zürich, cat.2, ill.

Photograph unavailable

15. *Way Out (Brown Exit)*, 1963-64

Leather, neon, studs and wood
66 ¹/8 x 46 ¹/16 x 5 ⁷/8 in / 168 x 107 x 15 cm

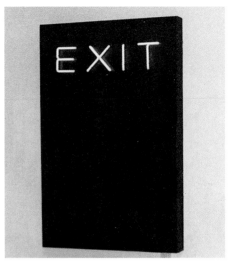

16. *Exit*, 1963-64

Leather, neon, studs and wood
(72 ¹/4 x 48 x 7 ⁷/8 in / 183.5 x 122 x 20 cm)

Sheffield City Art Galleries (Mappin Art Gallery)

EXHIBITED - 1981-82, *Clive Barker: Sculpture, Drawings and Prints*
(retrospective exhibition), Mappin Art Gallery, Sheffield and tour, cat.4.

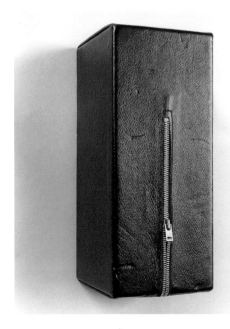

17. *Zip Box No. 1*, 1963-64

Leather, steel and wood
12 ⁵/16 x 5 ¹/8 x 6 ⁵/16 in / 31.3 x 13 x 16 cm

EXHIBITED - 1964, *118 Show*, Kasmin, London.
1981-82, *Clive Barker: Sculpture, Drawings and Prints*
(retrospective exhibition), Mappin Art Gallery, Sheffield and tour,
cat.3 (as 'Zipped Box' and with erronous measurements).
1994-95, *Worlds in a Box*, City Art Centre, Edinburgh and tour, cat.6.

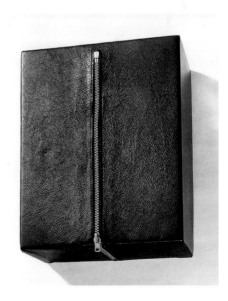

18. *Zip Box No. 2*, 1963-64

Leather, steel and wood
12 x 10 x 5 in / 30.5 x 25.4 x 12.7 cm

EXHIBITED - 1987, *British Pop Art*, Birch and Conran Fine Art,
London.

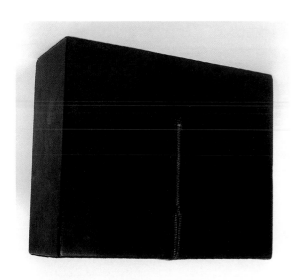

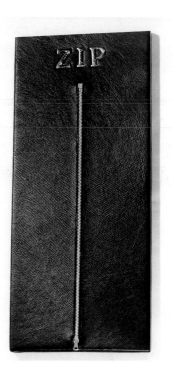

19. *Zip Box 3*, 1963-64

Leather, steel and wood
12 x 15 x 5 ¹/2 in / 30.5 x 38 x 14 cm

20. *Little Zip No. 2*, 1963-64

Leather, steel and wood
24 x 10 ¹/2 x (1) in / 61 x 26.7 x (2.6) cm

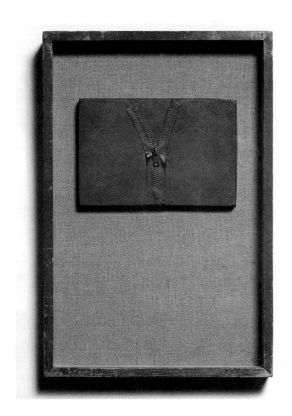

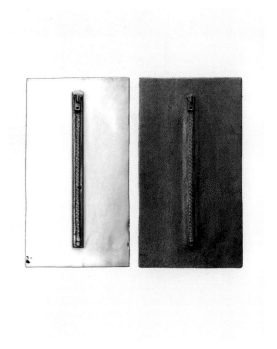

21. *Zip 1*, 1964

One in bronze ex foundry
One in polished aluminium
5 ³/4 x 8 ⁵/8 x ³/4 in / 14.6 x 21.9 x 1.9 cm (bronze)

EXHIBITED - 1981-82, *Clive Barker: Sculpture, Drawings and Prints* (retrospective exhibition), Mappin Art Gallery, Sheffield and tour, cat.2.

22. (left) *Zip 2*, 1964 Aluminium ex foundry
Abandoned in 1964

23. (right) *Zip*, 1964 Bronze ex foundry
Abandoned in 1964

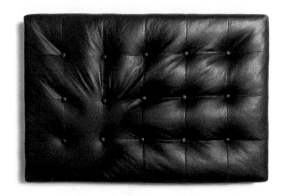

24. *Seat*, 1964

Leather, studs and wood
30 ³/4 x 20 ³/4 x (3) in / 78.1 x 52.1 x (7.6) cm

25. *Right Hand Zip*, 1964-65

Leather, steel and wood
24 x 60 x (1) in / 61 x 152.4 x (2.6) cm

EXHIBITED - 1967, *Ventures*, Arts Council of Great Britain, touring exhibition, cat.6.

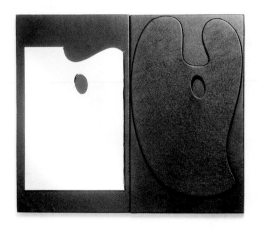

27. *Two Palettes for Jim Dine*, 1964

Leather, chrome-plated brass and wood
26 x 30 x 2 in / 66 x 76.2 x 5 cm

EXHIBITED - 1967, *Ventures*, Arts Council of Great Britain, touring exhibition, cat.5 (dated 1964-65).
1981-82, *Clive Barker: Sculpture, Drawings and Prints* (retrospective exhibition), Mappin Art Gallery, Sheffield and tour, cat.5 (dated 1964-65).
1991, *Pop Art*, Royal Academy of Arts, London, cat.9, ill. pl.146, p.196.
1992, *Pop Art*, Museum Ludwig, Cologne, cat.133, ill.
1992, *Arte Pop*, Museo Nacional Reina Sofia, Madrid, cat.ill.p.164.
1993, *Pop Art*, The Montreal Museum for Fine Arts, Montreal, cat.10, ill. p.195.
2001, *Pop Art: U.S./ U.K. Connections 1956-1966*, The Menil Collection, Houston, cat.36, ill. p.183.

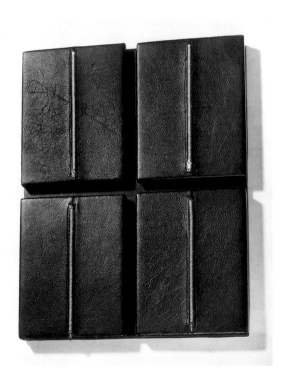

26. *Four Zips*, 1964-65

Leather, steel and wood
19 x 15 x 1 ¹/2 in / 48.3 x 38 x 3.8 cm

EXHIBITED - 1982, *Kunst der Klassischen Moderne bis zur Gegenwart*, Galerie Kunsthandlung Roche, Bremen.

28. *Pencil Box*, 1965

Mixed media
6 ³/8 x 10 ⁵/8 x 15 ³/8 in / 16.2 x 27 x 39.1 cm

29. *Pencils*, 1965

Mixed media

12 3/8 x 16 1/2 x 8 1/2 in / 31.5 x 41.9 x 21.6 cm

30. *Sunbeam Shaver*, 1965

Mixed media

10 1/2 x 9 1/2 x 10 3/4 in / 26.7 x 24.2 x 27.3 cm

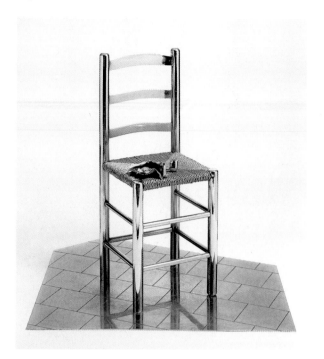

32. *Van Gogh's Chair I*, 1966

Chrome-plated steel, chrome-plated bronze and chrome-plated brass

34 in / 86.4 cm high

EXHIBITED - 1966, *New Idioms*, Robert Fraser Gallery, London.
1967, *Salon de la Jeune Peinture*, Musée d'Art Moderne de la Ville de Paris, Paris.
1968, *British Artists: 6 Painters, 6 Sculptors* (exhibition circulated by Museum of Modern Art, New York), cat.ill.
1968, *Mostra Mercato d'Arte Contemporanea*, Palazzo Strozzi, Florence (shown by Hanover Gallery).
1969, *Clive Barker*, Hanover Gallery, London, cat.6, ill.
1970, *British Sculpture out of the Sixties*, ICA, London, cat.3, ill.
1971, *Métamorphose de l'objet. Art et anti-art 1910-1970*, Palais des Beaux-Arts, Brussels and tour, cat.135.
1973, *Künstler aus England*, Baukunst-Galerie, Cologne, cat.1, ill.
1981-82, *Clive Barker: Sculpture, Drawings and Prints* (retrospective exhibition), Mappin Art Gallery, Sheffield and tour, cat.7.
1982, *Milestones in Modern British Sculpture*, Mappin Art Gallery, Sheffield, exhibit 18.
1985, *The Irresistible Object: Still Life 1600-1985*, Leeds City Art Galleries, Leeds, cat.54, ill.p.44.
1993, *Reflet-Restitution. La Sculpture pop et hyperréaliste*, Abbaye Saint-André, Meymac.
2001, *Pop Art: U.S./U.K. Connections 1956-1966*, The Menil Collection, Houston, cat.56, ill. p.221.

31. *Silver Zip*, 1965

Silver, leather and wood

9 x 3 x (3/4) in / 23 x 7.6 x (1.9) cm

33. *Van Gogh's Chair II*, 1966

Chrome-plated steel, chrome-plated bronze and chrome-plated brass
34 in / 86.4 cm high

EXHIBITED - 1968, *Clive Barker: Recent Works*, Robert Fraser Gallery, London, cat.7 (as 'Van Gogh's Chair III').
1981-82, *British Sculpture in the 20th Century*, Whitechapel Art Gallery, London, exhibit 112.
1991, *Pop Art*, Royal Academy of Arts, London, cat.10, ill. p.197.
1992, *Pop Art*, Museum Ludwig, Cologne, cat.134, ill.
1992, *Arte Pop*, Museo Nacional Reina Sofia, Madrid, cat.ill. p.163.
1993, *Pop Art*, Montreal Museum of Fine Arts, Montreal, cat.11, ill. p.211.

Photograph unavailable

34. *Van Gogh's Chair III*, 1966

Chrome-plated steel, chrome-plated bronze and chrome-plated brass
34 in / 86.4 cm high

35. *Table with Drawing Board I*, 1966

Chrome-plated steel and chrome-plated bronze
29 ⁵/8 (to tabletop) x 35 ¹³/16 x 28 ¹⁵/16 in
75.3 x 91 x 73.5 cm

EXHIBITED - 1967, *Salon de la Jeune Peinture*, Musée d'Art Moderne de la Ville de Paris, Paris.
1968, *Clive Barker: Recent Works*, Robert Fraser Gallery, London, cat.13, ill.
1968, *Contemporary British Painting and Sculpture*, Museum of Modern Art, Oxford.
1968, *Mostra Mercato d'Arte Contemporanea*, Palazzo Strozzi, Florence (shown by Robert Fraser Gallery).
1969, *Young and Fantastic*, ICA, London and tour.
1973, *Künstler aus England*, Baukunst-Galerie, Cologne, cat.2, ill.
1993, *Reflet-Restitution. La Sculpture pop et hyperréaliste*, Abbaye Saint-André, Meymac.

36. *Table with Drawing Board II*, 1966

Painted steel and painted bronze
29 ⁵/8 (to tabletop) x 35 ¹³/16 x 28 ¹⁵/16 in
75.3 x 91 x 73.5 cm

EXHIBITED - 1968, *Clive Barker: Recent Works*, Robert Fraser Gallery, London, cat.14.
1968, *Contemporary British Painting and Sculpture*, Museum of Modern Art, Oxford.
1969, *Young and Fantastic*, ICA, London and tour (as 'Still Life with Drawing Board').
1969, *Tribute to Robert Fraser*, Robert Fraser Gallery, London.
1973, *Künstler aus England*, Baukunst-Galerie, Cologne, cat.3.
1981-82, *Clive Barker: Sculpture, Drawings and Prints* (retrospective exhibition), Mappin Art Gallery, Sheffield and tour, cat.8.
1983, *BlackWhite*, Robert Fraser Gallery, London.

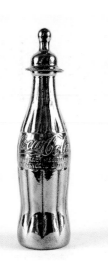

37. *Coke with Teat*, 1966 and 1973

Polished bronze
2 uneditioned works, one made for
each son upon their birth, 1 A/P
8 3/4 in / 22.2 cm high

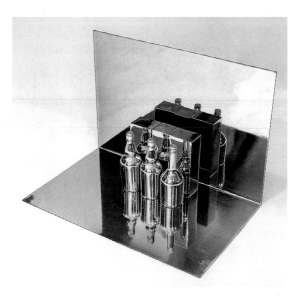

38. *Morandi Still Life*, 1966

Chrome-plated steel and chrome-plated bronze
22 x 32 x 20 in / 56 x 81.3 x 50.8 cm

The Hirshhorn Museum and Sculpture Garden,
Smithsonian Institution, Washington, D.C.

EXHIBITED - 1968, *Clive Barker: Recent Works*, Robert Fraser Gallery,
London, cat.12, ill.
1968, *British Artists: 6 Painters, 6 Sculptors* (exhibition circulated by
Museum of Modern Art, New York).

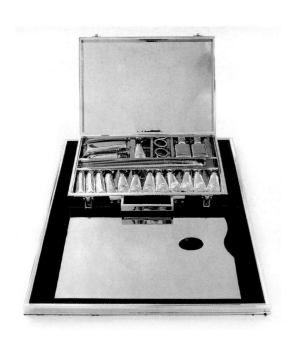

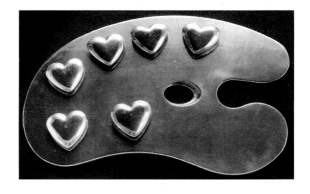

40. *Palette for Rose*, 1966

Polished aluminium
16 in / 40.7 cm long

39. *Art Box I*, 1966

Chrome-plated steel, chrome-plated bronze
and vitrolite
3 x 20 1/2 x 25 3/4 in / 7.6 x 52.1 x 64.8 cm (closed)

EXHIBITED - 1968, *Clive Barker: Recent Works*,
Robert Fraser Gallery, London, cat.1. ill.

41. *Zip Mouth Organ*, 1966

Chrome-plated brass
8 1/2 in / 21.6 cm long

The Hirshhorn Museum and Sculpture Garden,
Smithsonian Institution, Washington, D.C.

EXHIBITED - 1968, *Clive Barker: Recent Works*, Robert Fraser Gallery,
London, cat.10 (as 'Mouth Organ', edition of 3).

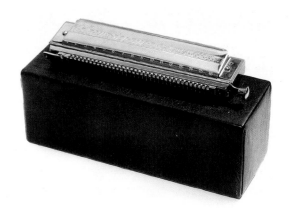

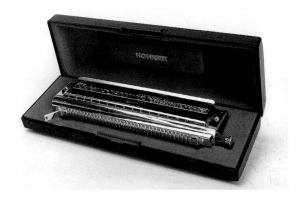

43. *Cigar for Richard*, 1966

Mixed media
Box 1 ³/₁₆ x 9 ¹⁵/₁₆ x 1 ⁵/₈ in / 3 x 25.2 x 4.1 cm
Cigar 9 in / 23 cm long

Cigar for Richard Hamilton

42. *Zip Mouth Organ*, 1966

Mixed media
Box 1 ³/₄ x 9 ¹/₄ x 3 ¹¹/₃₂ in / 4.5 x 23.5 x 8.5 cm

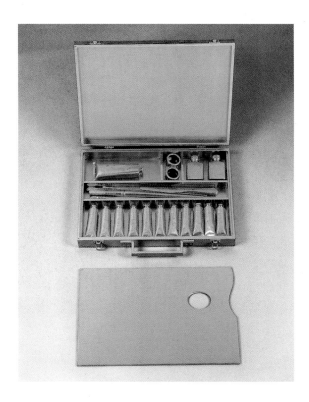

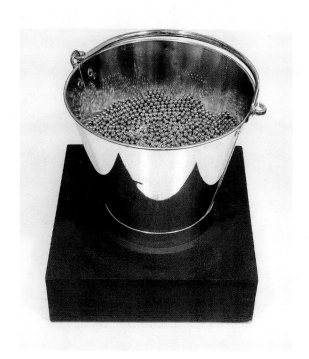

44. *Art Box II*, 1967

Gold-plated brass and gold-plated bronze
2 ¹/₂ x 16 x 12 ¹/₄ in / 6.4 x 40.7 x 31.1 cm (closed)

EXHIBITED - 1968, *Clive Barker: Recent Works*, Robert Fraser Gallery, London, cat.2.
1968, *Mostra Mercato d'Arte Contemporanea*, Palazzo Strozzi, Florence (shown by Robert Fraser Gallery).
1969, *Pop Art*, Hayward Gallery, London, cat.6, ill.no.52.
1981-82, *Clive Barker: Sculpture, Drawings and Prints* (retrospective exhibition), Mappin Art Gallery, Sheffield and tour, cat.11, (as 'Art Box I', ill.)
1987, *Pop Art U.S.A. - U.K.*, Odakyu Grand Gallery, Tokyo and tour, cat.34, ill. p.83 (illustrated without palette).
1997, *Pop 60's: Transatlantic Crossing*, Centro Cultural de Belém, Lisbon, cat.162, ill. p.185.
1993, *Reflet-Restitution. La Sculpture pop et hyperréaliste*, Abbaye Saint-André, Meymac.
1999, *A Cabinet of Curiosities from the Collections of Peter Blake*, Morley Gallery, London.

45. *Bucket of Raindrops*, 1967

Chrome-plated steel and painted wood
Bucket 10 in / 25.4 cm high
12 in / 30.5 cm diameter

EXHIBITED - 1967, *Nuove Tecniche d'Immagine*, Biennale Internazionale d'Arte, San Marino, p.44, ill.
1968, *Clive Barker: Recent Works*, Robert Fraser Gallery, London, cat.3, ill.
1969, *Young and Fantastic*, ICA, London and tour.

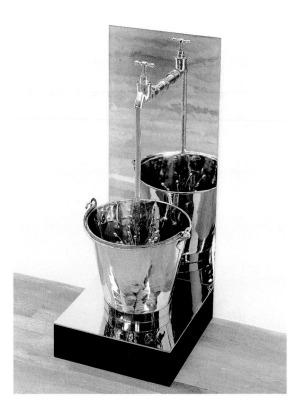

46. *Splash*, 1967

Chrome-plated steel, chrome-plated brass and painted wood.
34 x 15 x 14 in / 86.4 x 38 x 35.6 cm

Tate, London

EXHIBITED - 1968, *British Artists: 6 Painters, 6 Sculptors* (exhibition circulated by Museum of Modern Art, New York), cat.ill.
1968, *Clive Barker: Recent Works*, Robert Fraser Gallery, London, cat.4.
1977, *British Artists of the 60's*, Tate Gallery, London.
1981-82, *Clive Barker: Sculpture, Drawings and Prints* (retrospective exhibition), Mappin Art Gallery, Sheffield and tour, cat.9.
1986, *Forty Years of Modern Art 1945-1985*, Tate Gallery, London.
1988-91, *Modern British Sculpture from the Collection*, Tate Gallery, Liverpool, cat.ill. p.125 (with erronous measurements).
1997, *Pop Art*, Norwich Castle Museum, Norwich, cat.2, ill.
1998-2001, *Modern British Art*, Tate Gallery, Liverpool.

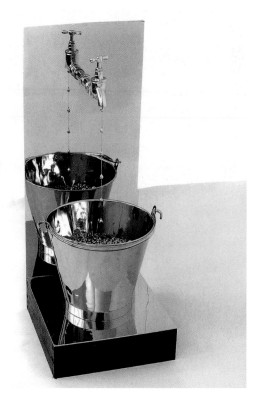

47. *Drips*, 1967

Chrome-plated steel, chrome-plated brass and painted wood
34 x 15 x 14 in / 86.4 x 38 x 35.6 cm

EXHIBITED - 1968, *Clive Barker: Recent Works*, Robert Fraser Gallery, London, cat.6, ill.

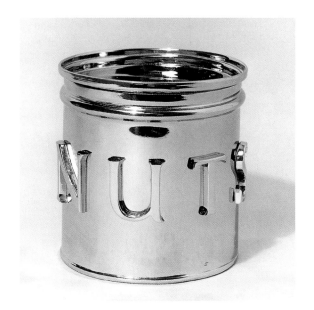

48. *Nuts*, 1967

Chrome-plated brass and lead
3 1/2 in / 8.9 cm high; 3 1/2 in / 8.9 cm diameter

EXHIBITED - 1968, *Clive Barker: Recent Works*, Robert Fraser Gallery, London, cat.15, ill.

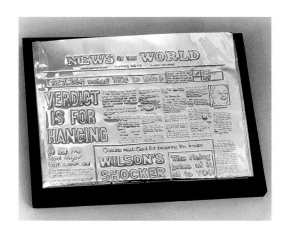

49. *Newspaper*, 1967

Chrome-plated brass
2 x 14 x 18 ¹/2 in / 5 x 35.6 x 47 cm

EXHIBITED - 1968, *Clive Barker: Recent Works*, Robert Fraser Gallery, London, cat.9, ill.
1969, *Young and Fantastic*, ICA, London and tour (as 'News of the World').
1981-82, *Clive Barker: Sculpture, Drawings and Prints* (retrospective exhibition), Mappin Art Gallery, Sheffield and tour, cat.10.

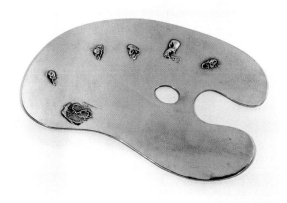

50. *My Palette*, 1967

Polished aluminium
19 ¹/2 in / 49.5 cm long

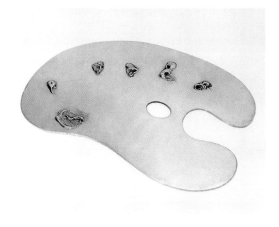

51. *My Palette 2*, 1967

Polished bronze
19 ¹/2 in / 49.5 cm long

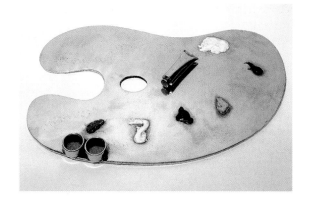

52. *Palette and Tube*, 1967

Polished aluminium, partly painted
19 ¹/2 in / 49.5 cm long

53. *Palette & 2 Tubes*, 1967

One in polished bronze
One in polished aluminium,
gold and silver plate
19 ¹/2 in / 49.5 cm long

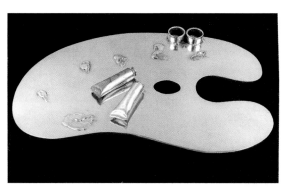

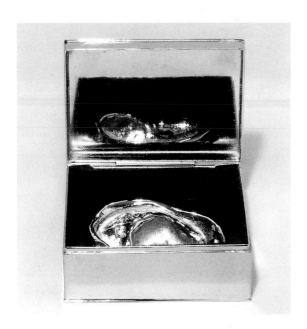

54. *Van Gogh's Ear*, 1967

Chrome-plated bronze and chrome-plated copper
Edition of 10
Box 1 3/8 x 3 1/8 x 2 1/2 in / 3.5 x 8 x 6.4 cm

EXHIBITED - 1968, *Clive Barker: Recent Works*, Robert Fraser Gallery,
London, cat.8.
1987, *British Pop Art*, Birch and Conran Fine Art, London.

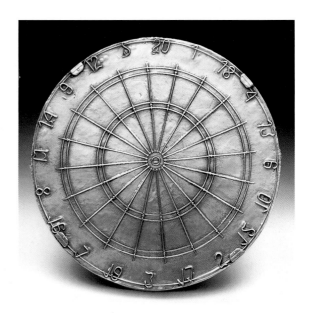

55. *Tom Bruen's Teeth*, 1967

Mixed media
5 1/8 x 7 x 2 15/16 in / 13 x 17.8 x 7.5 cm

EXHIBITED - 1968, *Clive Barker: Recent Works*, Robert Fraser Gallery,
London, cat.11, ill. (as edition of 5).
1981-82, *Clive Barker: Sculpture, Drawings and Prints* (retrospective exhib-
ition), Mappin Art Gallery, Sheffield and tour, cat.6 (dated 1966).

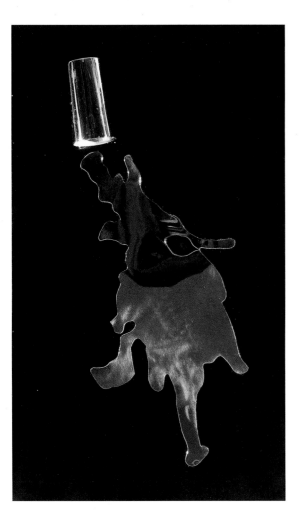

57. *Dartboard*, 1967

Polished aluminium
17 1/2 in / 44.5 cm diameter

EXHIBITED - 1995, *Post-War to Pop*, Whitford Fine Art, London.

56. *Spill*, 1967

Chrome-plated brass and vitrolite
3 1/2 x 20 x 30 in / 8.9 x 50.8 x 76.2 cm

The Hirshhorn Museum and Sculpture Garden,
Smithsonian Institution, Washington, D.C.

EXHIBITED - 1968, *Clive Barker: Recent Works*, Robert Fraser Gallery,
London, cat.5.

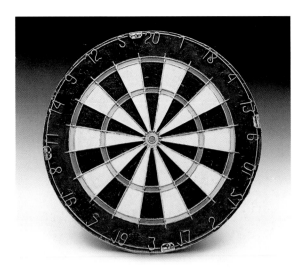

58. *Painted Dartboard*, 1967

Painted aluminium
17 1/2 in / 44.5 cm diameter

EXHIBITED - 1995, *Post-War to Pop*, Whitford Fine Art, London.

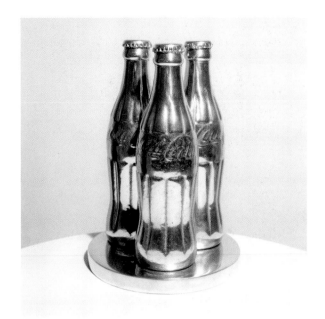

59. *3 Cokes Study*, 1967

Polished aluminium
8 1/4 in / 21 cm high; 5 7/8 in / 15 cm diameter

EXHIBITED - 1995, *Post-War to Pop*, Whitford Fine Art, London.
1997, *Pop 60's: Transatlantic Crossing*, Centro Cultural de Belém, Lisbon, cat.163, ill. p.186.

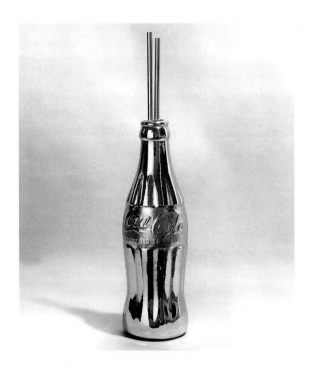

60. *Coke with Two Straws*, 1968

Edition of 8 in chrome-plated bronze
One in sterling silver (cast 1976)
10 15/16 in / 27.8 cm high

EXHIBITED - 1969, *Clive Barker*, Hanover Gallery, London, cat.10, ill.
1981-82, *Clive Barker: Sculpture, Drawings and Prints* (retrospective exhibition), Mappin Art Gallery, Sheffield and tour, cat.15.
1993, *Pop Art*, The Montreal Museum of Fine Arts, Montreal, cat.12, ill. p.210.
1993, *Reflet-Restitution. La Sculpture pop et hyperréaliste*, Abbaye Saint-André, Meymac, cat.ill.

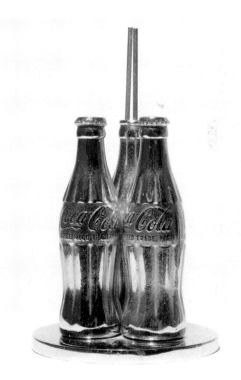

61. *3 Cokes*, 1968

Chrome-plated bronze,
11 1/2 in / 29.2 cm high; 6 15/16 in / 17.6 cm diameter

EXHIBITED - 1969, *Pop Art*, Hayward Gallery, London, cat.9, ill.no.102.
1969, *Clive Barker*, Hanover Gallery, London, cat.9, ill. (as 'Three Coca-Cola Bottles')
1981-82, *Clive Barker: Sculpture, Drawings and Prints* (retrospective exhibition), Mappin Art Gallery, Sheffield and tour, cat.14.
1984, *British Pop Art*, Robert Fraser Gallery, London.

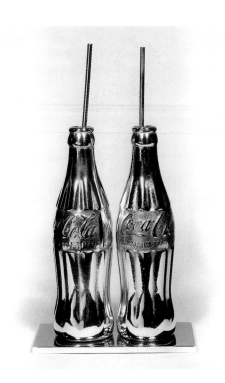

62.	*Twin Cokes*, 1968
Chrome-plated bronze
11 x 6 x 3 in / 28 x 15.2 x 7.6 cm

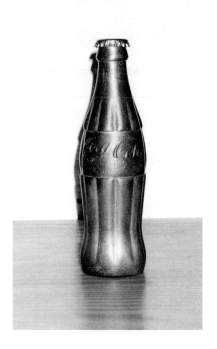

63.	*Coke*, 1968
Bronze with real cap
7 11/16 in / 19.5 cm high

EXHIBITED - 1999, *A Cabinet of Curiosities from the Collections of Peter Blake*, Morley Gallery, London.

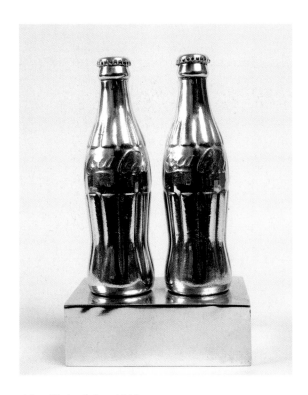

64.	*Twin Cokes*, 1968
Polished aluminium
Edition of 3
1 A/P
9 3/4 in / 24.8 cm high

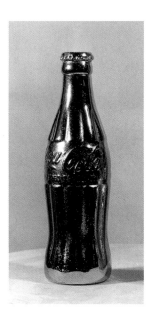

65.	*Coke with Cap*, 1968
Chrome-plated bronze
8 in / 20.3 cm high

EXHIBITED - 1969, *Clive Barker*, Hanover Gallery, London, cat.12.

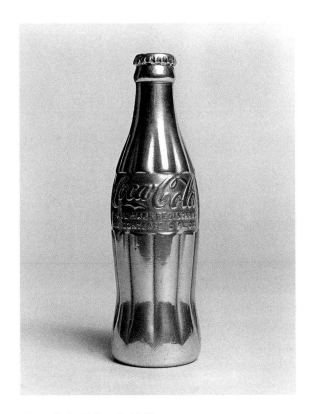

66. *Coke & Cap 2*, 1968

Polished aluminium
7 3/4 in / 19.7 cm high

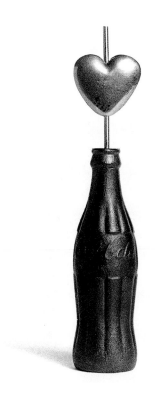

67. *For Rose XXX*, 1968

Bronze with dark brown patina and polished brass
11 3/4 in / 29.9 cm high

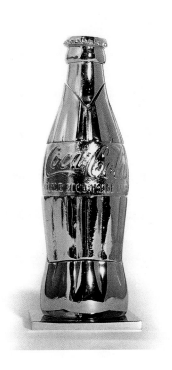

68. *Coca-Cola Puzzle*, 1968

Chrome-plated bronze
8 in / 20.3 cm high

EXHIBITED - 1969-70, *Play Orbit*, Royal National Eisteddfod of Wales, Flint and ICA, London, cat.ill. p.109.

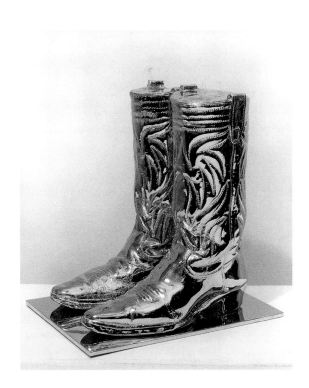

69. *Cowboy Boots*, 1968

Chrome-plated bronze
13 1/4 x 9 1/4 x 12 1/2 in / 33.7 x 23.5 x 31.7 cm

EXHIBITED - 1969, *Clive Barker*, Hanover Gallery, London, cat.8, ill. 1981-82, *Clive Barker: Sculpture, Drawings and Prints* (retrospective exhibition), Mappin Art Gallery, Sheffield and tour, cat.12.

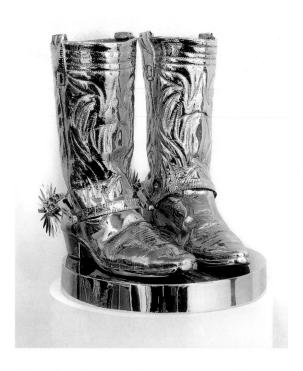

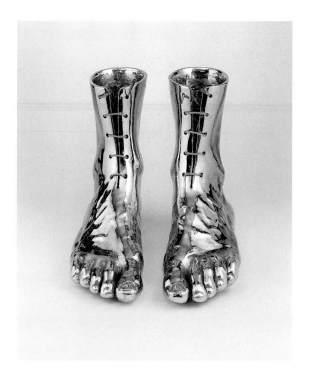

70. *Rio – Homage to Marlon Brando*, 1968

Chrome-plated bronze
Edition of 3
14 1/2 in / 36.8 cm high; 12 in / 30.5 cm diameter

EXHIBITED - 1969, *Pop Art*, Hayward Gallery, London, cat.7, ill.no.116.
1969, *Young and Fantastic*, ICA, London and tour.
1969, *Clive Barker*, Hanover Gallery, London, cat.4, ill.
1972, *Clive Barker/David Oxtoby/ Norman Stevens/ Michael Vaughan/ David Versey/ Roy Tunnicliffe/John Loker*, Studio 4, London.
1973, *Künstler aus England*, Baukunst-Galerie, Cologne, cat.4, ill.
1981-82, *Clive Barker: Sculpture, Drawings and Prints* (retrospective exhibition), Mappin Art Gallery, Sheffield and tour, cat.13.
1993, *Pop Art*, The Museum of Fine Arts, Montreal, cat.13, ill. p.210.
1993, *Reflet-Restitution. La Sculpture pop et hyperréaliste*, Abbaye Saint-André, Meymac.

71. *Homage to Magritte*, 1968-69

Chrome-plated bronze
Edition of 6
7 3/4 in / 19.7 cm high

EXHIBITED - 1969, *Poetic Image*, Hanover Gallery, London, cat.ill.
1969, *Young and Fantastic*, ICA, London and tour, cat.ill.
1969, *Pop Art*, Hayward Gallery, London, cat.8, ill.no.63.
1969, *Clive Barker*, Hanover Gallery, London, cat.3, ill.
1971, *Métamorphose de l'objet. Art et anti-art 1910-1970*, Palais des Beaux-Arts, Brussels and tour, cat.136, ill.p.140.
1973, *Künstler aus England*, Baukunst-Galerie, Cologne, cat.5, ill.
1974, *Zehn Jahre Baukunst*, Baukunst-Galerie, Cologne, cat.25, ill.
1976, *Schuhwerke*, Kunsthalle Nürnberg, Nuremberg.
1981-82, *Clive Barker: Sculpture, Drawings and Prints* (retrospective exhibition), Mappin Art Gallery, Sheffield and tour, cat.19, ill.
1986-87, *Contrariwise: Surrealism and Britain 1930-1986*, Glynn Vivian Art Gallery, Swansea and tour, cat.11, ill. p.12.

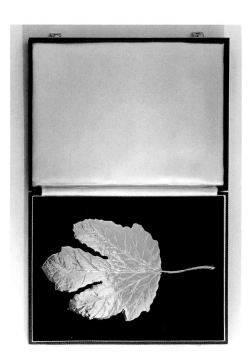

72. *For Jacqueline*, 1968

Mixed media (leaf in chrome-plated brass)
1 x 9 x 12 in / 2.6 x 23 x 30.5 cm

EXHIBITED - 1968, *Tout Terriblement Guillaume Apollinaire*, ICA, London, cat.6.

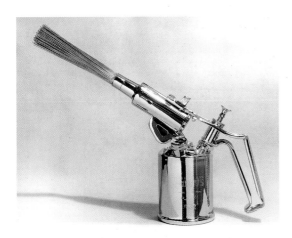

74. *Yardstick I*, 1968

Chrome-plated brass and wood
1 1/4 x 41 x 2 1/4 in / 3.2 x 104.1 x 5.7 cm

EXHIBITED - 1968, *Mostra Mercato d'Arte Contemporanea*, Palazzo Strozzi, Florence (shown by Robert Fraser Gallery as 'Rule (a)').

73. *Blowlamp*, 1968

Chrome-plated brass
12 x 15 x 3 3/4 in / 30.5 x 38.1 x 9.5 cm

75. *Yardstick II*, 1968

Polished brass and wood
1 1/4 x 41 x 2 1/4 in / 3.2 x 104.1 x 5.7 cm

EXHIBITED - 1968, *Mostra Mercato d'Arte Contemporanea*, Palazzo Strozzi, Florence (shown by Robert Fraser Gallery as 'Rule (b)').

76. (left) *Magritte's Pipe*, 1968

Mixed media
6 3/4 in / 17.2 cm long

77. (right) *Madam Magritte's Pipe*, 1968

Mixed media
5 3/4 in / 13.4 cm long

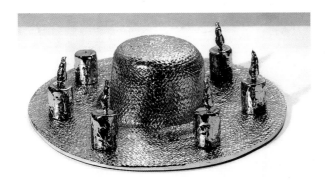

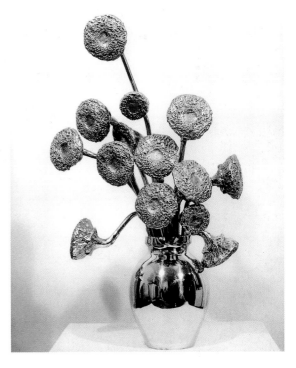

79. *Van Gogh's Hat with Candles 1*, 1969

Chrome-plated bronze
4 1/2 x 17 x 18 in / 11.5 x 43.2 x 45.7 cm

EXHIBITED - 1969, *Clive Barker*, Hanover Gallery, London, cat.13, ill.
1973, *Künstler aus England*, Baukunst-Galerie, London, cat.7, ill.
1981-82, *Clive Barker: Sculpture, Drawings and Prints* (retrospective exhibition), Mappin Art Gallery, Sheffield and tour, cat.20.

78. *Van Gogh's Sunflowers*, 1969

Polished bronze and polished copper
37 1/2 in / 95.3 cm high

EXHIBITED - 1969, *Clive Barker*, Hanover Gallery, London, cat.7, ill.
1970, *British Sculpture out of the Sixties*, ICA, London, cat.4, ill.

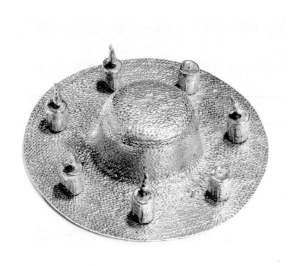

80. *Van Gogh's Hat with Candles 2*, 1969

Copper-plated bronze
4 ¹/2 x 17 x 18 in / 11.5 x 43.2 x 45.7 cm

<small>EXHIBITED - 1969, *Clive Barker*, Hanover Gallery, London, cat.14, ill.</small>

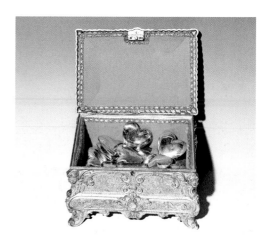

81. *Heart Box*, 1969

Mixed media
7 ¹/4 x 9 ¹/16 x 6 ¹/2 in / 18.4 x 23 x 16.5 cm

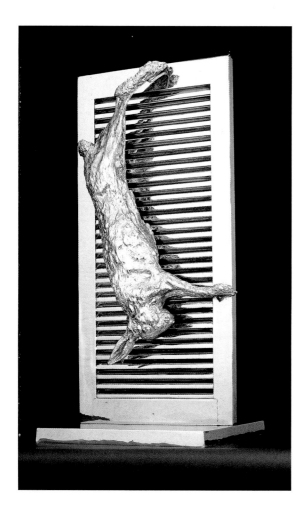

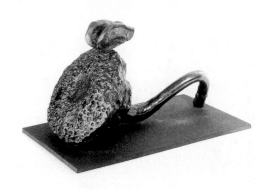

82. *Van Gogh's Sunflower*, 1969

Polished bronze and bronze with green patina
5 ⁷/8 x 10 ¹/2 x 6 in / 15 x 26.7 x 15.2 cm

83. *Homage to Soutine*, 1969

Chrome-plated bronze
37 ¹/2 x 17 ³/4 x 17 ³/4 in / 95.3 x 45.1 x 45.1 cm

Berardo Collection, Sintra Museum of Modern Art, Sintra

<small>EXHIBITED - 1969, *Clive Barker*, Hanover Gallery, London, cat.1, ill.
1973, *Künstler aus England*, Baukunst-Galerie, Cologne, cat.6.
1981-82, *Clive Barker: Sculpture, Drawings and Prints* (retrospective exhibition), Mappin Art Gallery, Sheffield and tour, cat.21.
1983, *BlackWhite*, Robert Fraser Gallery, London.
1987, *Monumenta*, Middelheim, Antwerp, cat.p.71, ill.
1996, *The Berardo Collection*, Sintra Museum of Modern Art, Sintra, cat.88, ill.
1997, *Pop 60's: Transatlantic Crossing*, Centro Cultural de Belém, Lisbon, cat.165, ill. p.187.</small>

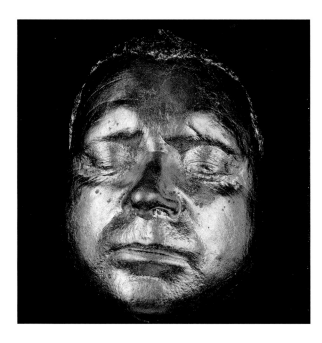

84. *Homage to Picasso*, 1969

Chrome-plated bronze
15 x 20 x 20 in / 38 x 50.8 x 50.8 cm

EXHIBITED - 1969, *Clive Barker*, Hanover Gallery, London, cat.5, ill.
1973, *Künstler aus England*, Baukunst-Galerie, London, cat.9.

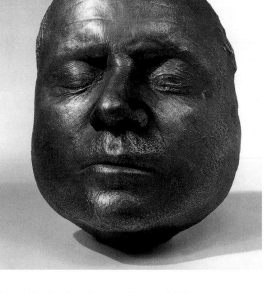

85. *Life Mask of Francis Bacon*, 1969

8 1/4 in / 21 cm high (bronze)
Edition of 8 and 2 A/P in bronze with brown patina
2 in chrome plated bronze (one of which signed
by Francis Bacon)
1 prototype in bronze with golden brown patina
mounted on wooden base
1 plaster cast
Second edition of 3 in bronze, 1971

EXHIBITED - 1969, *Clive Barker*, Hanover Gallery, London, cat.19, ill.
1972, *British Figurative Art Today and Tomorrow*, Nova-London Fine Art,
Copenhagen, ill. front cover.
1973, *Künstler aus England*, Baukunst-Galerie, Cologne, cat.8.
1981-82, *Clive Barker: Sculpture, Drawings and Prints* (retrospective ex-
hibition), Mappin Art Gallery, Sheffield and tour, cat.23.

86. *Life Mask of Francis Bacon*, 1969

Gilded bronze
8 1/4 in / 21 cm high

National Portrait Gallery, London

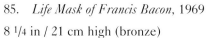

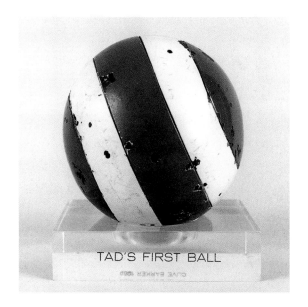

87. *Tad's First Ball*, 1969

Perspex and painted bronze
4 3/4 x 4 5/16 x 3 1/4 in / 12.1 x 11 x 8.3 cm

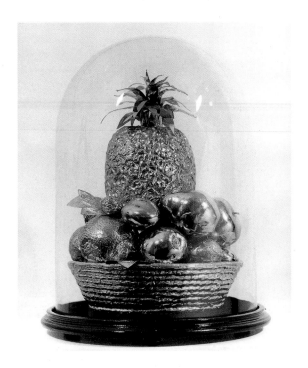

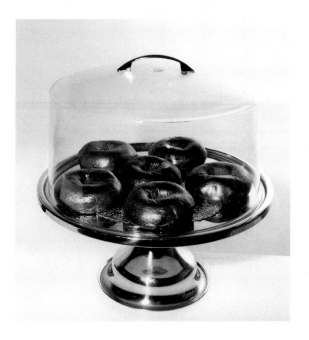

89. *Bagels*, 1969

Mixed media (bagels in bronze with brown patina)
13 in / 33 cm high; 13 in / 33 cm diameter

88. *Victorian Fruit*, 1969

Chrome-plated bronze, glass and painted wood
16 ¹/₂ in / 41.9 cm high

EXHIBITED - 1969, *Clive Barker*, Hanover Gallery, London, cat.11, ill.
1981-82, *Clive Barker: Sculpture, Drawings and Prints* (retrospective exhibition), Mappin Art Gallery, Sheffield and tour, cat.16, ill.
1993, *Reflet-Restitution. La Sculpture pop et hyperréaliste*, Abbaye Saint-André, Meymac.

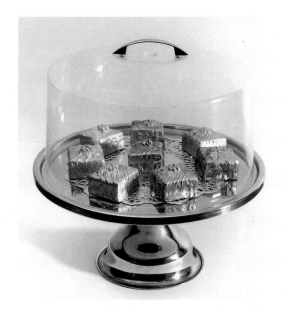

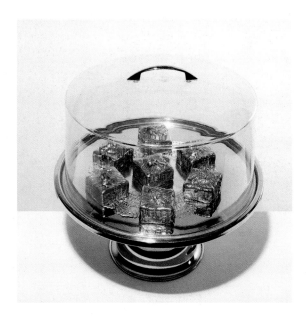

90. *French Fancies*, 1969

Mixed media (fancies in polished aluminium)
13 in / 33 cm high; 13 in / 33 cm diameter

91. *French Fancies*, 1969

Mixed media (fancies in polished copper)
13 in / 33 cm high; 13 in / 33 cm diameter

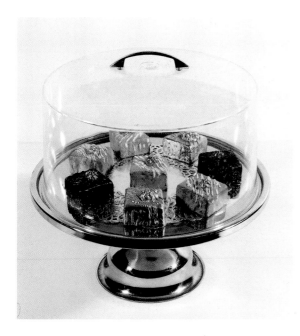

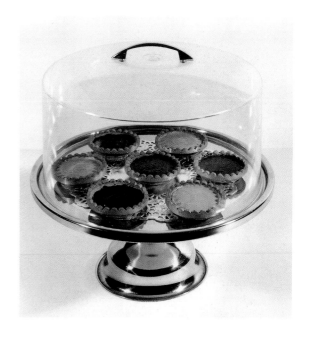

92 *French Fancies*, 1969

Mixed media (fancies in painted aluminium)
13 in / 33 cm high; 13 in / 33 cm diameter

EXHIBITED - 1997, *Les Sixties: Great Britain and France 1962-1973*,
Brighton Museum and Art Gallery, Brighton, cat.ill. (as painted bronze,
dated 1970).

93. *Jam Tarts*, 1969

Mixed media (jam tarts in painted bronze)
13 in / 33 cm high; 13 in / 33 cm diameter

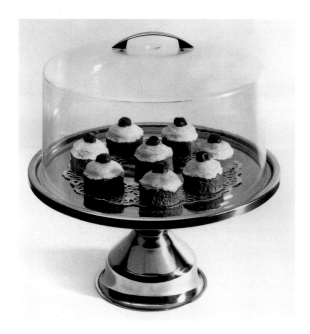

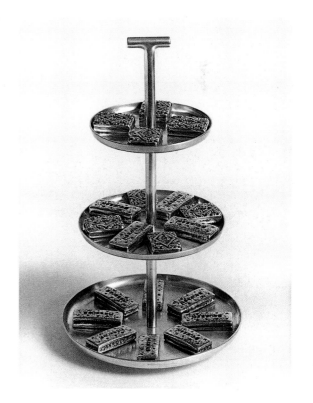

94. *Iced Cherry Cakes*, 1969

Mixed media (cakes in painted bronze)
13 in / 33 cm high; 13 in / 33 cm diameter

EXHIBITED - 1995, *Post-War to Pop*, Whitford Fine Art, London.
1997, Pop 60's, *Transatlantic Crossing*, Centro Cultural de Belém,
Lisbon, cat.164, ill. p.186.

95. *Biscuits*, 1969-97

Polished aluminium and steel
15 1/4 in / 38.7 cm high

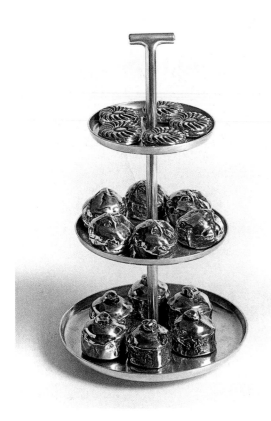

96. *Cakes and Tarts*, 1969-97

Polished aluminium and steel
15 1/4 in / 38.7 cm high

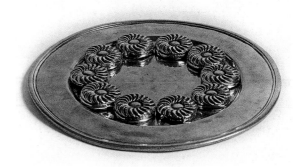

97. *Jammie Dodgers*, 1969-98

Polished aluminium and pewter
12 1/4 in / 31.1 cm diameter

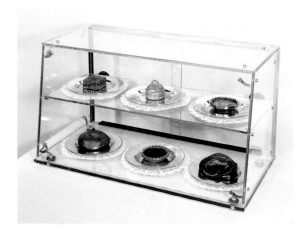

99. *Six Cakes*, 1969-99

Mixed media
12 3/4 in / 32.5 cm high; 30 in / 76.3 cm wide

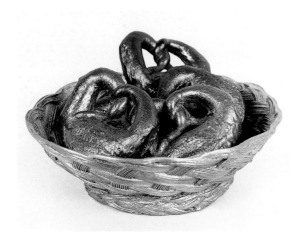

98. *Pretzels*, 1969

Bronze with brown patina and bronze ex foundry
10 in / 25.4 cm diameter

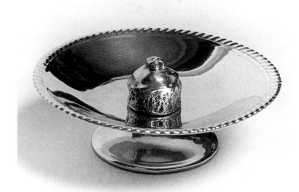

100. *One Cake Left*, 1969

Polished aluminium
4 in / 10.2 cm high; 9 5/8 in / 24.5 cm diameter

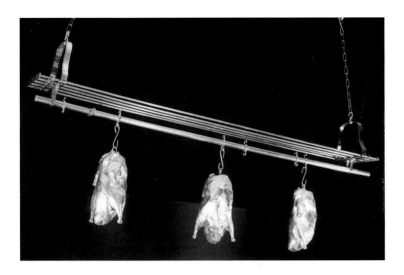

101. *Three Peking Ducks*, 1969

Silver-plated bronze and stainless steel
72 7/8 in / 185 cm long
Each duck approximately 16 x 10 in / 40.7 x 25.4 cm

'Mr Chow' restaurant, London

EXHIBITED - 1998, *30th Anniversary of Mr Chow: Portrait Collection*, Pace
Wildenstein, Beverly Hills and Mayor Gallery, London, cat.28, ill.
2000, *Portrait Collection of Mr Chow*, Galerie Enrico Navarra, Paris, ill.
p.12, p.20 and p.119.

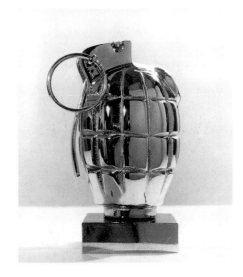

102. *Hand Grenade*, 1969

Chrome-plated bronze
Edition of 6
4 1/2 in / 11.5 cm high

EXHIBITED - 1969, *Clive Barker*, Hanover Gallery, London,
cat.15.
1981-82, *Clive Barker: Sculpture, Drawings and Prints*
(retrospective exhibition), Mappin Art Gallery, Sheffield
and tour, cat.18.

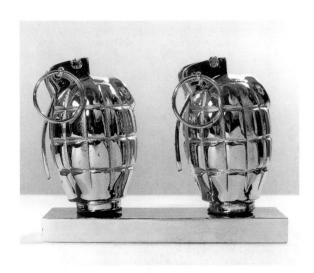

103. *Two Hand Grenades*, 1969

Chrome-plated bronze
Edition of 6
4 1/2 x 6 x 2 in / 11.5 x 15.2 x 5.1 cm
4/6 Imperial War Museum, London

EXHIBITED - 1969, *Young and Fantastic*, ICA, London and tour, (measurements exclude base).
1969, *Clive Barker*, Hanover Gallery, London, cat.16, ill.
1983-84, *Clive Barker: War Heads*, Imperial War Museum, London.
1984, *Barrier 1977-80 and Contemporary Acquisitions*, Imperial War Museum, London.
1992, *Declarations of War: Art from the Collection of the Imperial War Museum*, Kettles Yard, Cambridge.
1993, *No More Heroes Anymore: Contemporary Art from the Imperial War Museum*, Royal Scottish Academy, Edinburgh.

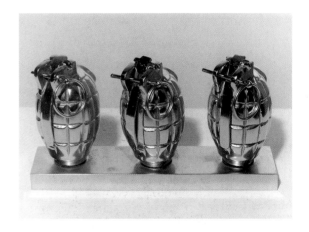

104. *Three Hand Grenades*, 1969

Chrome-plated bronze
Edition of 6
4 1/2 x 8 1/2 x 2 in / 11.5 x 21.6 x 5 cm

EXHIBITED - 1969, *Clive Barker*, Hanover Gallery, London, cat.17, ill.

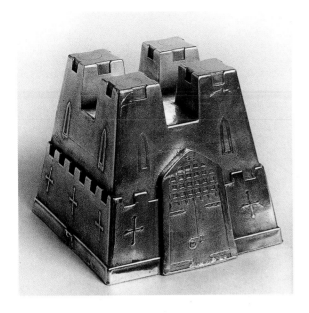

105. *Tad's Castle*, 1969

Polished aluminium
6 5/8 in / 16.8 cm high

106. *Commissioner Gordon's Phone*, 1969

Mixed media
9 1/2 in / 24.2 cm high; 14 5/16 in / 36.4 cm diameter

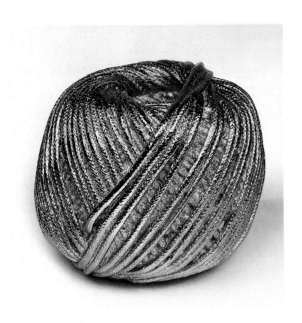

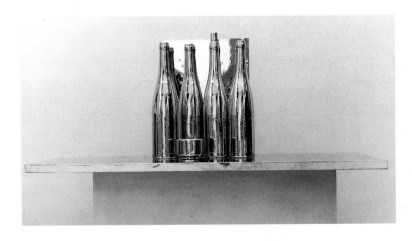

108. *Homage to Morandi*, 1969

Chrome-plated bronze and chrome-plated steel
14 x 19 x 36 in / 35.6 x 48.3 x 91.4 cm

EXHIBITED - 1969, *Clive Barker*, Hanover Gallery, London, cat.2, ill.

107. *Ball of String*, 1969

Chrome-plated bronze
Edition of 8
6 1/4 in / 15.9 cm high

EXHIBITED - 1969, *Clive Barker*, Hanover Gallery, London, cat.18, ill.
1970-71, *New Multiple Art*, Whitechapel Art Gallery, London, cat.33, ill.

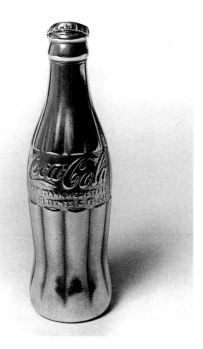

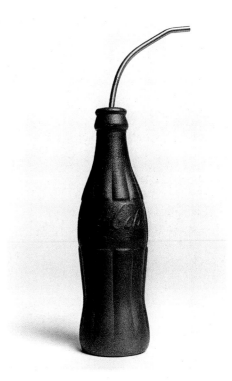

109. *Ppssst*, 1969

Polished aluminium
8 1/8 in / 20.6 cm high

110. *Coke with Bent Straw*, 1969

Bronze with brown patina
10 1/4 in / 26 cm high

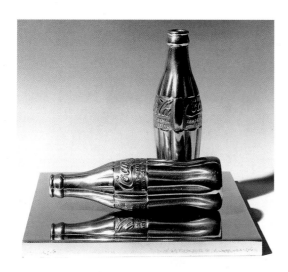

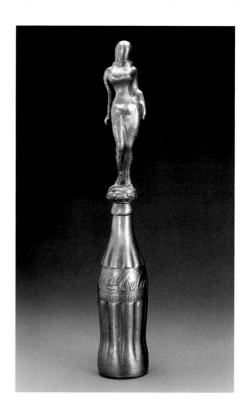

111. *Two Cokes, One Fallen*, 1969

Polished aluminium
8 1/4 x 9 3/4 x 9 3/4 in / 21 x 24.8 x 24.8 cm

113. *American Beauty*, 1969

Bronze with brown patina
14 9/16 in / 37 cm high

Photograph unavailable

112. *Blue Coke*, 1969

Bronze with blue patina
(10 1/2 in / 26.7 cm high)

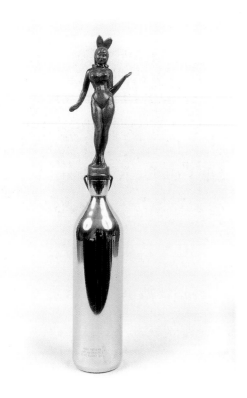

114. *Hugh Hefner's Hot Water Bottle*, 1969

Polished copper, polished brass and bronze with brown patina
18 ⁷/₈ in / 48 cm high

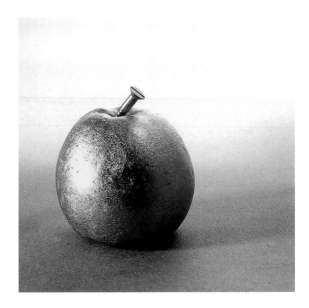

115. *Russet Apple Being Screwed*, 1969

Acid etched bronze
Edition of 3
3 ¹/₈ in / 8 cm high

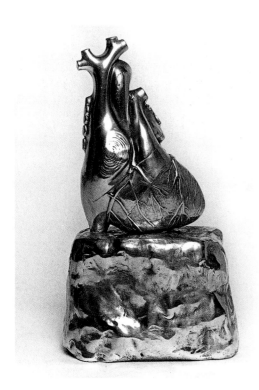

116. *Heart*, 1969-96

Polished aluminium
Edition of 6
10 ³/4 in / 27.3 cm high

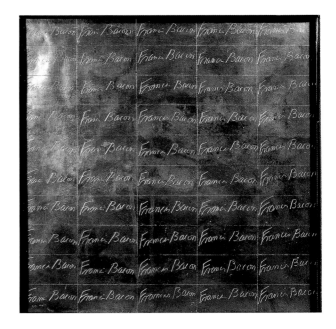

117. *50 Francis Bacon Signatures*, 1969

Bronze with brown patina, brass and glass
20 x 20 x 5 in / 50.8 x 50.8 x 12.7 cm

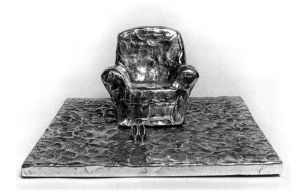

118. *Portrait of Madam Magritte, Study 1*, 1970

Polished aluminium
5 1/2 x 11 7/8 x 11 7/8 in / 14 x 30.2 x 30.2 cm

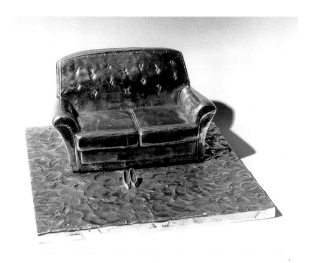

119. *Portrait of Madam Magritte, Study 2*, 1970

Polished aluminium
5 1/4 x 11 7/8 x 11 7/8 in / 13.4 x 30.2 x 30.2 cm

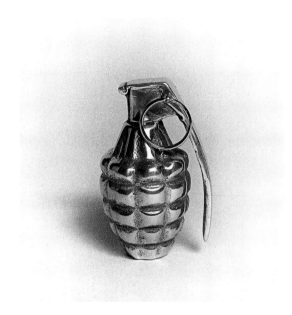

120. *Hand Grenade USA*, 1970

Polished aluminium
4 3/16 in / 10.7 cm high
Edition of 10
1 Study
2 A/P

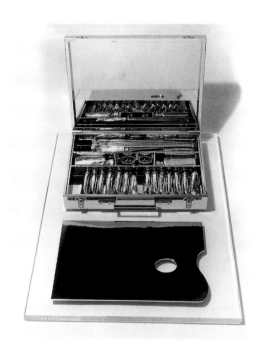

121. *Art Box*, 1970

Chrome-plated brass and chrome-plated bronze
2 9/16 x 13 7/8 x 10 3/4 in / 6.5 x 35.3 x 27.3 cm
(closed)

EXHIBITED - 1981-82, *British Sculpture in the 20th Century*, Whitechapel
Art Gallery, London, exhibit 111 (as 'Paint Box' 1969).
1987, *British Pop Art*, Birch and Conran Fine Art, London.
1999, *A Cabinet of Curiosities from the Collections of Peter Blake*, Morley
Gallery, London.

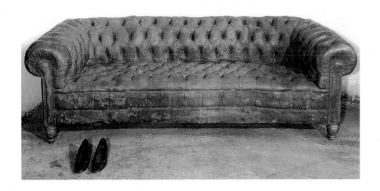

122. *Portrait of Madame Magritte*, 1970-73

Bronze with brown and green patina
29 1/8 x 89 3/4 x 35 in / 74 x 228 x 89 cm

Städtische Kunsthalle, Mannheim

EXHIBITED - 1973, *Künstler aus England*, Baukunst-Galerie, Cologne, cat.14, ill.
1975-76, *Der Ausgesparte Mensch: Aspekte der Kunst der Gegenwart*, Städtische Kunsthalle,
Mannheim, cat.16, ill.

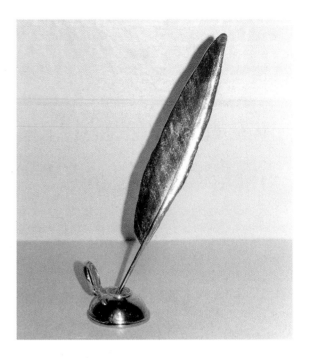

123. *The Critic Writes*, 1970

Chrome-plated bronze
Edition of 5
11 1/4 in / 28.6 cm high

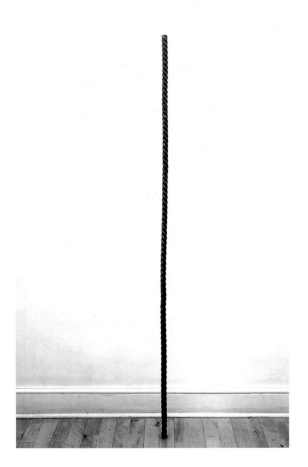

124. *Rope (Piece of Old Rope)*, 1970

Bronze with brown patina
65 7/8 in / 167.3 cm long

125. *Figure*, 1970

Bronze with brown patina
17 1/2 in / 44.5 cm high

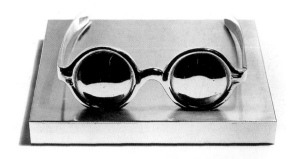

126. *Parcel*, 1970-71

4 x 10 x 5 in / 10.2 x 25.4 x 12.7 cm
Edition of 8:
2 in chrome-plated bronze
2 in polished bronze
2 in black enamelled bronze
2 in bronze with brown patina

EXHIBITED - 1981-82, *Clive Barker: Sculpture, Drawings and Prints* (retrospective exhibition), Mappin Art Gallery, Sheffield and tour, cat.26 (as dated 1972).

127. *David Hockney's Glasses*, 1970

Edition of 3 in chrome plated bronze
1 A/P in bronze with brown patina on perspex base
2 x 6 ³/16 x 5 ¹/2 in / 5 x 15.7 x 14 cm (Edition)
2 ³/4 x 7 ³/8 x 6 in / 7 x 18.8 x 15.2 cm (A/P)

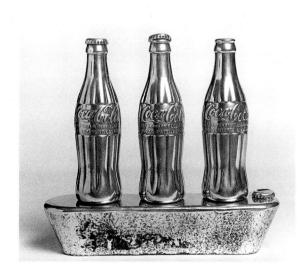

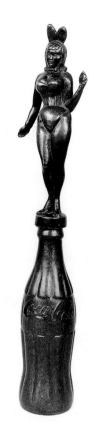

128. *Coke, Nearly Off, Off*, 1970

Polished aluminium
10 ¹/2 in / 26.7 cm high; 12 in / 30.5 cm wide

129. *Monument*, 1970-93

Polished bronze, polished
copper and polished brass
25 ¹/4 in / 64.1 cm high

130. *A Lovely Shape*, 1970

Bronze with brown patina
15 in / 38 cm high

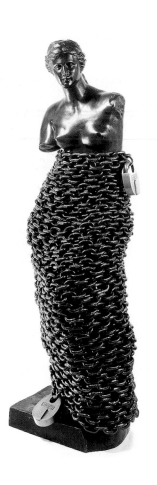

131. *Chained Venus*, 1971

Bronze with black patina and steel
39 in / 99 cm high

EXHIBITED - 1971, *Der Geist des Surrealismus*,
Baukunst-Galerie, Cologne, cat.139, ill. p.110.
1972, *British Figurative Art Today and Tomorrow*,
Nova-London Fine Art, Copenhagen, cat.ill.
1972, *Clive Barker/ David Oxtoby/ Norman Stevens/
Michael Vaughan/ David Versey/ Roy Tunnicliffe/
John Loker*, Studio 4, London.
1973, *Künstler aus England*, Baukunst-Galerie,
Cologne, cat.11.
1974, *Zehn Jahre Baukunst*, Baukunst-Galerie,
Cologne, cat.26.
2000, *D'Après l'Antique*, Musée du Louvre, Paris,
cat.272, ill. p.484.

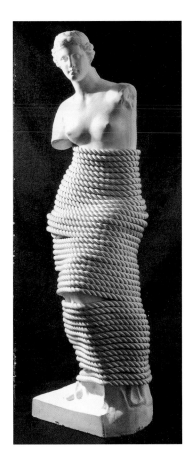

132. *Roped Venus*, 1971

Plaster and rope
39 in / 99 cm high
Destroyed by the artist

133. *Cremated Richard Hamilton Painting*, 1971

Mixed media
8 ³/₄ x 11 x 6 ³/₄ in / 22.2 x 27.9 x 17.1 cm

EXHIBITED - 1981-82, *Clive Barker: Sculpture, Drawings and Prints* (retrospective
exhibition), Mappin Art Gallery, Sheffield and tour, cat.25.
1993, *The Sixties Art Scene in London*, Barbican Centre, London, exhibit 24.
1994-95, *Worlds in a Box*, City Art Centre, Edinburgh and tour, cat.7, ill. p.10.

134. *Cremated Joe Tilson Painting*, 1971

Mixed media
6 ³/₄ x 12 ¹/₄ x 7 ⁵/₁₆ in / 17.2 x 31.1 x 18.6 cm

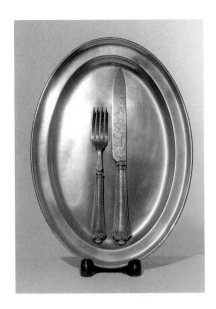

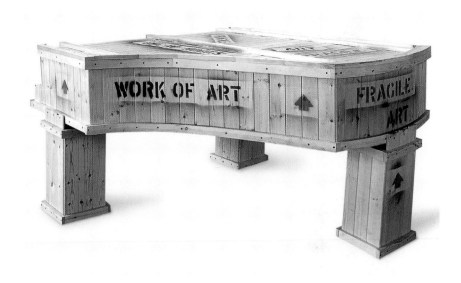

135. *Victorian Couple*, 1971

Silver and silver plate
14 x 10 1/8 in / 35.6 x 25.7 cm

136. *Object to Be Shipped Abroad*, 1971-73

Mixed media
40 x 64 x 84 in / 101.6 x 162.6 x 213.4 cm

EXHIBITED - 1973, *Künstler aus England*, Baukunst-Galerie, Cologne, cat.15.
1979, *Furniture↔Sculpture*, Ikon Gallery, Birmingham, cat.ill.

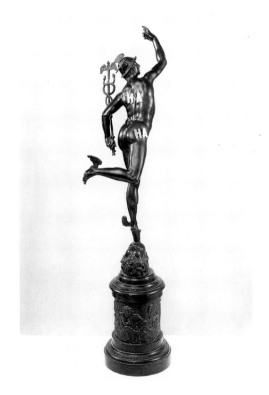

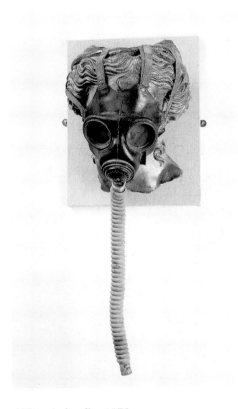

137. *Classical Sculpture Being Laughed At*, 1972

Bronze with brown patina and polished brass
33 in / 83.8 cm high

EXHIBITED - 1972, *Clive Barker/David Oxtoby/ Norman Stevens/ Michael Vaughan/ David Versey/ Roy Tunnicliffe/John Loker*, Studio 4, London.
1973, *Künstler aus England*, Baukunst-Galerie, Cologne, cat.13.
1981-82, *Clive Barker: Sculpture, Drawings and Prints* (retrospective exhibition), Mappin Art Gallery, Sheffield and tour, cat.27, ill.

138. *Aphrodite*, 1972

Mixed media
30 1/2 x 12 x 10 3/4 in / 77.5 x 30.5 x 27.3 cm

EXHIBITED - 1973, *Künstler aus England*, Baukunst-Galerie, Cologne, cat.12.
1981-82, *Clive Barker: Sculpture, Drawings and Prints* (retrospective exhibition), Mappin Art Gallery, Sheffield and tour, cat.28, ill.

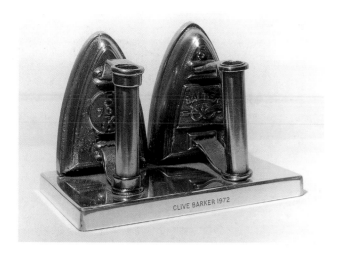

139. *Mr and Mrs Iron*, 1972

Cast iron and polished aluminium
6 1/8 x 8 7/8 x 5 3/4 in / 15.6 x 22.5 x 14.6 cm

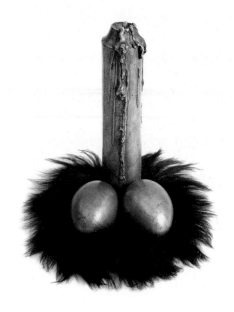

140. *Erotic Still Life*, 1972

Bronze with brown patina and synthetic fur
7 1/16 in / 18 cm high

EXHIBITED - 1983, *Small is Beautiful. Part 3*, Angela Flowers
Gallery, London.

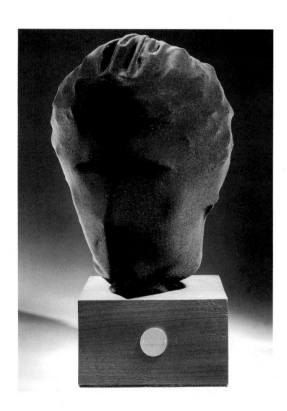

141. *Portrait of an Unknown Beauty*, 1973

Mixed media
15 1/2 in / 39.4 cm high

EXHIBITED - 1973, *Künstler aus England*, Baukunst-Galerie,
Cologne, cat.17, ill.
1975-1976, *Der Ausgesparte Mensch: Aspekte der Kunst der Gegenwart*,
Städtische Kunsthalle, Mannheim, cat.15, ill.
1981-82, *Clive Barker: Sculpture, Drawings and Prints* (retrospective
exhibition), Mappin Art Gallery, Sheffield and tour, cat.32.

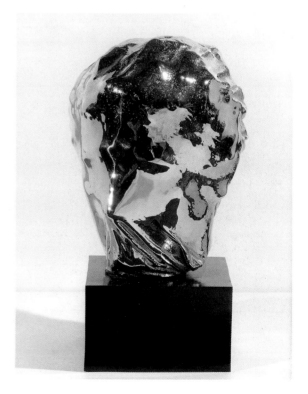

142. *Portrait of an Unknown Beauty*, 1973

Chrome-plated bronze and bronze with black patina
15 1/2 in / 39.4 cm high

EXHIBITED - 1987-88, *Clive Barker: Portraits*, National Portrait Gallery,
London and tour, cat.55, ill.

110

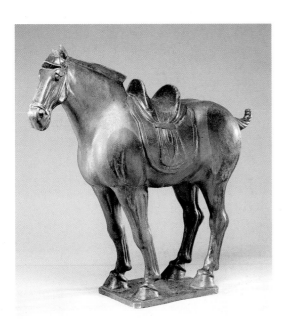

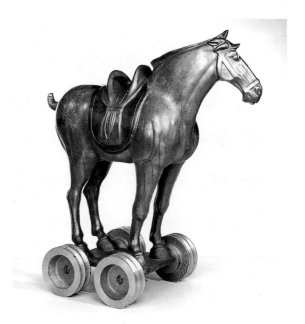

143. *Tang Horse*, 1973

Bronze with brown and blue-green patina
21 in / 53.3 cm high

'Mr Chow' restaurant, New York

144. *Tang Chariot*, 1973

Bronze with green patina and polished aluminium
21 1/8 in / 53.7 cm high

EXHIBITED - 1974, *Clive Barker: Heads and Chariots*, Anthony d'Offay,
London, cat.1.
1976, *Summer Exhibition*, Royal Academy of Arts, London, exhibit 82 (as
'Tang Horse').
1981-82, *Clive Barker: Sculpture, Drawings and Prints* (retrospective ex-
hibition), Mappin Art Gallery, Sheffield and tour, cat.33, ill.
1999, *A Cabinet of Curiosities from the Collections of Peter Blake*, Morley
Gallery, London, ill. p.20.

146. *Cremated David Hockney Painting*, 1973

Mixed media
6 3/4 x 12 1/4 x 7 5/16 in / 17.1 x 31.1 x 18.6 cm

145. *Helmet*, 1973

Polished brass and polished bronze
9 1/2 in / 24.2 cm high

Sheffield City Art Galleries (Graves Art Gallery)

EXHIBITED - 1974, *Clive Barker: Heads and Chariots*, Anthony
d'Offay, London, cat.4, ill.
1981-82, *Clive Barker: Sculpture, Drawings and Prints* (retrospective
exhibition), Mappin Art Gallery, Sheffield and tour, cat.30, ill.

147. *Small Object To Be Shipped Abroad*, 1973

Bronze with brown patina
27 x 16 x 15 ¹/2 in / 68.6 x 40.7 x 39.4cm

EXHIBITED - 1973, *Künstler aus England*, Baukunst-Galerie,
Cologne, cat.19 (as 'Very Expensive Object').
1981-82, *Clive Barker: Sculpture, Drawings and Prints* (retrospective
exhibition), Mappin Art Gallery, Sheffield and tour, cat.24 (dated
1971).

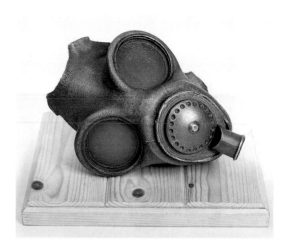

148. *Skull (Gas Mask)*, 1973

Bronze with brown patina
Edition of 3
5 in / 12.7 cm high

3/3 Imperial War Museum, London

EXHIBITED - 1974, *Clive Barker: Heads and Chariots*, Anthony
d'Offay, London, cat.2.
1973, *Künstler aus England*, Baukunst-Galerie, Cologne, cat.16.
1981-82, *Clive Barker: Sculpture, Drawings and Prints* (retrospective
exhibition), Mappin Art Gallery, Sheffield and tour, cat.31.
1983-84, *Clive Barker: War Heads*, Imperial War Museum, London.
1987, *British Pop Art*, Birch and Conran Fine Art, London.

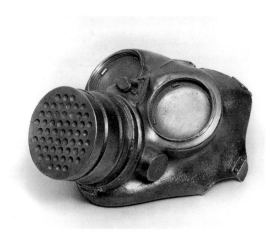

149. *Animal Skull (Gas Mask)*, 1973

Polished brass
5 in / 12.7 cm high

Imperial War Museum, London

EXHIBITED - 1974, *Clive Barker: Heads and Chariots*, Anthony d'Offay,
London, cat.3 (as edition of 3).
1983-84, *Clive Barker: War Heads*, Imperial War Museum, London.

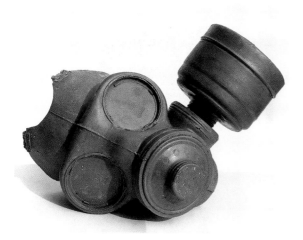

150. *Monster Head (Gas Mask)*, 1974

Bronze with brown patina
8 in / 20.3 cm high

Imperial War Museum, London

EXHIBITED - 1974, *Clive Barker: Heads and Chariots*, Anthony d'Offay,
London, cat.10, ill.
1981-82, *Clive Barker: Sculpture, Drawings and Prints* (retrospective ex-
hibition), Mappin Art Gallery, Sheffield and tour, cat.34.
1983-84, *Clive Barker: War Heads*, Imperial War Museum, London.

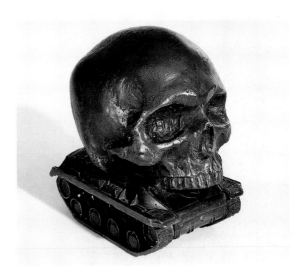

151. *War Head*, 1974

Bronze with brown patina
8 1/2 in / 21.6 cm high

Imperial War Museum, London

EXHIBITED - 1974, *Clive Barker: Heads and Chariots*, Anthony d'Offay,
London, cat.7, ill.
1981-82, *Clive Barker: Sculpture, Drawings and Prints* (retrospective ex-
hibition), Mappin Art Gallery, Sheffield and tour, cat.37, ill.
1983-84, *Clive Barker: War Heads*, Imperial War Museum, London.

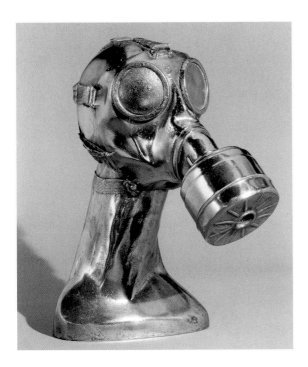

152. *German Head '42*, 1974

Polished brass
15 1/2 in / 39.4 cm high

Imperial War Museum, London

EXHIBITED - 1974, *Clive Barker: Heads and Chariots*, Anthony d'Offay,
London, cat.8.
1981-82, *Clive Barker: Sculpture, Drawings and Prints* (retrospective ex-
hibition), Mappin Art Gallery, Sheffield and tour, cat.35.
1983-84, *Clive Barker: War Heads*, Imperial War Museum, London.

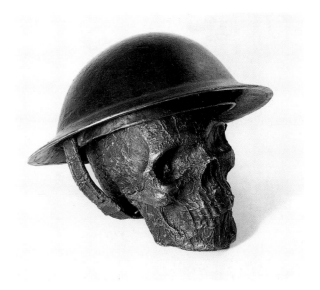

153. *Study for War Memorial*, 1974-83

Bronze with brown patina
7 1/2 in / 19 cm high

Imperial War Museum, London

EXHIBITED - 1974, *Clive Barker: Heads and Chariots*, Anthony d'Offay,
London, cat.9 unfinished version shown (as 'Death's Head' and edition of 3).
1981-82, *Clive Barker: Sculpture, Drawings and Prints* (retrospective exhib-
ition), Mappin Art Gallery, Sheffield and tour, cat.36 unfinished
version shown (as 'Skull', 1974-81).
1983-84, *Clive Barker: War Heads*, Imperial War Museum, London.

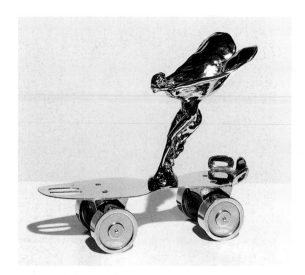

154. *Chariot*, 1974

Chrome-plated brass and chrome-plated bronze
Edition of 7
2 A/P
7 ¹/2 in / 19 cm high; 9 in / 23 cm long

EXHIBITED - 1974, *Clive Barker: Heads and Chariots*, Anthony d'Offay,
London, cat.5.
1976, *Small is Beautiful. Part 2: Sculpture*, Angela Flowers Gallery,
London, cat.6.
1981-82, *Clive Barker: Sculpture, Drawings and Prints* (retrospective
exhibition), Mappin Art Gallery, Sheffield and tour, cat.38.

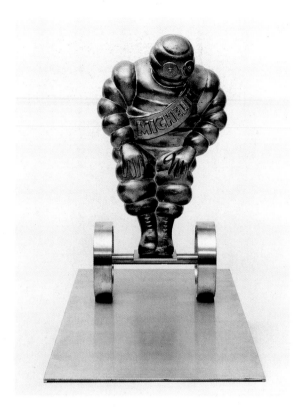

155. *Charioteer*, 1974

Polished bronze and polished brass
22 in / 56 cm high

EXHIBITED - 1974, *Clive Barker: Heads and Chariots*, Anthony d'Offay,
London, cat.6, ill.
1981-82, *Clive Barker: Sculpture, Drawings and Prints* (retrospective
exhibition), Mappin Art Gallery, Sheffield and tour, cat.39.

156. *Flowers*, 1974

Bronze with brown patina
14 ³/4 in / 37.5 cm high

EXHIBITED - 1977, Kinsman Morrison Gallery, London.

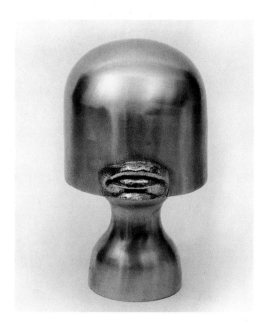

157. *Head of Jean*, 1974

Polished brass
10 ¹/2 in / 26.7 cm high

EXHIBITED - 1974, *Clive Barker: Heads and Chariots*, Anthony
d'Offay, London, cat.11, ill.

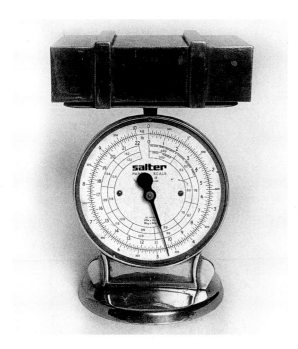

158. *Parcel Post*, 1975

Mixed media
13 in / 33 cm high

<small>EXHIBITED - 2000, *Things: Assemblage, Collage and Photography since 1935*, Norwich Gallery, Norwich and tour.</small>

159. *Torso of Marianne Faithfull*, 1975

Chrome-plated brass
24 in / 61 cm high

<small>EXHIBITED - 1980-81, *Nudes*, Angela Flowers Gallery, London. 1981-82, *Clive Barker: Sculpture, Drawings and Prints* (retrospective exhibition), Mappin Art Gallery, Sheffield and tour, cat.42.</small>

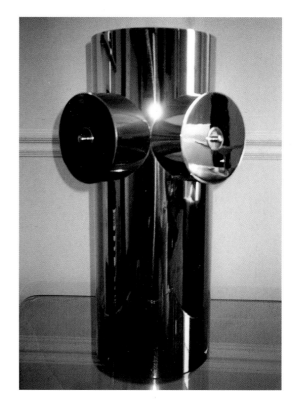

160. *Torso (Rose)*, 1975

Chrome-plated brass
24 in / 61 cm high

<small>EXHIBITED - 1981-82, *Clive Barker: Sculpture, Drawings and Prints* (retrospective exhibition), Mappin Art Gallery, Sheffield and tour, cat.41 (as 'Torso').</small>

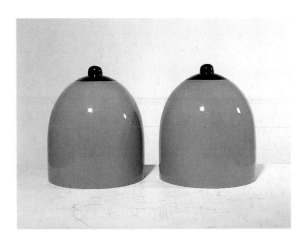

161. *Tits (M.F.)*, 1975

Painted wood
6 1/2 in / 16.5 cm high

162. *Vase (Column)*, 1975

Oak and mahogany
6 in / 15.2 cm high excluding column (illustrated)
48 13/16 in / 124 cm high including column

<small>EXHIBITED - 1981-82, *Clive Barker: Sculpture, Drawings and Prints* (retrospective exhibition), Mappin Art Gallery, Sheffield and tour, cat. 43 (as 'Wooden Column').</small>

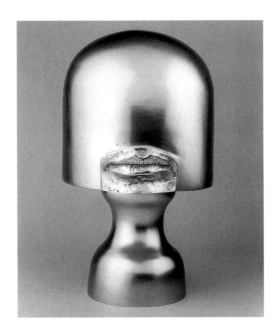

163. *Giuseppe (Head of Eskenazi)*, 1975

Polished bronze
10 1/4 in / 26 cm high

<small>EXHIBITED - 1981-82, *Clive Barker: Sculpture, Drawings and Prints* (retrospective exhibition), Mappin Art Gallery, Sheffield and tour, cat.40.</small>

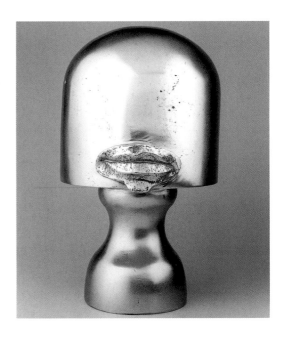

164. *L. E. (Laura Eskenazi)*, 1975

Polished bronze
10 7/16 in / 26.5 cm

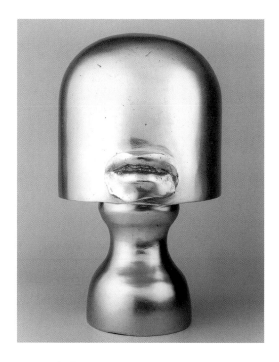

165. *Girl (Head of Monica Eskenazi)*, 1975
Polished bronze
10 $^{7}/_{16}$ in / 26.5 cm

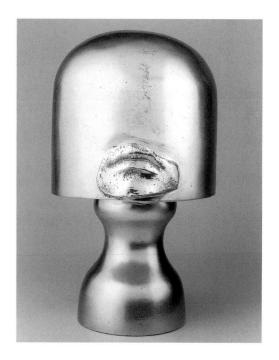

166. *Boy (Head of Daniel Eskenazi)*, 1975
Polished bronze
10 $^{1}/_{4}$ in / 26 cm high

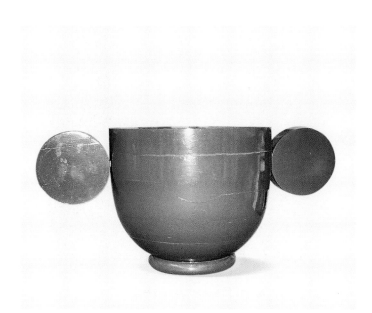

167. *Bowl*, 1975
Painted wood
17 $^{1}/_{4}$ in / 43.8 cm high
39 in / 99 cm wide

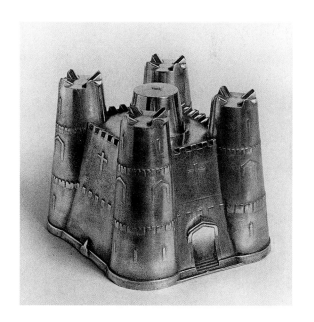

168. *Castle for Ras*, 1976
Polished aluminium
6 in / 15.3 cm high

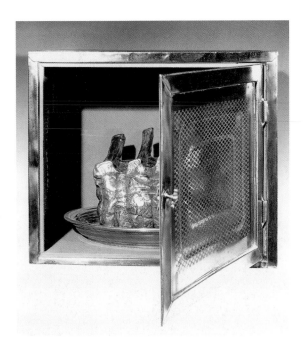

169. *Meat Safe*, 1978

Polished steel, partly painted, and polished
aluminium
14 x 16 3/4 x 11 7/16 in / 35.6 x 42.6 x 29 cm

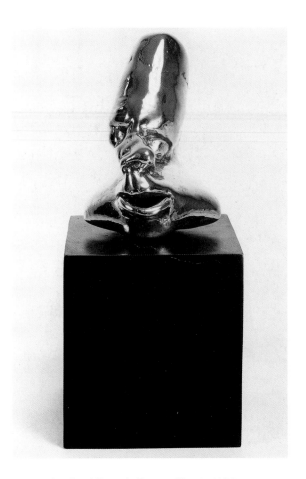

170. *Study of Francis Bacon, No. 1*, 1978

Polished bronze and bronze with black patina
13 5/8 in / 34.6 cm high
Arts Council Collection, Hayward Gallery, London

1 A/P in chrome-plated bronze and bronze with
black patina
13 5/8 in / 34.6 cm high
1 A/P in polished bronze and bronze with black
patina
13 5/8 in / 34.6 cm high

EXHIBITED - 1978, *Clive Barker: 12 Studies of Francis Bacon. Francis
Bacon: 3 Studies of Clive Barker*, Felicity Samuel Gallery, London.
1979, ... *A Cold Wind Brushing the Temple*, Arts Council of Great Britain, ill.
1981-82, *Clive Barker: Sculpture, Drawings and Prints* (retrospective
exhibition), Mappin Art Gallery, Sheffield and tour, cat.44
(measurement excluding base).

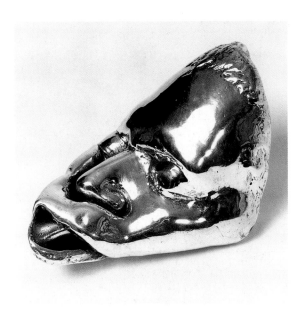

172. *Study of Francis Bacon, No. 3*, 1978

Polished bronze
4 1/8 in / 10.5 cm high; 9 in / 23 cm long

EXHIBITED - 1978, *Clive Barker: 12 Studies of Francis Bacon. Francis
Bacon: 3 Studies of Clive Barker*, Felicity Samuel Gallery, London.
1981-82, *Clive Barker: Sculpture, Drawings and Prints* (retrospective
exhibition), Mappin Art Gallery, Sheffield and tour, cat.45.

Photograph unavailable

171. *Study of Francis Bacon, No. 2*, 1978

Chrome-plated bronze
(17 in / 43.2 cm high)

EXHIBITED - 1978, *Clive Barker: 12 Studies of Francis Bacon. Francis
Bacon: 3 Studies of Clive Barker*, Felicity Samuel Gallery, London.

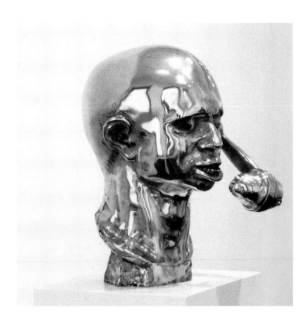

173. *Study of Francis Bacon, No. 4*, 1978

Polished brass
15 in / 38 cm high

EXHIBITED - 1978, *Clive Barker: 12 Studies of Francis Bacon. Francis Bacon: 3 Studies of Clive Barker*, Felicity Samuel Gallery, London.

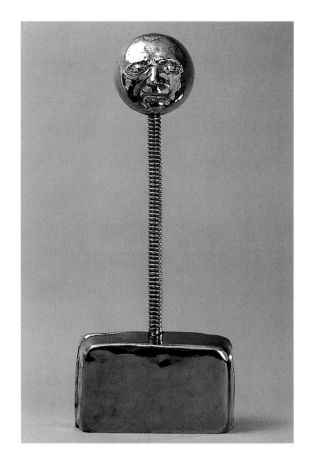

174. *Study of Francis Bacon, No. 5*, 1978

Polished bronze
36 1/4 in / 92.1 cm high

EXHIBITED - 1978, *Clive Barker: 12 Studies of Francis Bacon. Francis Bacon: 3 Studies of Clive Barker*, Felicity Samuel Gallery, London. 1981-82, *Clive Barker: Sculpture, Drawings and Prints* (retrospective exhibition), Mappin Art Gallery, Sheffield and tour, cat.46.

175. *Study of Francis Bacon, No. 6*, 1978

Polished brass
15 in / 38 cm high

Aberdeen Art Gallery, Aberdeen

EXHIBITED - 1978, *Clive Barker: 12 Studies of Francis Bacon. Francis Bacon: 3 Studies of Clive Barker*, Felicity Samuel Gallery, London. 1981-82, *Clive Barker: Sculpture, Drawings and Prints* (retrospective exhibition), Mappin Art Gallery, Sheffield and tour, cat.47, ill.

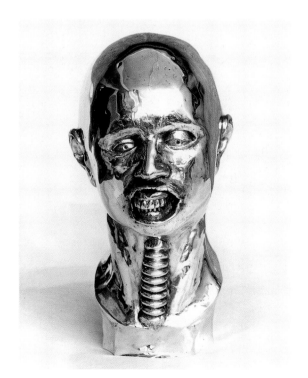

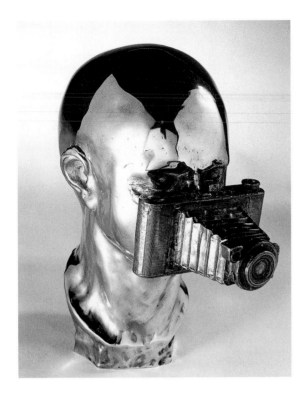

176. *Study of Francis Bacon, No. 7*, 1978

Polished brass and polished bronze
15 in / 38 cm high

Hull City Museums and Art Gallery (Ferens Art
Gallery), Hull (presented by the Contemporary
Arts Society)

EXHIBITED - 1978, *Clive Barker: 12 Studies of Francis Bacon. Francis
Bacon: 3 Studies of Clive Barker*, Felicity Samuel Gallery, London.
1981-82, *13ª Biennale Internazionale del Bronzetto Piccola Scultura*, cat.ill.
(as 'Portrait of Francis Bacon with Camera, IX').

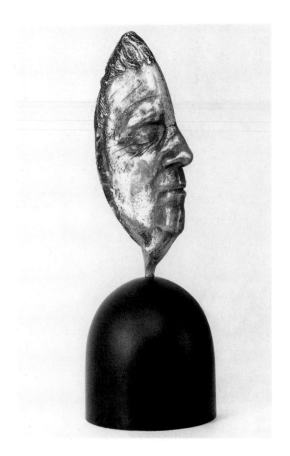

177. *Study of Francis Bacon, No. 8*, 1978

Polished bronze and bronze with black patina
17 in / 43.2 cm high

EXHIBITED - 1978, *Clive Barker: 12 Studies of Francis Bacon. Francis
Bacon: 3 Studies of Clive Barker*, Felicity Samuel Gallery, London.
1981-82, *Clive Barker: Sculpture, Drawings and Prints* (retrospective
exhibition), Mappin Art Gallery, Sheffield and tour, cat.48.

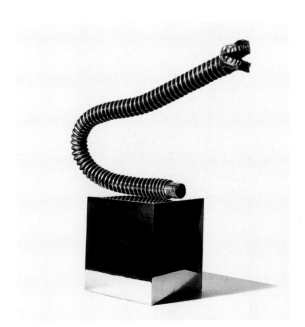

178. *Study of Francis Bacon, No. 9*, 1978

Polished bronze and polished brass
22 in / 56 cm high

Wolverhampton Art Gallery, Wolverhampton

EXHIBITED - 1978, *Clive Barker: 12 Studies of Francis Bacon. Francis
Bacon: 3 Studies of Clive Barker*, Felicity Samuel Gallery, London.
1981-82, *Clive Barker: Sculpture, Drawings and Prints* (retrospective
exhibition), Mappin Art Gallery, Sheffield and tour, cat.49.

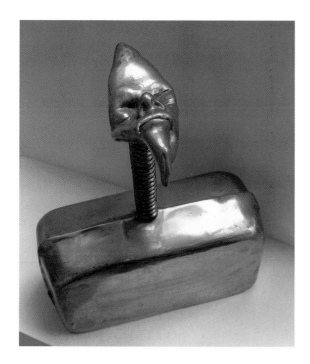

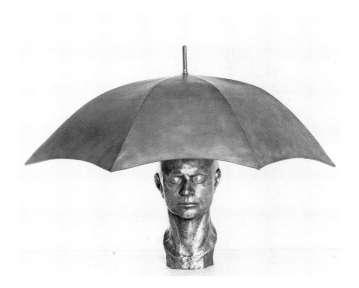

179. *Study of Francis Bacon, No. 10*, 1978

Polished brass
(23 in / 58.4 cm) high

EXHIBITED - 1978, *Clive Barker: 12 Studies of Francis Bacon. Francis Bacon: 3 Studies of Clive Barker*, Felicity Samuel Gallery, London.
1981-82, *13ª Biennale Internazionale del Bronzetto Piccola Scultura*, Padua (as 'Portrait of Francis Bacon VIII').

180. *Study of Francis Bacon, No. 11*, 1978

Polished brass
28 in / 71 cm high

EXHIBITED - 1978, *Clive Barker: 12 Studies of Francis Bacon. Francis Bacon: 3 Studies of Clive Barker*, Felicity Samuel Gallery, London.

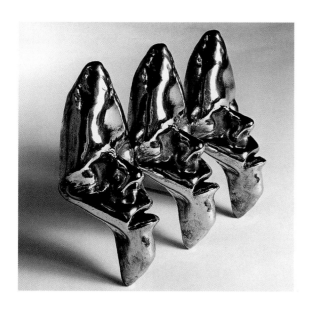

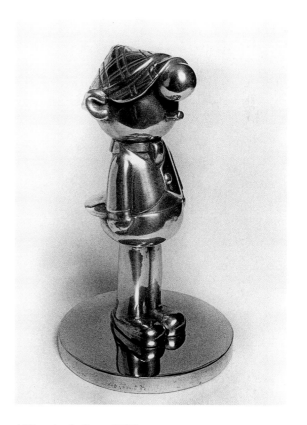

181. *Study of Francis Bacon, No. 12*, 1978

Polished bronze
10 in / 25.4 cm high

EXHIBITED - 1978, *Clive Barker: 12 Studies of Francis Bacon. Francis Bacon: 3 Studies of Clive Barker*, Felicity Samuel Gallery, London.
1981-82, *13ª Biennale Internazionale del Bronzetto Piccola Scultura*, Padua (as 'Portrait of Francis Bacon, No V').

182. *Andy Capp*, 1978

Edition of 6 in polished aluminium
Study in polished bronze
9 in / 23 cm high; 6 7/8 in / 17.5 cm diameter

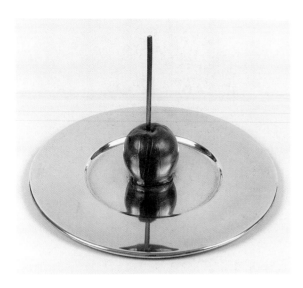

183. *Toffee Apple for Tad*, 1979

184. *Toffee Apple for Ras*, 1979

Bronze with brown patina and silver plate
7 1/2 in / 19 cm high; 12 in / 30.5 cm diameter

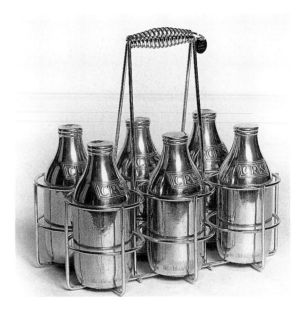

185. *6 Pints*, 1979-96

Polished aluminium and chrome plated steel
13 x 12 5/8 x 8 5/8 in / 33 x 32.1 x 21.9 cm

186. *Helen*, 1980

Oak
7 1/4 in / 18.4 cm high

Exhibited - 1981-82, *Clive Barker: Sculpture, Drawings and Prints* (retrospective exhibition), Mappin Art Gallery, Sheffield and tour, cat.50 (as 'Study of Helen', 1981).

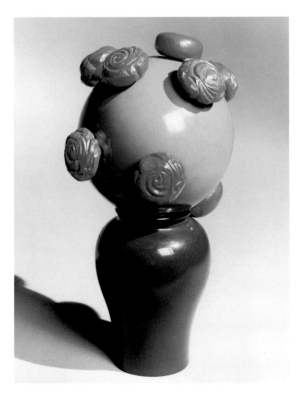

187. *Vase of Flowers*, 1981

Painted wood
16 in / 40.7 cm high

Exhibited - 1981-82, *Clive Barker: Sculpture, Drawings and Prints* (retrospective exhibition), Mappin Art Gallery, Sheffield and tour, cat.53.

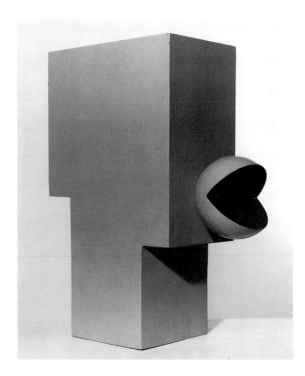

188. *Head of Eduardo Paolozzi*, 1981

Painted wood
13 15/16 in / 35.4 cm high

EXHIBITED - 1981-82, *Clive Barker: Sculpture, Drawings and Prints* (retrospective exhibition), Mappin Art Gallery, Sheffield and tour, cat.52. 1984-85, *Look! People*, St.Paul's Gallery, Leeds and National Portrait Gallery, London, cat.2.

189. *Man from N.Y.C.*, 1981

Pitch pine
13 in / 33 cm high

190. *Glass of Water*, 1981

Edition of 3 in polished
aluminium
Prototype in wood
9 1/4 in / 23.5 cm high

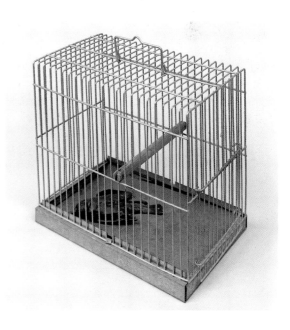

191. *Dead Bird*, 1981

Mixed media
10 x 9 5/8 x 6 in / 25.4 x 24.5 x 15.2 cm

EXHIBITED - 1981-82, *Clive Barker: Sculpture, Drawings and Prints* (retrospective exhibition), Mappin Art Gallery, Sheffield and tour, cat.55.

Photograph unavailable

192. *Ship in a Bottle*, 1981
Mixed media
(Bottle 12 in / 30.5 cm long)

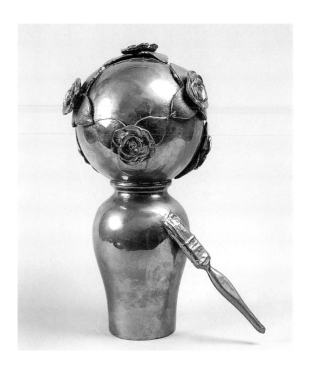

193. *Vase of Flowers with Brush*, 1981
Chrome-plated bronze
15 1/2 in / 39.4 cm high

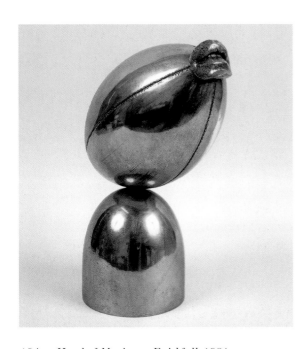

194. *Head of Marianne Faithfull*, 1981
Polished bronze
13 1/2 in / 34.3 cm high

EXHIBITED - 1984-85, *Look! People*, St.Paul's Gallery, Leeds and
National Portrait Gallery, London, cat.4.

195. *Head of Jo House*, 1981
Polished bronze
11 1/2 in / 29.2 cm high

EXHIBITED - 1981-82, *Clive Barker: Sculpture, Drawings and Prints*
(retrospective exhibition), Mappin Art Gallery, Sheffield and tour, cat.51.
1984-85, *Look! People*, St.Paul's Gallery,
Leeds and National Portrait Gallery, London, cat.3.
1993-94, *The Portrait Now*, National Portrait Gallery, London, cat.5, ill. p.62.

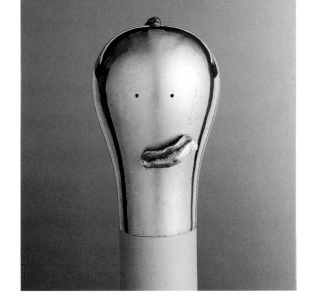

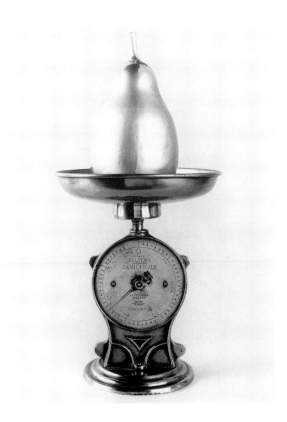

196. *Nearly Five Pounds of Pears*, 1981

Mixed media
20 1/2 in / 52.1 cm high

197. *Mother and Child*, 1981

Polished brass
10 1/2 in / 26.7 cm high

EXHIBITED - 1981-82, *Clive Barker: Sculpture, Drawings and Prints* (retrospective exhibition), Mappin Art Gallery, Sheffield and tour, cat.54.

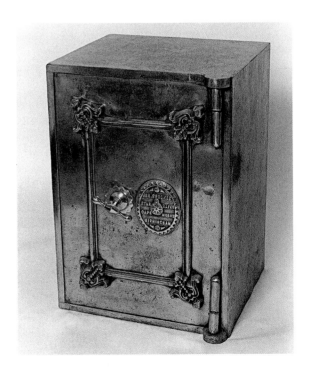

198. *Bullion*, 1981

Polished steel, polished brass and polished
aluminium
24 x 17 x 15 in / 61 x 43.2 x 38 cm

199. *French Bread*, 1983

Mixed media
7 7/8 in / 20 cm high; 17 5/16 in / 44 cm long

201. *Strange Plant for Peter*, 1983

Mixed media

7 1/2 in / 19 cm high; 5 1/2 in / 14 cm diameter

EXHIBITED - 1999, *A Cabinet of Curiosities from the Collections of Peter Blake*, Morley Gallery, London, cat. ill. p.22.

200. *Black Vase of Flowers*, 1983

Bronze with black patina

15 1/2 in / 39.4 cm high

'Le Caprice' restaurant, London

EXHIBITED - 1986, *The Flower Show*, Stoke-on-Trent
City Museum and Art Gallery, Hanley and tour, cat.83, ill. p.61.

202. *Roses*, 1983

Bronze with brown patina, partly painted

15 1/2 in / 39.4 cm high

203. *Escargot*, 1983

Bronze with brown patina
8 3/4 in / 22.2 cm high

204. *Crucifixion on a Red Hill*, 1983

Mixed media
8 in / 20.3 cm high

205. *Cockerel on Bucket*, 1983

Chrome-plated bronze
27 3/16 in / 69 cm high

206. *Rooster Head*, 1983

Bronze with brown patina
8 in / 20.3 cm high

207. *Cock's Head*, 1983

Bronze with brown patina
(10 1/4 in / 26 cm) high

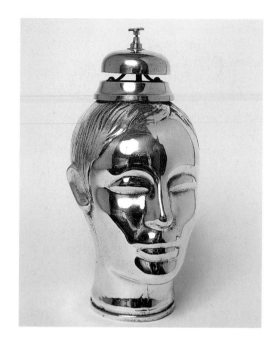

208. *Bell Boy*, 1984-95

Polished brass
12 1/2 in / 31.8 cm high

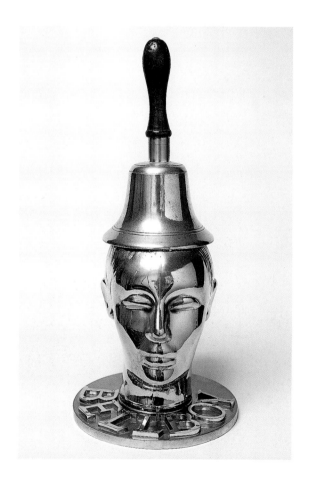

209. *Bell Boy II*, 1984-1995

Polished brass and wood
20 in / 50.8 cm high

210. *Man from U.S.A.*, 1985

Polished brass
13 in / 33 cm high

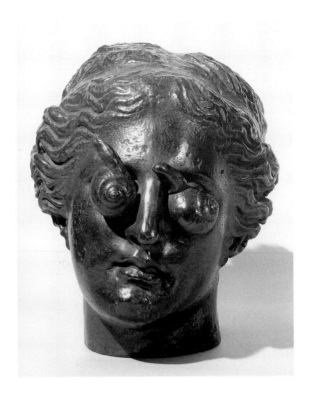

211. *Venus Escargot,* 1987

Bronze with green-black patina
Edition of 3
11 1/8 in / 28.3 cm high

EXHIBITED - 1987-88, *Clive Barker: Portraits,* National Portrait Gallery,
London and tour, cat.56, ill.
1987, *Pop Art U.S.A.-U.K.,* Odakyu Grand Gallery, Tokyo and tour,
cat.35, ill. p.84.
1992, *Summer Exhibition,* Redfern Gallery, London.
1995, *British Surrealism 1935-1995,* England & Co., London, exhibit 17.

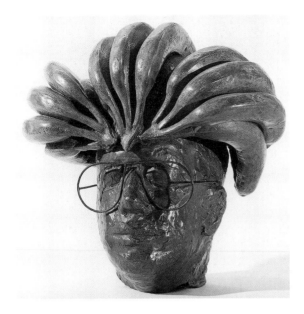

212. *Self-Portrait with Bananas,* 1987

Bronze with brown patina
12 in / 30.5 cm high

EXHIBITED - 1987-88, *Clive Barker: Portraits,* National Portrait Gallery,
London and tour, cat.58, ill.

213. *Linda's Medal,* 1987

Bronze with brown patina
Approximately 2 1/2 in / 6.4 cm diameter

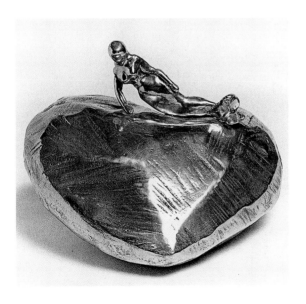

214. *For Linda,* 1987

Polished aluminium
8 5/8 in / 21.9 cm high

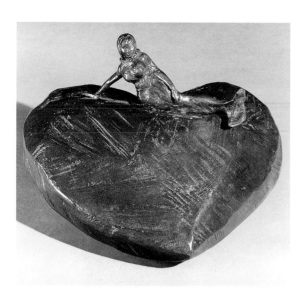

215. *Mermaid on Heart*, 1987

Bronze with brown patina
9 in / 23 cm high

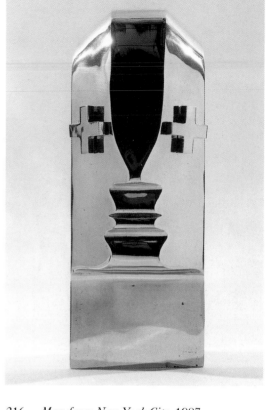

216. *Man from New York City*, 1987

Polished bronze
Edition of 3
1 A/P
12 5/8 in / 32.1 cm high

EXHIBITED - 1987-88, *Clive Barker: Portraits*, National Portrait
Gallery, London and tour, cat.57, ill.

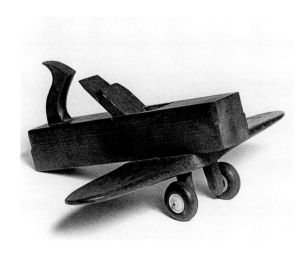

217. *Jack's Plane*, 1987-95

Mixed media
7 3/4 x 22 x 17 in / 19.7 x 56 x 43.2 cm

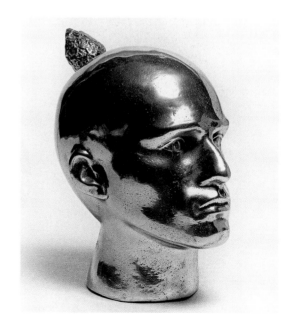

218. *Man Hit by Piece of Halley's Comet*, 1987

Polished aluminium and bronze ex foundry
11 1/8 in / 28.3 cm high

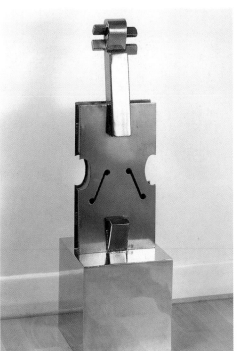

219. *Small Violin*, 1987
Polished aluminium
32 in / 81.3 cm high

220. *Cubist Violin*, 1988
Bronze and steel ex foundry
60 in / 152.4 cm high

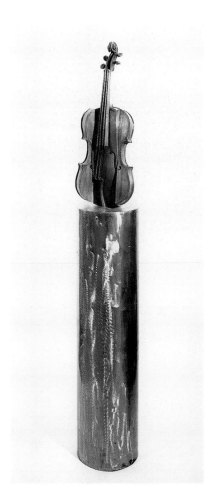

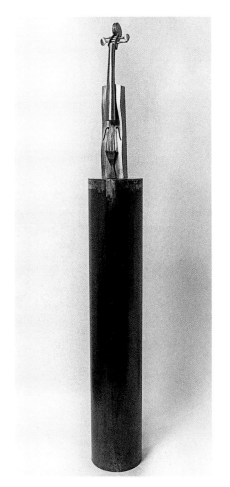

221. *Violin No. 2*, 1988
Polished brass and
graphite on steel
74 in / 188 cm high

222. *Violin No. 3*, 1988
Rusted steel
58 in / 147.3 cm high

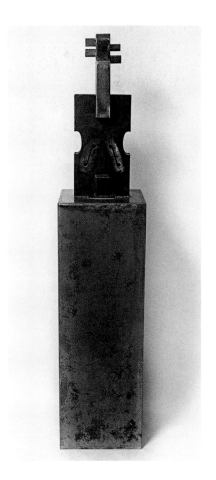

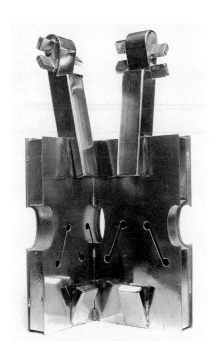

223. *Two Violins*, 1988
Polished steel
22 in / 56 cm high

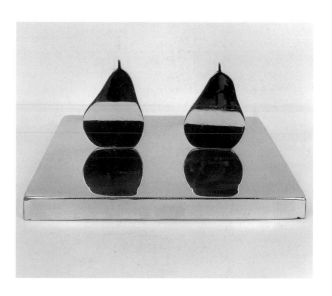

224. *Two Pears (Stainless Steel)*, 1988
Polished stainless steel
5 1/2 x 12 x 12 in / 14 x 30.5 x 30.5 cm

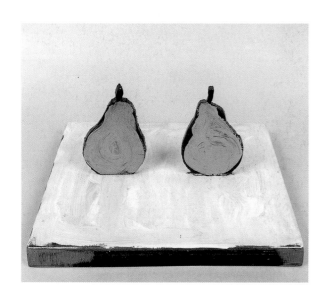

225. *Two Green Pears*, 1988
Painted steel
5 1/2 x 12 x 12 in / 14 x 30.5 x 30.5 cm

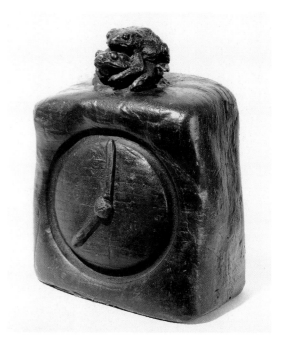

226. *Linda's Clock 7 P.M. 30th January 1988*, 1988
Bronze with brown patina
8 x 6 x 3 1/2 in / 20.3 x 15.2 x 8.9 cm

227. *Linda's Tall Clock*, 1988

Bronze with dark brown patina and rusted steel
60 in / 152.4 cm high

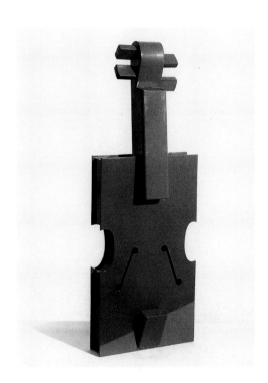

228. *Little House in Arizona*, 1988

Polished aluminium and polished brass
2 1/2 x 12 1/4 x 10 7/8 in / 6.4 x 31.1 x 27.6 cm

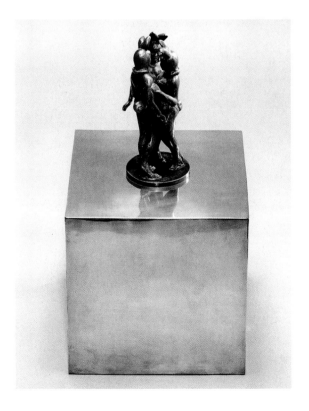

229. *The Three Graces (In a Playboy Style)*, 1988-99

Polished bronze and bronze with brown patina
16 in / 40.7 cm high

230. *The Red Violin for Linda Kilgore*, 1989

Painted steel
22 x 8 x 1 3/4 in / 56 x 20.3 x 4.5 cm

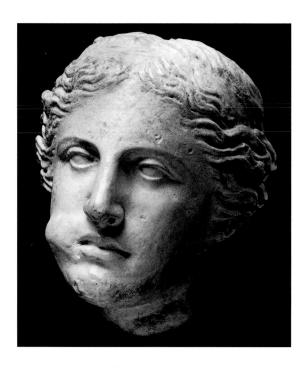

231. *Venus with Tongue in Cheek*, 1990

Bronze with green patina
11 in / 28 cm high

Exhibited - 1991, *Objects for the Ideal Home: The Legacy of Pop Art*,
Serpentine Gallery, London, p.34, ill.

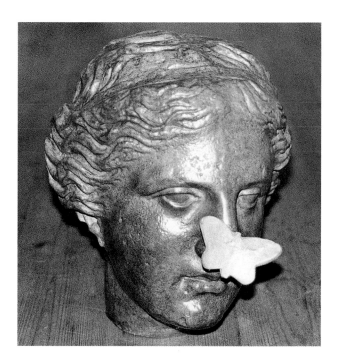

232. *Venus with Butterfly*, 1990

Edition of 3 in bronze with green patina
Study in polished aluminium and polished bronze
11 in / 28 cm high

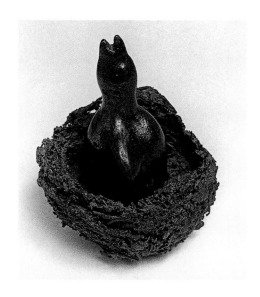

233. *Little Bird in His Nest*, 1990

Bronze with brown patina
5 3/16 in / 13.2 cm high

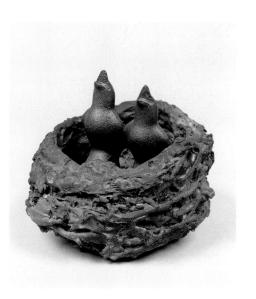

234. *Twins*, 1990

Bronze with brown patina
4 3/4 in / 12.1 cm high

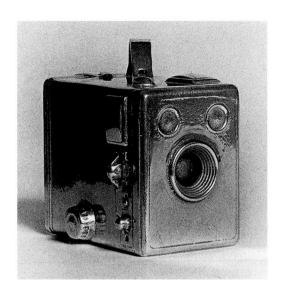

235. *Box Camera*, 1990

Polished aluminium
5 x 3 ¹/₄ x 4 ¹/₂ in / 12.7 x 8.3 x 11.5 cm

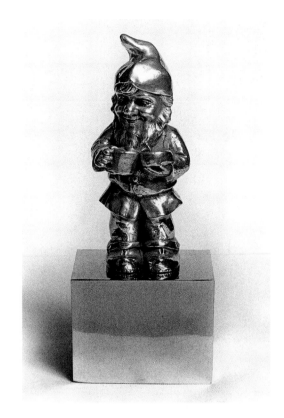

236. *Gnome*, 1990-95

Polished aluminium
Edition of 6
3 A/P
18 ¹/₂ in / 47 cm high

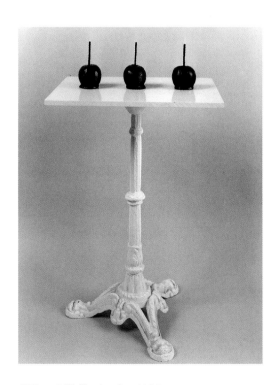

237. *3 Toffee Apples*, 1992

Bronze with brown patina and painted cast iron
32 ¹/₂ in / 82.6 cm high

EXHIBITED - 1992, *Summer Exhibition*, Royal Academy of Arts, London, exhibit 27.

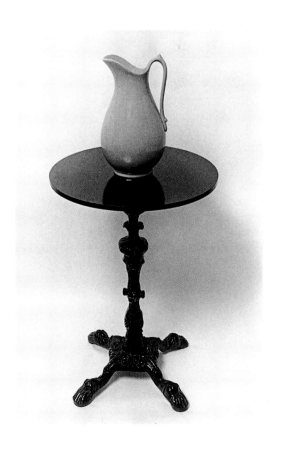

238. *Table with Yellow Jug*, 1992
Painted bronze and painted cast iron
40 in / 101.6 cm high

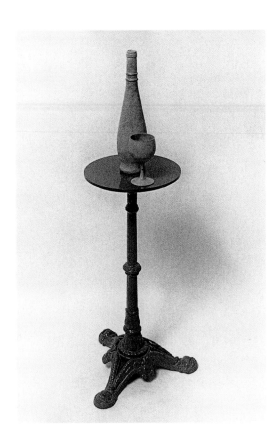

239. *Table with Bottle and Glass*, 1992-93

Bronze with green patina and painted cast iron
40 in / 101.6 cm high

240. *Table with Brushes (F.B.)*, 1992-93

Bronze with dark brown patina and painted
cast iron
41 1/2 in / 105.4 cm high

EXHIBITED - 1994, *Summer Exhibition*, Royal Academy of
Arts, London, exhibit 879 (brushes shown without table, as
edition of 6).

241. *Vase with Flower and Snail*, 1992

Bronze with green-blue and brown patina
15 in / 38 cm high

EXHIBITED - 1993, *Summer Exhibition*, Royal Academy of Arts,
London, exhibit 1745.

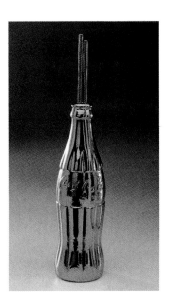

242. *Gold Coke*, 1992

Gold plated bronze
Edition of 40 (only 9 cast)
10 5/8 in / 27 cm high
With wooden presentation box

EXHIBITED - 1993, *The Fab Year Show*, Independent
Editions, Business Design Centre, London.

243. *Study for a Monument to Francis Bacon*, 1992

Polished bronze
Edition of 3
12 in / 30.5 cm high

244. *Study for Monument for Luton (Elephant)*, 1993

Polished steel
8 in / 20.3 cm high

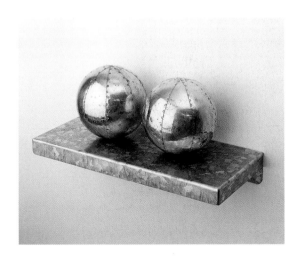

245. *Balls*, 1993

Silver, polished brass and zinc
4 3/4 in / 12.1 cm high

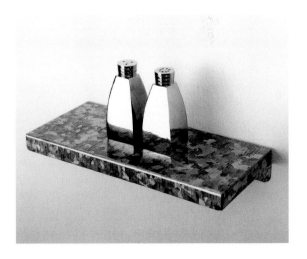

246. *Salt & Pepper*, 1993

Polished stainless steel and zinc
Edition of 3
4 1/4 in / 11.8 cm high

247. *2 Candlesticks*, 1993

Polished aluminium and zinc
10 ³/8 in / 26.3 cm high

248. *Game*, 1993

Polished aluminium
20 in / 50.8 cm tall; 11 in / 28 cm wide

249. *Flower in Jug*, 1995

Polished aluminium
Edition of 5
16 ¹/2 in / 41.9 cm high

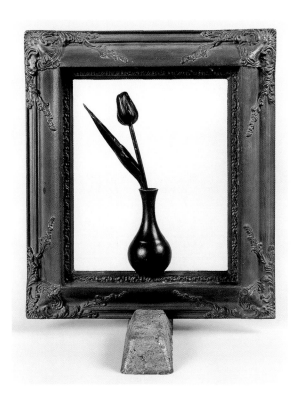

250. *Vase of Flowers in a Frame 1*, 1995

Bronze with brown patina
18 in / 45.7 cm high

EXHIBITED - 2000, *Clive Barker: Recent Work*, Whitford Fine Art,
London, cat. 8, ill.

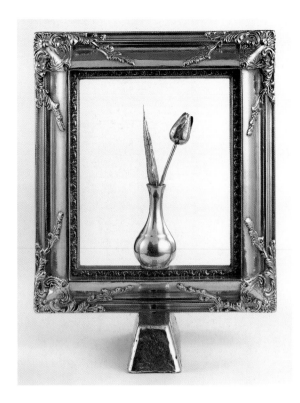

251. *Vase of Flowers in a Frame 2*, 1995
Polished aluminium
18 1/8 in / 46.1 cm high

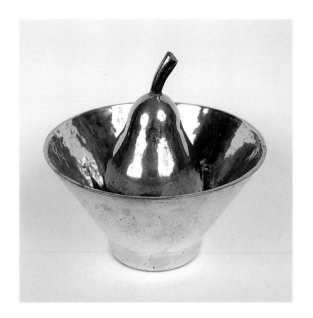

252. *Fruit Bowl and Pear*, 1995
Polished bronze
10 in / 25.4 cm high; 10 1/4 in / 26 cm diameter

EXHIBITED - 2000, *Clive Barker: Recent Work*, Whitford Fine Art,
London, cat.21.

253. *Glue Pot*, 1995
Bronze with dark brown patina,
polished bronze and polished brass
17 1/2 in / 44.5 cm high

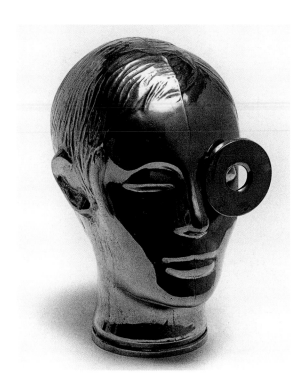

254. *Man with Monocle,* 1995
Polished brass
9 1/2 in / 24.2 cm high

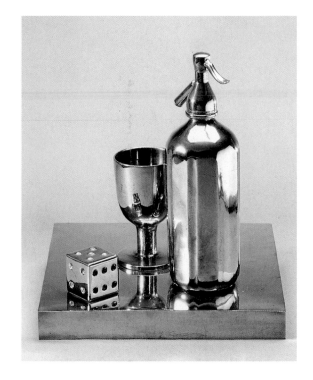

255. *Cubist Still Life 1,* 1995
Polished bronze
13 1/2 in / 34.3 cm high

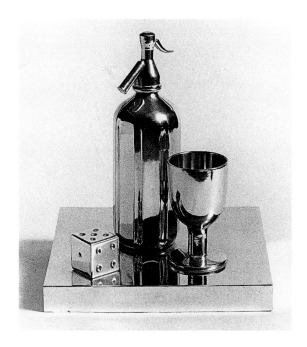

256. *Cubist Still Life 2,* 1995
Polished aluminium
13 5/8 in / 34.6 cm high

257. *Vase and Thistle,* 1995
Polished bronze and bronze ex foundry
16 1/2 in / 41.9 cm high

258. *One Dozen Bottles*, 1995

Polished aluminium
20 3/4 x 9 x 9 in / 52.7 x 23 x 23 cm

259. *Flying Ducks*, 1995

Polished aluminium
Edition of 6
2 A/P
Largest duck 8 3/8 in / 21.3 cm long

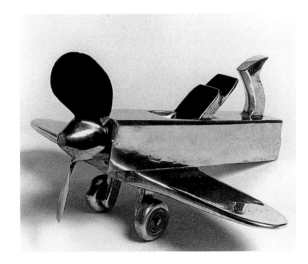

260. *Jack's Plane - 2*, 1995

Polished aluminium and polished brass
11 1/4 x 21 5/8 x 19 1/4 in / 28.6 x 55 x 48.9 cm

261. *Figure (Fragment)*, 1995

Polished bronze
Edition of 9
3 A/P
1 Study
4 1/2 in / 11.5 cm high

262. *Girl and Her Pussy*, 1995-96

Polished bronze
Edition of 4
1 A/P
8 ³/4 in / 22.2 cm high

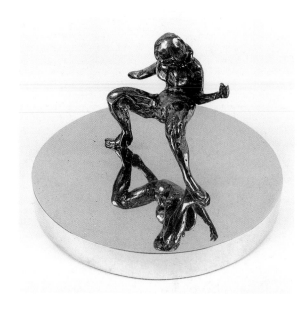

263. *Dancer*, 1995-96

Polished bronze
5 in / 12.7 cm high; 7 ¹³/16 in / 19.8 cm diameter

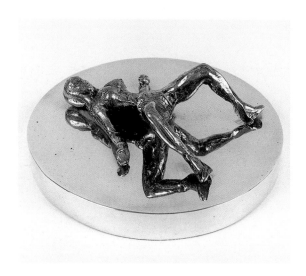

264. *Study for a Sunbather 1*, 1995-96

Polished bronze
2 ¹/2 in / 6.4 cm high; 7 ¹³/16 in / 19.8 cm diameter

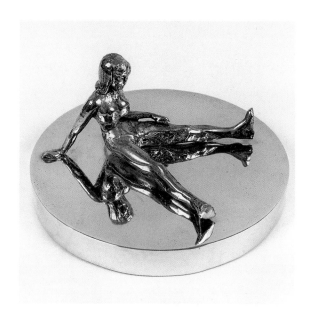

265. *Study for a Sunbather 2*, 1995-96

Polished bronze
4 ¹/8 in / 10.5 cm high; 7 ¹³/16 in / 19.8 cm diameter

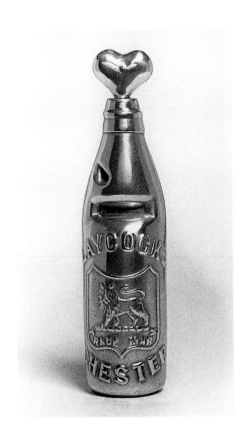

266. *For a Girl*, 1995

Polished aluminium

10 $^1/_2$ in / 26.7 cm high

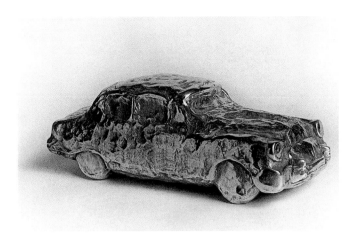

267. *Old Buick*, 1995

Polished aluminium

Edition of 3

3 $^1/_2$ x 11 $^1/_2$ x 4 $^1/_4$ in / 8.9 x 29.2 x 10.8 cm

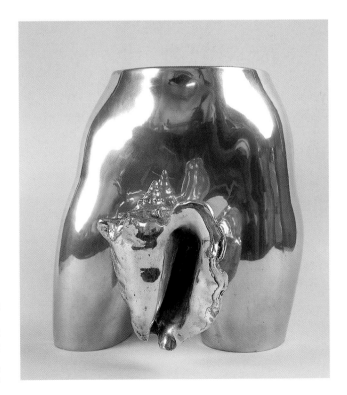

268. *Foxy Lady*, 1995-99

Polished aluminium

14 $^1/_2$ in / 36.8 cm high

EXHIBITED - 2000, *Clive Barker: Recent Work*,
Whitford Fine Art, London, cat.14, ill. (as 'Foxy Woman').

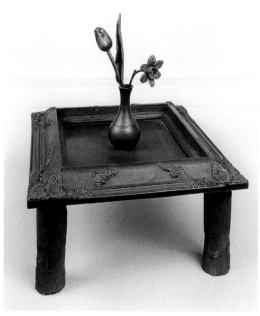

269. *Flowers on a Table*, 1996

Bronze with brown patina
17 1/4 x 17 1/8 x 15 1/4 in / 43.8 x 43.5 x 38.7 cm

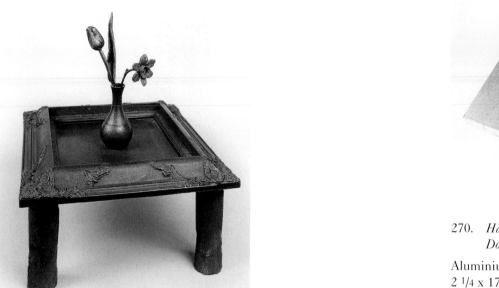

270. *Hampstead Paving Stone &*
 Dogshit for Tad, 1996

Aluminium ex foundry and bronze ex foundry
2 1/4 x 17 3/4 x 14 3/4 in / 5.7 x 45.1 x 37.5 cm

272. *Cup of Tea*, 1996-99

Polished aluminium
6 1/4 x 11 3/4 x 11 3/4 in / 15.9 x 29.9 x 29.9 cm

271. *Flower & Jug on Stool*, 1996-97

Polished aluminium
33 in / 83.8 cm high

273. *Bottle and Butterfly*, 1996
Polished aluminium
9 ³/4 in / 24.8 cm high

274. *For Katie*, 1996
Polished aluminium
10 in / 25.4 cm high

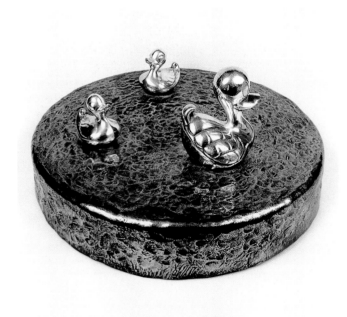

275. *Duck Pond*, 1996
Polished aluminium and bronze with brown patina
19 ¹/8 in / 48.6 cm diameter

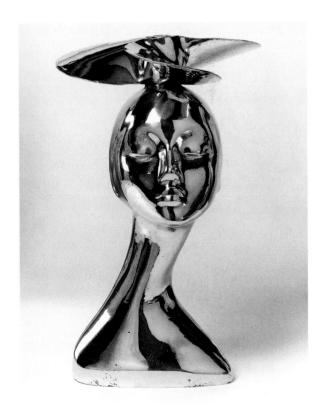

276. *Woman with Strange Hat (Ascot)*, 1996
Polished brass
17 ¹/2 in / 44.5 cm high

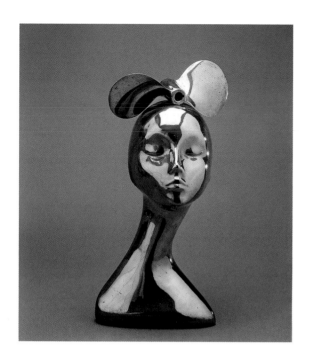

277. *Girl with Bow in Her Hair,* 1996
Polished brass
17 1/2 in / 44.5 cm high

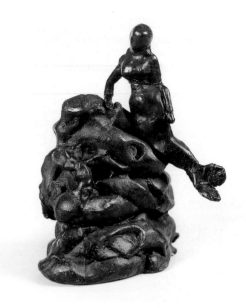

278. *Siren,* 1996
Bronze with brown and green-brown patina
8 7/8 in / 22.6 cm high

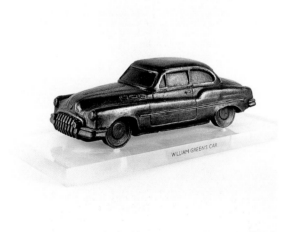

279. *William Green's Car,* 1996
Bronze with brown patina and perspex
4 1/4 x 13 5/16 x 6 in / 10.8 x 33.8 x 15.2 cm

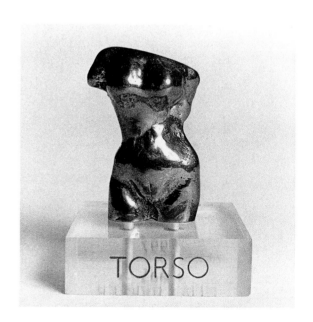

280. *Torso,* 1997
Polished bronze and perspex
3 1/4 in / 8.3 cm high

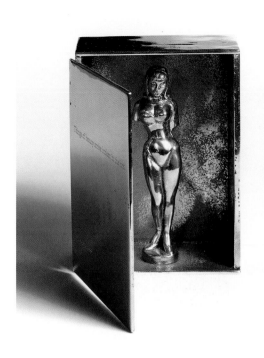

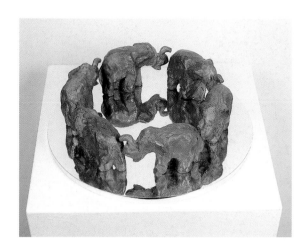

282. *6 Elephants*, 1997

Bronze ex foundry and polished aluminium
3 15/16 in / 10 cm high; 14 15/16 in / 38 cm diameter

281. *Things of Beauty Arrive Broken in the Box*, 1997

Polished bronze
7 3/4 x 5 3/4 x 3 in / 19.7 x 14.6 x 7.6 cm

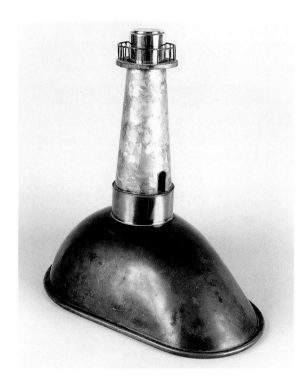

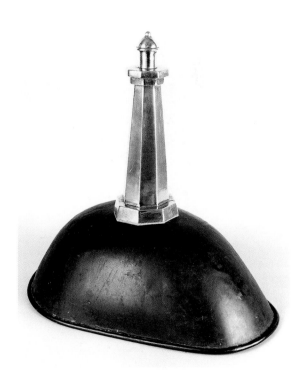

283. *Lighthouse on a Rock No. 1*, 1997

Copper, galvanised steel and polished aluminium
16 in / 40.7 cm high

284. *Lighthouse on a Rock No. 2*, 1997

Polished aluminium and polished brass
16 1/2 in / 41.9 cm high

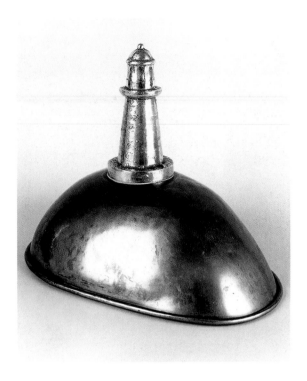

285. *Lighthouse on a Rock No. 3*, 1997
Polished aluminium and polished brass
12 ³/4 in / 32.4 cm high

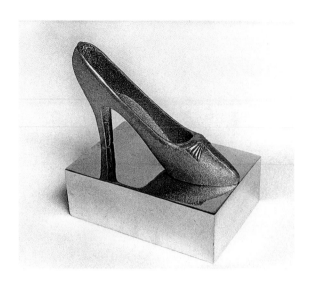

286. *For Cinderella*, 1997
Polished aluminium
6 x 5 ¹⁵/₁₆ x 4 in / 15.2 x 15.1 x 10.2 cm

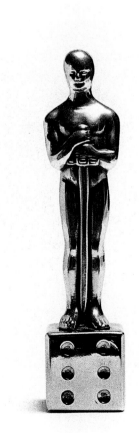

288. *Twin Ducks*, 1997
Polished aluminium
5 ¹/2 in / 14 cm high

EXHIBITED - 1998, *Twin Images*, The Fine Art Society, London, cat. 4, ill.

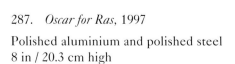

287. *Oscar for Ras*, 1997
Polished aluminium and polished steel
8 in / 20.3 cm high

289. *Stove and Coffee Pot*, 1997

Polished brass, polished aluminium
and cast iron
32 in / 81.3 cm high

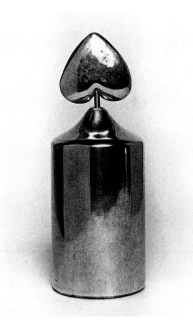

290. *Candle in the Wind*, 1997

Polished aluminium
8 1/4 in / 21 cm high

291. *For Barry*, 1997

Polished aluminium
15 3/4 in / 40 cm high

292. *Western Still Life*, 1997

Mixed media
10 5/8 in / 27 cm high; 15 3/4 in / 40 cm diameter

293. *My Rabbit*, 1997

3 ³/8 in / 8.6 cm high; 7 ¹/16 in / 18 cm long
Polished aluminium
Edition of 9
3 A/P
1 Study

EXHIBITED - 2000, *Clive Barker: Recent Work*, Whitford Fine Art, London, cat. 22.

294. *Frightened Teddy*, 1998

Mixed media
19 ¹¹/16 x 13 x 39 ³/8 in / 50 x 33 x 100 cm

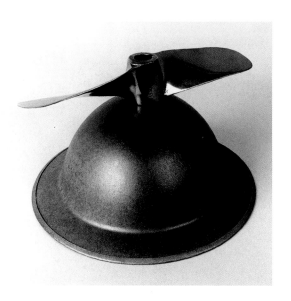

295. *Helicopter Helmet*, 1998

Mixed media
6 ¹/2 in / 16.5 cm high

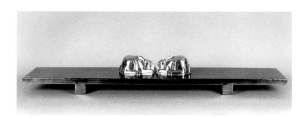

296. *Two Rabbits*, 1998

Polished aluminium and polished steel
6 ¹¹/16 x 8 ⁷/8 x 49 ⁵/8 in / 17 x 22.5 x 126 cm

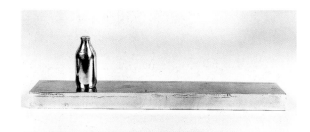

297. *Milk on Doorstep (1 Pint Please)*, 1998

Polished aluminium
Edition of 3
9 ³/8 x 35 ¹¹/16 x 5 ⁵/8 in / 23.8 x 90.6 x 14.3 cm

298. *Helmet 1*, 1998

Polished aluminium
11 in / 28 cm high

EXHIBITED - 2000, *Clive Barker: Recent Work*, Whitford Fine Art,
London, cat.1, ill.

299. *Helmet 2*, 1998

Polished aluminium
16 in / 40.7 cm high

EXHIBITED - 2000, *Clive Barker: Recent Work*, Whitford Fine Art,
London, cat.5, ill.

300. *Helmet 3*, 1998

Polished aluminium
14 in / 35.6 cm high

EXHIBITED - 2000, *Clive Barker: Recent Work*, Whitford Fine Art,
London, cat.6, ill.

301. *Helmet 4*, 1998

Polished aluminium
13 1/4 in / 33.7 cm high

EXHIBITED - 2000, *Clive Barker: Recent Work*, Whitford Fine Art,
London, cat.15, ill.

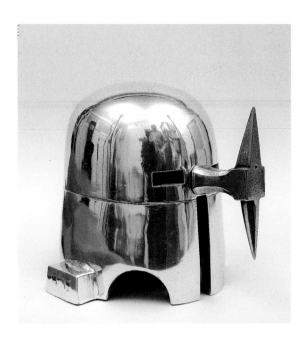

302. *Helmet 5*, 1998

Polished aluminium
8 3/4 in / 22.2 cm high

Exhibited - 2000, *Clive Barker: Recent Work*, Whitford Fine Art, London, cat.19, ill.

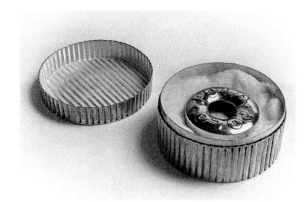

303. *Polo Box*, 1998

Polished aluminium and silver plate
2 1/8 in / 5.4 cm high; 3 13/16 in / 9.7 cm diameter

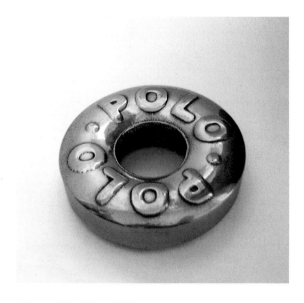

304. *Polo Mint*, 1998

2 in polished aluminium
1 in polished bronze ('For Marco')
2 1/4 in / 5.7 cm diameter (aluminium)

305. *Lemon and Coffee Pot*, 1998

Polished aluminium
Edition of 3
9 9/16 x 17 3/4 x 14 13/16 in / 24.3 x 45.1 x 37.6 cm

152

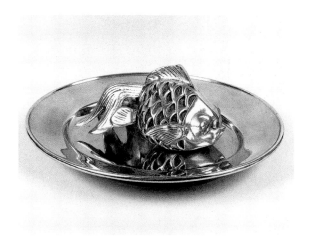

306. *Fish on a Plate*, 1998
Polished aluminium
21 1/4 x 16 3/4 in / 54 x 42.6 cm oval

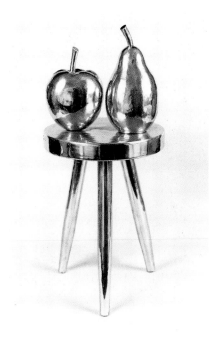

307. *Apple and Pear*, 1998
Polished aluminium
25 1/2 in / 64.8 cm high

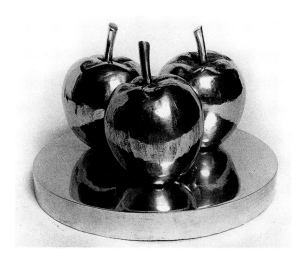

308. *3 Apples*, 1998
Polished aluminium
9 1/2 in / 24.2 cm high; 14 5/8 in / 37.2 cm diameter

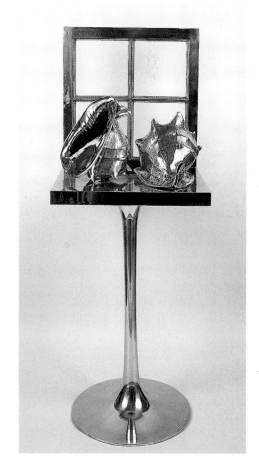

309. *Still Life (2 Shells Against a Window)*, 1998

Polished aluminium
46 1/4 in / 117.5 cm high

EXHIBITED - 2000, *Clive Barker: Recent Work*,
Whitford Fine Art, London, cat.9, ill.

310. *Soda Bread*, 1998
Polished aluminium
7 ¹/₂ in / 19 cm diameter

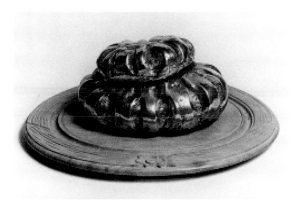

311. *Cottage Loaf*, 1998
Polished aluminium and wood
4 ¹/₂ in / 11.5 cm high; 11 ³/₄ in / 29.9 cm diameter

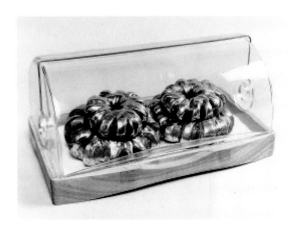

312. *2 Cottage Loaves*, 1998
Mixed media
7 ¹/₈ x 15 ⁵/₁₆ x 8 ⁵/₈ in / 18.1 x 38.9 x 21.9 cm

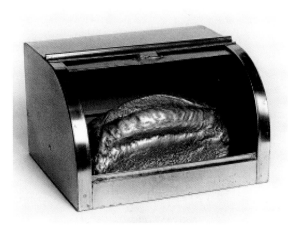

313. *Large Loaf*, 1998-99
Polished aluminium and stainless steel, partly painted
7 x 12 x 10 in / 17.8 x 30.5 x 25.4 cm

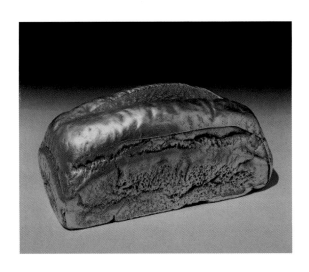

314. *Bread and Bread Bin*, 1998
Mixed media
Bread 9 ⁷/₁₆ in / 24 cm long
(illustrated without the bread bin)

154

315. *Ladybird*, 1998
Polished aluminium and aluminium ex foundry
6 1/8 in / 15.5 cm long

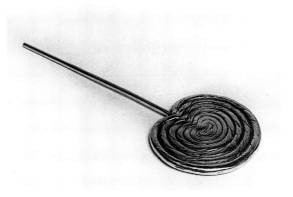

316. *Lollipop*, 1998
Polished aluminium
Edition of 6
18 1/4 in / 46.4 cm long

EXHIBITED - 2000, *Clive Barker: Recent Work*, Whitford Fine Art, London, cat.23.

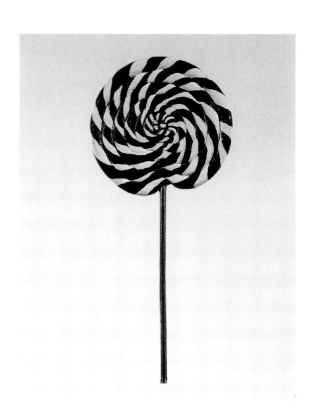

317. *Painted Lolly – Red*, 1998
Painted aluminium
18 1/4 in / 46.4 cm long

Photograph unavailable

318. *Painted Lolly – Yellow*, 1998
Painted aluminium
18 1/4 in / 46.4 cm long

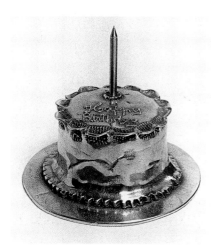

319. *Happy Birthday*, 1998
Polished aluminium
4 3/4 in / 12.1 cm high; 5 15/16 in / 15.1 cm diameter

155

320. *Posy*, 1998

Polished aluminium

4 5/16 in / 11 cm high

321. *Dogs Dinner*, 1998

Mixed media
Edition of 3
1 A/P
2 3/4 in / 7 cm high; 9 7/8 in / 25.1 cm diameter

322. *For a Lucky Dog*, 1998

Mixed media
4 3/8 x 13 3/4 x 8 1/16 in / 11.1 x 35 x 20.5 cm

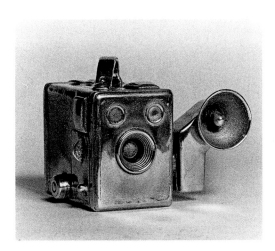

323. *Box Camera and Flash*, 1998

Polished aluminium
Edition of 2
1 Study
5 x 6 1/4 x 4 1/2 in / 12.7 x 15.9 x 11.5 cm

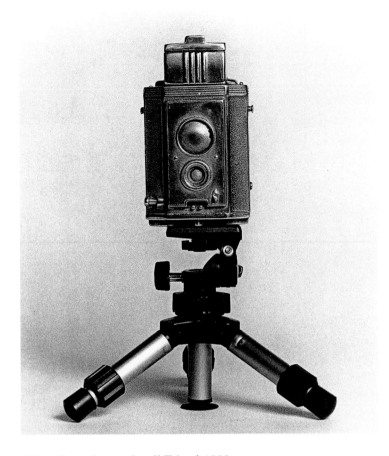

324. *Brownie on a Small Tripod*, 1998
Mixed media
12 in / 30.5 cm high

325. *Mobile for Ras*, 1998
Polished aluminium
8 ¹/₂ x 2 ¹/₄ x 2 ¹/₂ in / 21.6 x 5.7 x 6.4 cm

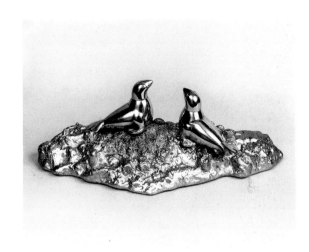

326. *Seal Island*, 1998
Polished aluminium and aluminium ex foundry
14 ³/₄ in / 37.5 cm long; 4 ²³/₃₂ in / 12.5 cm high

327. *Mervyn's Stick*, 1998
Polished aluminium
2 uneditioned works
32 in / 81.3 cm long

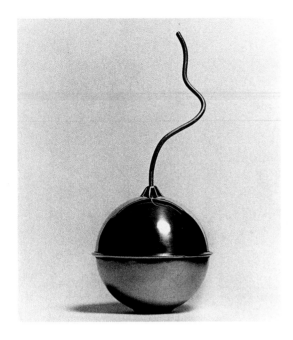

328. *Bomb*, 1998

Polished aluminium and polished brass
Edition of 8
2 A/P
1 Study
10 1/2 in / 26.7 cm high

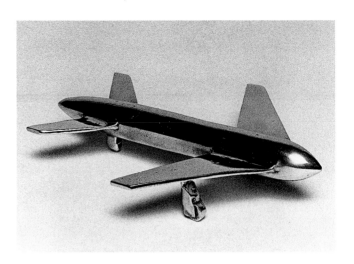

329. *Bomber*, 1998

Polished aluminium
Edition of 3
8 3/8 in / 21.3 cm long

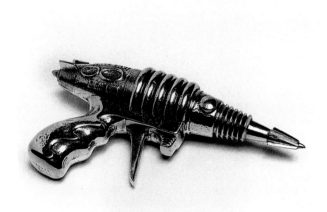

330. *Space Pilot X-Ray Gun*, 1998

Edition of 9 in polished aluminium
Edition of 3 in polished bronze
3 A/P in polished bronze
8 1/2 in / 21.6 cm long

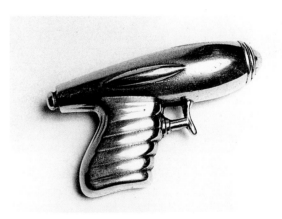

331. *Small Ray Gun*, 1998

Polished aluminium
Edition of 50
3 A/P
4 1/2 in / 11.5 cm long

333. *Football*, 1998

Polished aluminium
Edition of 6
2 A/P
8 1/16 in / 20.5 cm high

332. *Peanut Man*, 1998

Polished aluminium
Edition of 6
3 A/P
1 Study
11 in / 28 cm high

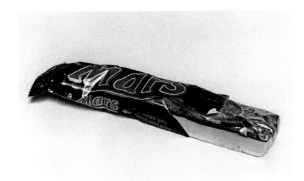

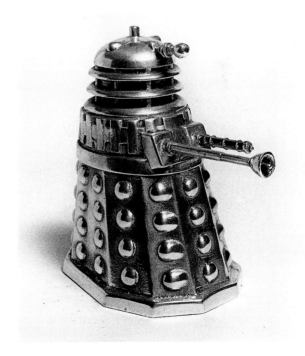

334. *Mars Bar*, 1998

Polished aluminium
Edition of 9
3 A/P
1 Study
7/8 x 4 x 1 1/4 in / 2.2 x 10.2 x 3.2 cm

335. *Dalek*, 1998

Polished aluminium
Edition of 6
1 Prototype
1 Study
6 1/8 in / 15.6 cm high

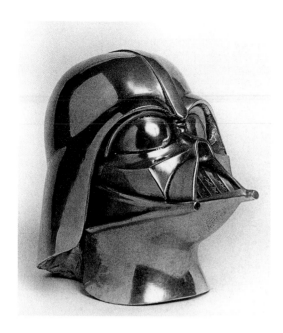

336. *Head of Darth Vader*, 1998

Polished aluminium
Edition of 6
3 A/P
11 3/4 in / 29.9 cm high

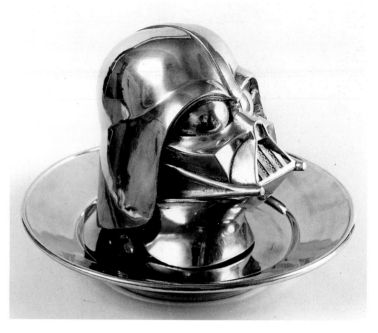

337. *Bring Me the Head of Darth Vader*, 1998

Polished aluminium
12 1/2 in / 31.8 cm high; 17 3/4 in / 45.1 cm diameter

EXHIBITED - 2000, *Clive Barker: Recent Work*, Whitford Fine Art, London, cat.7, ill.

338. *Mask for Ras*, 1998

Polished aluminium
6 1/8 in / 15.6 cm wide

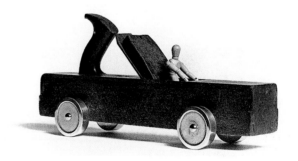

339. *Riding Along in my Automobile*, 1998

Mixed media
7 3/4 x 17 x 4 1/2 in / 19.7 x 43.2 x 11.5 cm

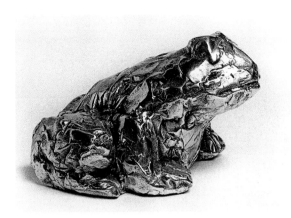

340. *Frog for Ras*, 1998-99

Polished aluminium
5 3/4 in / 14.6 cm high

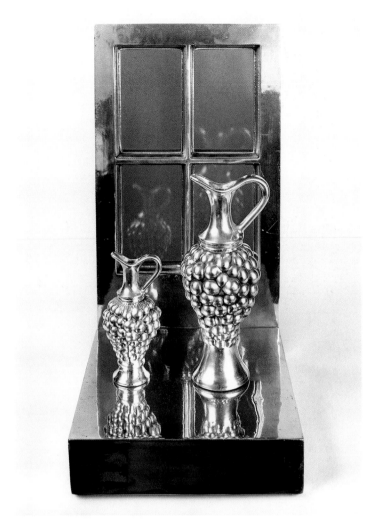

341. *2 Jugs Against a Blue Window*, 1998-2000

Polished aluminium and blue glass
21 3/4 x 13 1/2 x 11 3/4 in / 55.3 x 34.3 x 29.9 cm

EXHIBITED - 2000, *Clive Barker: Recent Work*, Whitford Fine Art, London, cat.16, ill.

342. *Emperor Dalek*, 1999

Polished bronze
Edition of 9
3 A/P
6 1/8 in / 15.6 cm high

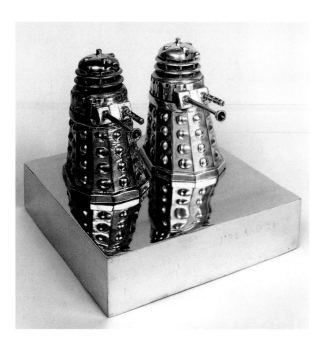

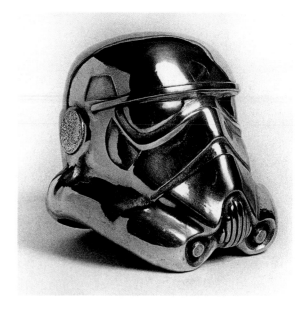

343. *The Emperor & His Wife*, 1999

Polished aluminium and polished bronze
Edition of 9
3 A/P
8 5/8 x 9 13/16 x 9 13/16 in / 21.9 x 24.9 x 24.9 cm

344. *Storm Trooper*, 1999

Polished aluminium
Edition of 6
10 in / 25.4 cm high

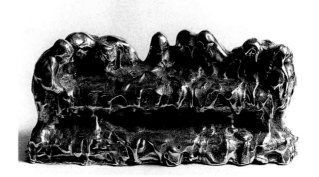

345. *Light Sabre*, 1999

Polished aluminium
2 uneditioned works
35 5/8 in / 90.5 cm long

346. *The Lost Supper*, 1999

Polished aluminium
7 1/8 x 13 3/4 x 4 3/4 in / 18.1 x 35 x 12.1 cm

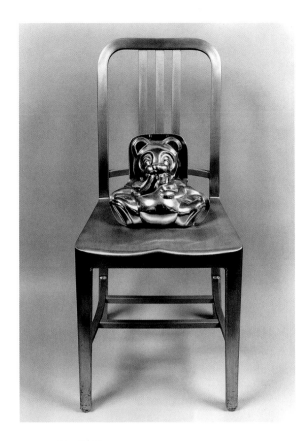

347. *My Teddy*, 1999

Polished and brushed aluminium
33 ³/4 in / 85.7 cm high

Exhibited - 2000, *Clive Barker: Recent Work*, Whitford Fine Art, London, cat.17, ill.

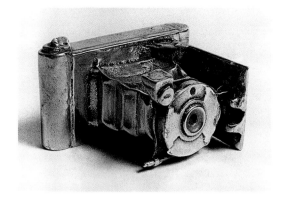

348. *Mallory's Camera*, 1999

Polished aluminium
2 ³/4 x 4 x 4 ³/4 in / 7 x 10.2 x 12.1 cm

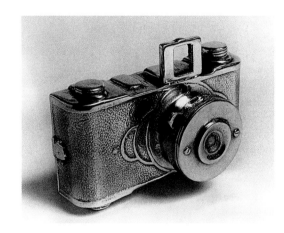

350. *Falcon*, 1999

Polished aluminium
3 ¹/2 x 5 ¹/4 x 2 ¹/4 in / 8.9 x 13.4 x 5.7 cm

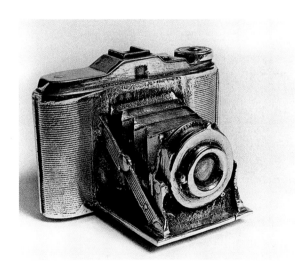

349. *Agfa*, 1999

Polished aluminium
3 ³/4 x 5 ³/4 x 3 ³/4 in / 9.5 x 14.6 x 9.5 cm

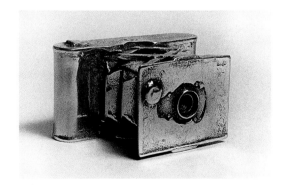

351. *Kodak*, 1999

Polished aluminium
2 ¹⁵/16 x 3 ⁹/16 x 2 ³/4 in / 7.5 x 9.1 x 7 cm

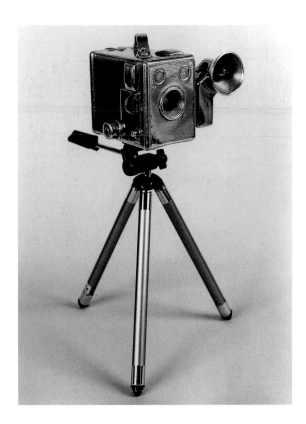

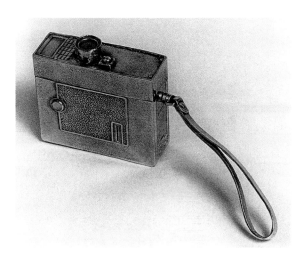

353. *Cine Camera*, 1999

Polished aluminium
Edition of 3
1 Study
11 5/8 in / 29.5 cm high

352. *Box Camera & Flash on Tripod*, 1999

Mixed media
14 3/4 in / 37.5 cm high

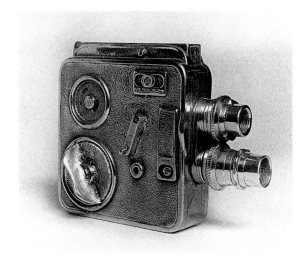

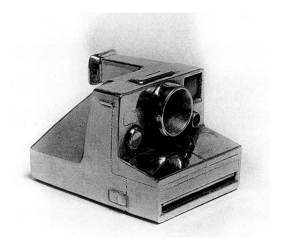

355. *Tad's Camera*, 1999

Polished aluminium
3 3/4 x 4 1/8 x 5 1/2 in / 9.5 x 10.5 x 14 cm

354. *Cine Camera - 2*, 1999

Polished aluminium
5 1/2 x 2 9/16 x 7 1/2 in / 14 x 6.5 x 19 cm

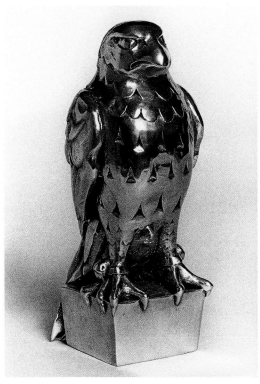

356. *Maltese Falcon*, 1999

Polished aluminium
Edition of 6
3 A/P
1 Study
1 Study in polished bronze
11 ³/4 in / 29.9 cm high

357. *My Magnum*, 1999

Polished aluminium
7 ³/4 in / 19.7 cm long

359. *Agent 007*, 1999

Polished aluminium
Edition of 9
3 A/P
1 Study
1 unique in polished ali bronze
1 unique in polished bronze
5 ³/4 in / 14.6 cm long

358. *My Webley*, 1999

Polished aluminium
Edition of 9
3 A/P
8 ⁵/8 in / 21.9 cm long

360. *For All My Western Heroes*, 1999
Polished aluminium
Edition of 3
12 ¹/4 in / 31.1 cm long

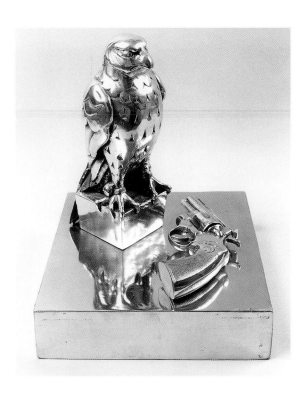

361. *The Maltese Falcon and a Magnum*, 1999

Polished aluminium
14 1/2 x 11 3/4 x 11 7/8 in
36.8 x 29.9 x 30.2 cm

EXHIBITED - 2000, *Clive Barker: Recent Work*, Whitford Fine Art, London, cat.13, ill.

362. *Study for Trophy*, 1999

Polished aluminium
13 3/8 in / 34 cm high

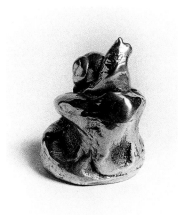

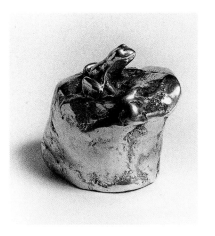

363. *Gavel for Graham*, 1999

Polished aluminium
(4 3/4 in / 12.1 cm high)

364. *Gavel for J.R.*, 1999

Polished aluminium
2 3/4 in / 7 cm high

365. *Gavel with Frog*, 1999

Polished aluminium
2 1/2 in / 6.4 cm high

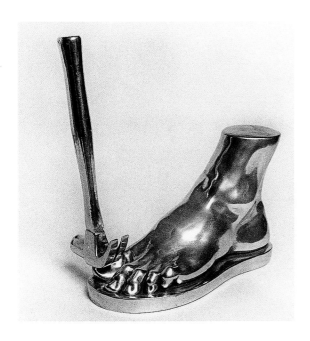

366. *Ouch*, 1999
Polished aluminium
Edition of 2
14 1/2 in / 36.8 cm high

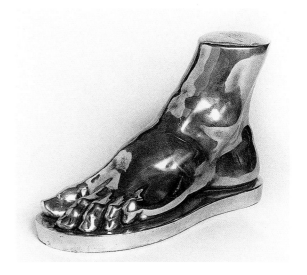

367. *Foot in the Door (Doorstop)*, 1999
Polished aluminium
Edition of 2
13 1/4 in / 33.7 cm long

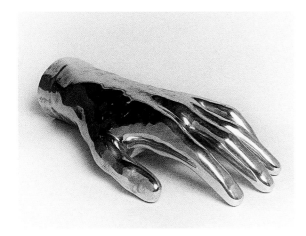

368. *Chopin Hand*, 1999
Polished aluminium
Edition of 2
8 5/8 in / 21.9 cm long

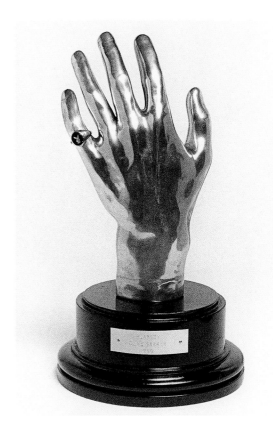

369. *Playboy*, 1999
Polished aluminium and painted wood
11 13/16 in / 30 cm high

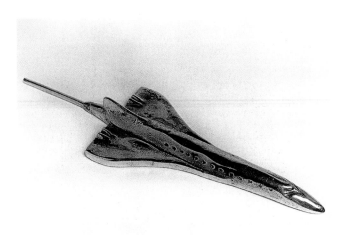

370. *Concorde Lolly*, 1999

Polished aluminium
18 ¹/₂ in / 47 cm long

Exhibited - 2000, *Clive Barker: Recent Work*, Whitford Fine Art, London, cat.25.

371. *New York Lolly*, 1999

Polished aluminium
14 in / 35.6 cm long

Exhibited - 2000, *Clive Barker: Recent Work*, Whitford Fine Art, London, cat.24.

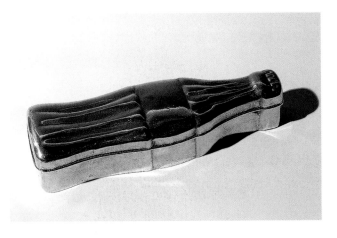

372. *New York Gift*, 1999

Polished aluminium
9 ¹/₄ in / 23.5 cm long

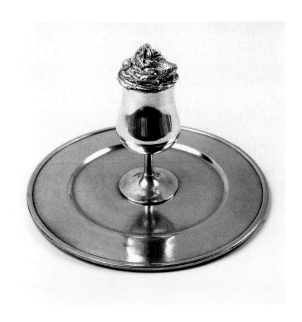

373. *Ice Cream Sundae*, 1999

Polished aluminium and pewter
8 ¹/₂ in / 21.6 cm high; 12 ³/₄ in / 32.4 cm diameter

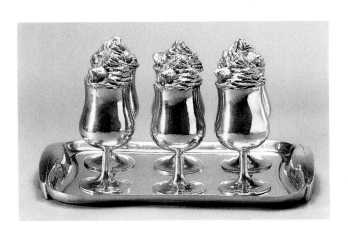

374. *Six Ice Cream Sundaes*, 1999

Polished aluminium
8 ¹/₄ x 16 ³/₄ x 10 ³/₄ in / 21 x 42.6 x 27.3 cm

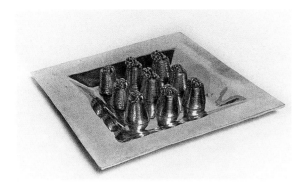

375. *9 Walnut Whips*, 1999

Polished aluminium
2 1/2 x 13 x 13 in / 6.4 x 33 x 33 cm

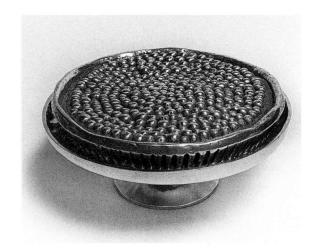

376. *Blueberry Flan*, 1999

Polished aluminium
Edition of 3
4 5/8 in / 11.8 cm high; 10 5/8 in / 27 cm diameter

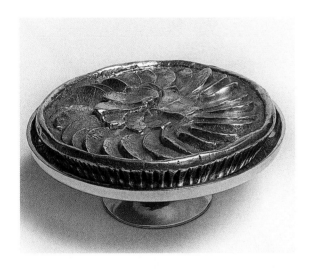

377. *Apple Flan*, 1999

Polished aluminium
Edition of 3
4 7/16 in / 11.3 cm high; 10 5/8 in / 27 cm diameter

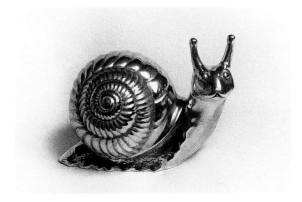

378. *Snail for Tad*, 1999

Polished aluminium
6 1/4 x 9 x 5 1/2 in / 15.9 x 23 x 14 cm

379. *Dennis the Menace*, 1999

Polished aluminium
Edition of 9
3 A/P
9 5/8 in / 24.5 cm high; 6 7/8 in / 17.5 cm diameter

380. *Superman*, 1999

Edition of 10 in gold-plated brass
3 A/P in polished aluminium and stainless steel
17 ³/₈ in / 44.1 cm high

381. *Spiderman*, 1999

Polished aluminium
Edition of 6
3 A/P
1 Study
20 in / 50.8 cm high

382. *Torso (Female)*, 1999

Polished aluminium
11 ¹/₂ in / 29.2 cm high

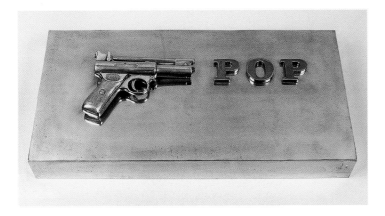

383. *Pop*, 1999

Polished aluminium and polished brass
4 1/2 x 23 3/4 x 11 13/16 in / 11.5 x 60.3 x 30 cm

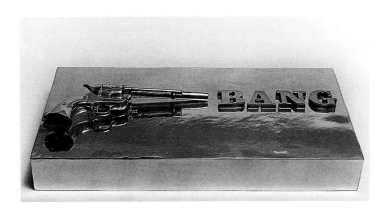

384. *Bang*, 1999

Polished aluminium and polished brass
4 5/8 x 23 3/4 x 11 13/16 in / 11.8 x 60.4 x 30 cm

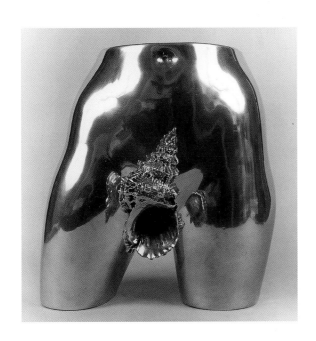

385. *Sexy Lady*, 1999

Polished aluminium
14 1/2 in / 36.8 cm high

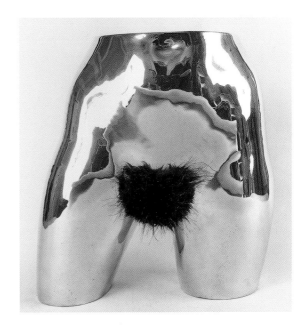

386. *I Thought She Was a Natural Blonde*, 1999-2000

Polished bronze and synthetic fur
14 1/8 in / 35.9 cm high

EXHIBITED - 2000, *Clive Barker: Recent Work*, Whitford Fine Art, London, cat.3, ill.

171

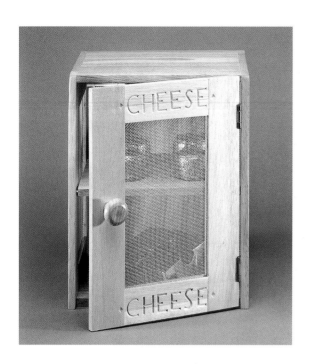

387. *Swiss Emmental, Crottin de Chèvre*, 1999
Mixed media
10 x 8 x 8 in / 25.4 x 20.3 x 20.3 cm

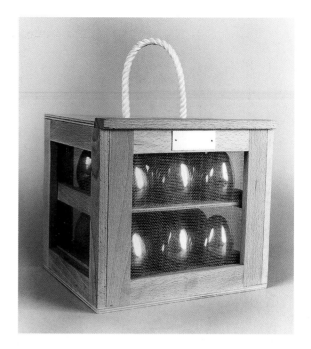

388. *Eggs*, 1999
Mixed media
7 1/2 x 8 5/16 x 7 3/4 in / 19 x 21.1 x 19.7 cm

389. *Egg*, 1999
Polished aluminium and silver plate
4 5/8 in / 11.8 cm high; 7 1/8 in / 18.1 cm diameter

390. *Happy Birthday*, 1999
Polished aluminium
Unnumbered edition of 6
2 9/16 in / 6.5 cm high; 4 in / 10.2 cm diameter

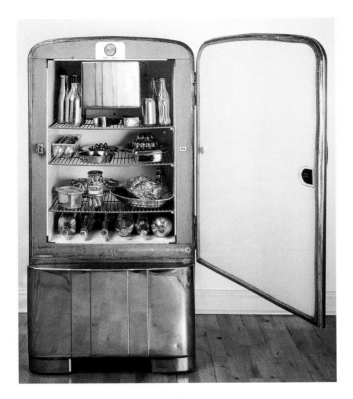

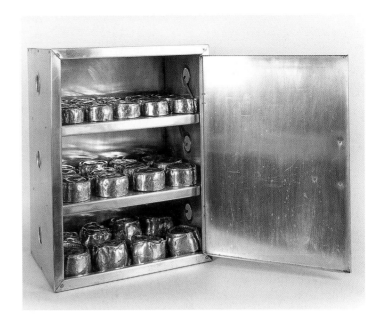

392. *Pork Pies*, 2000

Polished aluminium and copper
22 3/4 x 17 1/4 x 12 in / 57.8 x 43.8 x 30.5 cm

391. *Fridge*, 1999

Mixed media
54 x 28 1/2 x 23 in / 137.2 x 72.4 x 58.4 cm

Berardo Collection, Sintra Museum of Modern Art, Sintra

EXHIBITED - 2000, *Clive Barker: Recent Work*, Whitford Fine Art, London, cat.20, ill.
2001, *Summer Exhibition*, Royal Academy of Arts, London, exhibit 40, cat.ill. p.43.

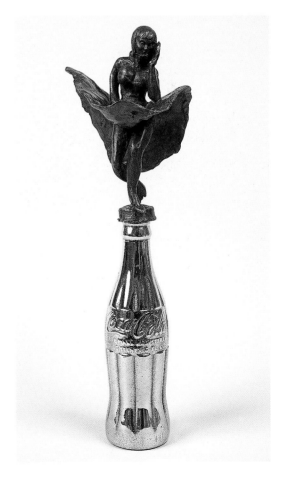

393. *MM*, 2000

Polished bronze and bronze with brown patina
Twelve variations
All approximately 14 1/8 in / 35.9 cm high

EXHIBITED - 2000, *Clive Barker: Recent Work*, Whitford Fine Art,
London, cat.11, 12, ill.

394. *Mickey Mouse,* 2000

Edition of 10 in polished aluminium
1 Prototype in polished aluminium
1 Prototype in polished bronze
18 1/2 in / 47 cm high (aluminium)

EXHIBITED - 2000, *Clive Barker: Recent Work,* Whitford Fine Art,
London, cat.4, ill.

395. *Mickey Mouse Two,* 2000

Polished bronze
Edition of 3
18 3/4 in / 47.6 cm high

396. *Sweets,* 2000

Mixed media
1 1/8 x 7 5/8 x 7 1/2 in / 2.9 x 19.4 x 19 cm

397. *Robodog,* 2000

Polished aluminium
Edition of 6
2 A/P
1 Study
8 1/2 in / 21.6 cm high

EXHIBITED - 2000, *Clive Barker: Recent Work,* Whitford Fine
Art, London, cat.10, ill.

398. *Dulux Dog*, 2000
Polished aluminium
11 7/8 in / 30.2 cm high

EXHIBITED - 2000, *Clive Barker: Recent Work*, Whitford Fine Art,
London, uncatalogued.

399. *Baby's Bottle (Edward)*, 2000
Polished aluminium
9 5/8 in / 24.5 cm long

400. *Baby's Bottle (Tom)*, 2000
Polished bronze
8 5/8 in / 21.9 cm long

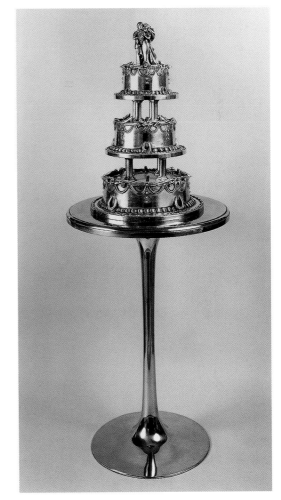

401. *Wedding Cake*, 2000
Polished aluminium
50 1/2 in / 128.3 cm high

EXHIBITED - 2000, *Clive Barker: Recent Work*,
Whitford Fine Art, London, cat.18, ill.

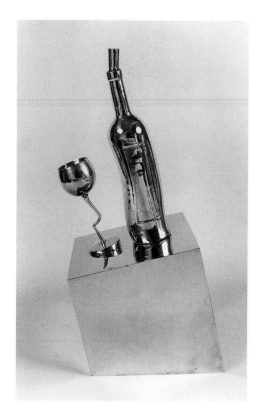

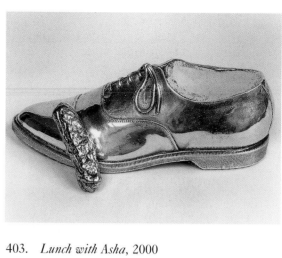

403. *Lunch with Asha*, 2000

Polished aluminium and polished bronze
Edition of 2
11 in / 28 cm long

402. *Drunken Still Life*, 2000

Polished bronze
21 1/8 in / 53.7 cm high

EXHIBITED - 2000, *Clive Barker: Recent Work*, Whitford Fine
Art, London, cat.2, ill.

404. *14th February 1929*, 2000

Mixed media
Edition of 6
1 A/P
1 Prototype
Case 42 1/2 in / 107.9 cm long
Gun 33 3/4 in / 85.7 cm long

405. *Two Torches*, 2000

Polished aluminium
13 in / 33 cm high

406. *Three Torches Study*, 2000

Polished aluminium
(11 in / 28 cm) high; 7 3/4 in / 19.7 cm diameter

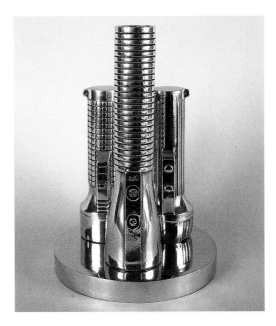

407. *Three Torches*, 2000

Polished aluminium
11 1/8 in / 28.3 cm high; 7 3/4 in / 19.7 cm
diameter

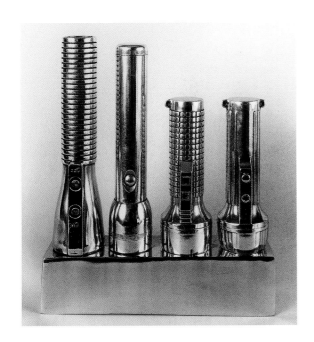

408. *Four Torches*, 2000

Polished aluminium
13 in / 33 cm high

409. *Minnie Mouse*, 2000

Polished aluminium and polished bronze
Edition of 9
3 A/P
8 3/4 in / 22.2 cm high; 6 7/8 in / 17.5 cm diameter

Exhibited - 2000, *Clive Barker: Recent Work*, Whitford Fine Art, London, cat.27.

410. *Tom and Jerry*, 2000

Polished aluminium
Edition of 3
23 ¹/₈ in / 58.7 cm high

EXHIBITED - 2000, *Clive Barker: Recent Work*, Whitford Fine Art, London, uncatalogued.

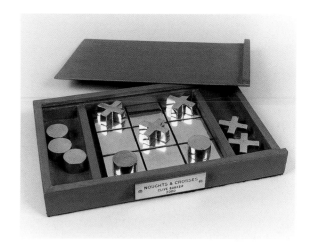

411. *Noughts & Crosses*, 2000

Mixed media
1 ¹/₂ x 12 x 7 ³/₈ in / 3.8 x 30.5 x 18.7 cm

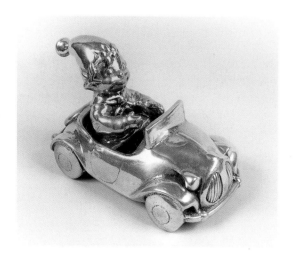

412. *Noddy and his Car*, 2000

Polished aluminium
Edition of 25
3 ⁵/₈ in / 9.3 cm high; 4 ⁷/₈ in / 12.4 cm long

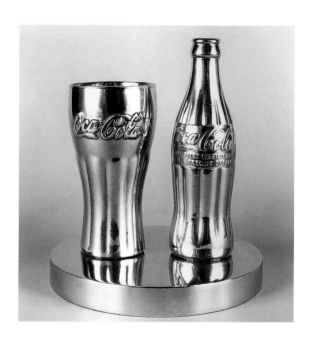

413. *My Birthday Drink*, 2000

Polished aluminium
8 ²¹/₃₂ in / 22 cm high; 7 ¹³/₁₆ in / 19.9 cm diameter

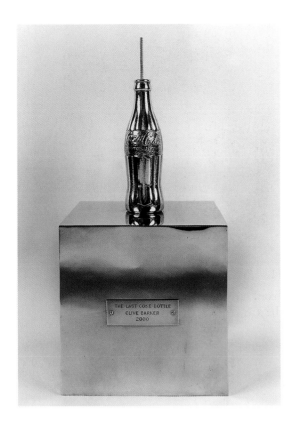

414. *The Last Coke Bottle*, 2000
Polished bronze
18 3/4 x 8 7/8 x 9 in / 47.6 x 22.5 x 23 cm

415. *Lollies*, 2000
Glass and polished aluminium
15 3/4 in / 40 cm high

416. *First Past the Post*, 2000
Mixed media
7 11/16 x 2 3/4 x 11 3/16 in / 19.5 x 7 x 28.4 cm

417. *15 Ronson Lighters*, 2000
Mixed media
12 3/4 x 15 1/8 x 7 3/8 in / 32.4 x 38.3 x 18.7 cm

418. *2 Large Cigars*, 2000

Mixed media
Case 7 7/8 in / 20 cm long
Cigars 6 7/8 in / 17.5 cm long

419. *5 Cigars*, 2000

Mixed media
Case 4 1/2 in / 11.5 cm long
Cigars 4 7/16 in / 11.3 cm long

420. *Two Cigars (For Adrian)*, 2000

Mixed media
Case 7 3/32 in / 18 cm long
Cigars 6 1/2 in / 16.5 cm long

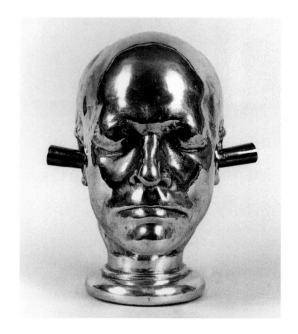

421. *William Blake is not Listening*, 2000

Polished aluminium and polished bronze
11 1/8 in / 28.3 cm high

422. *Father Christmas*, 2000

Polished aluminium
7 1/2 in / 19 cm high

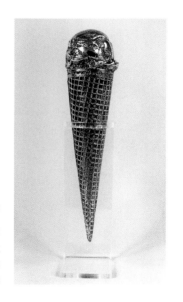

423. *Ice Cream*, 2000

Edition of 9 and 3 A/P in polished
aluminium and perspex
2 unique cones in polished bronze
8 3/4 in / 22.2 cm high (cone)

Functional Objects

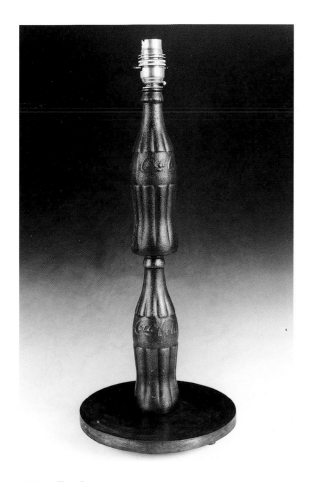

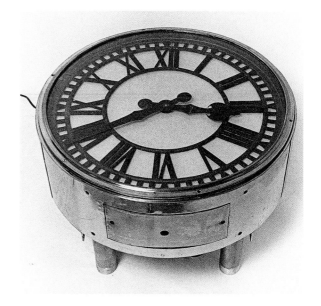

425. *Tea Time Table*, 1981-90

Polished bronze, polished brass and polished copper
18 in / 45.7 cm high; 26 1/2 in / 67.3 cm diameter

424. *For Rose*, 1968

Bronze with dark brown patina, with light fitting
17 in / 43.2 cm high; 7 7/8 in / 20 cm diameter

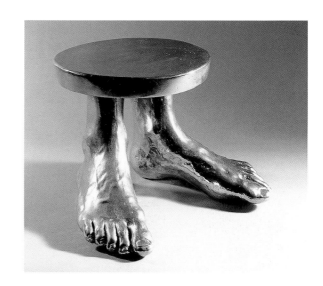

427. *Foot Stool*, 1983

Chrome-plated bronze
9 1/2 in / 24.2 cm high

426. *Vase*, 1981
Bronze with brown patina
10 3/16 in / 25.9 cm high

428. *Candle Stick*, 1986
Bronze with black patina
Pair
11 1/8 in / 28.3 cm high

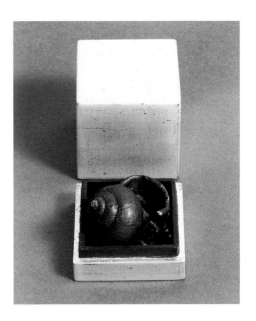

429. *Snail Ring No. 1*, 1987-88
Bronze, silver leaf and wood
Box 2 1/2 x 2 1/2 x 2 1/2 in / 6.4 x 6.4 x 6.4 cm

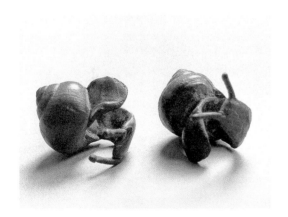

430. *Snail Ring*, 1987-88
3 Variations: 2 in bronze with brown black
patina and 1 in bronze with green patina
All approximately 2 in / 5 cm long

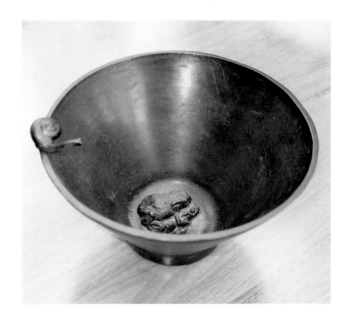

431. *Bowl*, 1987
Bronze with black patina
10 3/4 in / 27.3 cm diameter

432. *Arizona Table 1*, 1988

Polished steel
14 x 12 x 10 in / 35.6 x 30.5 x 25.4 cm

433. *Arizona Table 2*, 1988

Rusted steel
14 x 12 x 10 in / 35.6 x 30.5 x 25.4 cm

435. *Champagne Ring*, 1990

1 unique in polished aluminium
1 unique in polished bronze
1 15/16 in / 4.9 cm high

434. *Poker*, 1988

Bronze with brown patina
35 in / 89 cm long

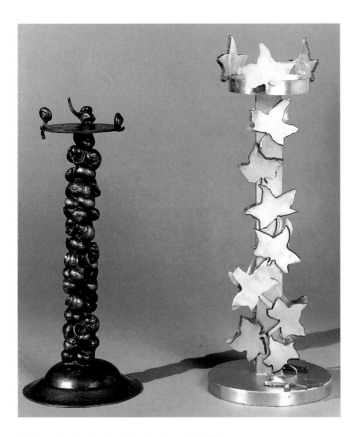

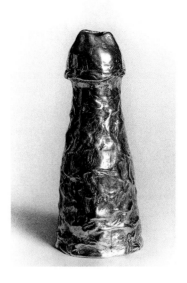

438. *Penis Vase*, 1994-98
Polished aluminium
10 3/4 in / 27.3 cm high

436. *Study for Ice-Bucket Stand*, 1990

Bronze with brown patina
21 in / 53.3 cm high
Commission for 'The Ivy' restaurant, London

437. *Study for Ice-Bucket Stand*, 1990

Polished stainless steel
25 in / 63.5 cm high
Commission for 'The Ivy' restaurant, London

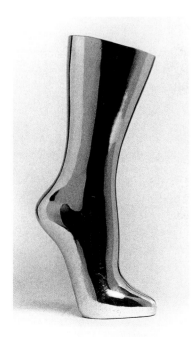

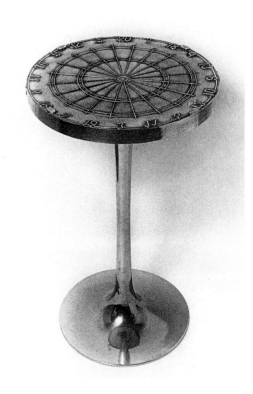

439. *Leg Vase*, 1995

Edition of 6 in polished
aluminium (*Leg Vase 1*)
Study in polished bronze
(*Leg Vase 2*)
14 in / 35.6 cm high

440. *Dartboard Table*, 1995

Polished aluminium
29 1/2 in / 75 cm high; 17 1/2 in / 44.5 cm
diameter

Biography

1940	Born in Luton, the fifth child of Frederick, a coach painter at Vauxhall Motors, and May, née Brown.
1949	An encounter with the collection of paintings at Hatfield House, Hertfordshire, awakened his interest in painting.
1952 -1957	Attended Beech Hill Secondary Modern, Luton, where he excelled at art. Mervyn Levy showed one of Barker's landscape paintings on BBC television. Levy's comments encouraged Barker to continue drawing and painting. Experience of helping his elder brother, Ivor, on his early morning bread delivery rounds, would later inspire a group of work.
1956	Met Rosemary (Rose or Ro) Bruen, his future wife.
1957	Started training as a painter at Luton College of Technology and Art. Developed a particular interest in the painting of Cézanne, Picasso, Soutine and Van Gogh, which would later be expressed in his sculpture. An unsympathetic sculpture teacher discouraged his interest in the subject.
1958	Started travelling regularly to London to view exhibitions at the Institute of Contemporary Arts (ICA), the Whitechapel Art Gallery and the New Vision Centre Gallery, where he befriended Peter Blake. Visited 'Five Young Painters', ICA (9 Jan. - 8 Feb.) which included work by Richard Smith and Peter Blake. 'Some Paintings from the E.J. Power Collection', ICA (13 Feb. - 19 April), showing work by Jackson Pollock, Mark Rothko and Clyfford Still, led Barker to experiment with abstract painting. Made *Object*, his first three-dimensional object. Visited 'Jackson Pollock' at the Whitechapel Art Gallery (Nov. - Dec.).
1959	Visited 'New American Painting', Tate Gallery (24 Feb. - 22 March) and continued experiments with abstraction. June: disappointed and frustrated with some aspects of his formal education, Barker decided to break with his art school training. Subsequently refused to take up a place offered by St. Martin's School of Art, London, reluctant to spend more time at art school.
1960	Saw Peter Blake's 'gold paintings' at the New Vision Centre Gallery (8 Jan. - 6 Feb.), and 'West Coast Hard Edge', ICA (from 23 March). Spring: started working on the assembly line at Vauxhall Motors, Luton, for a period of fifteen months. Working with chrome-plated and leather-upholstered car parts would later prove to be a formative experience.

Fig. 28
Luton, 1950: Clive Barker, aged 10

Imagined making art as consumer goods, the product of coordinated cooperation between specialist craftsmen.

1961 March: married Ro.
April: gave up his job at Vauxhall Motors and moved with Ro to London (Belsize Square, NW3). Commenced working for a pawnbroker on Portobello Road.
Summer: befriended art critic Roland Penrose who introduced him to Francis Bacon and Richard Smith, who had just returned from the United States.
Started concentrating on making objects. Using corrugated cardboard, Barker fabricated a series of five targets, realising his own versions of this Pop Art icon. He also made use of found objects. Submitted fabricated and found objects to physical transformation through the use of black paint.
All paintings dating 1958-59 were destroyed, after having been used as a back garden fence by Barker's father.

1962 Befriended David Hockney.
Continued working with found objects, now also utilising neon.
First use of the zip image in *Three Zips*, silkscreen on canvas.
February: series of targets included in 'Young Contemporaries', RBA Galleries, London.
May: started visiting the newly opened Robert Fraser Gallery in London.
October: saw Richard Smith's exhibition of paintings at the ICA (18 Oct. - 24 Nov.).

1963 Barker and his wife moved in with Richard Smith, sharing his house on Bath Street, London, EC1.
Smith's account of his two-year sojourn in New York (1959-61) and trip to America that year prompted Barker to recreate Smith's American leather jacket as *Dick's Jacket*. Crafted by a professional leather upholsterer, this work realised Barker's idea of using divided labour for making art. Subsequently commenced the series of leather stretched works incorporating studs, neon and real zips. These are considered as his first Pop works.
Visited 'The Popular Image', ICA (24 Oct. - 23 Nov.), first London overview of American Pop Art.
Befriended Richard Hamilton.

1964 Gave up his job as a pawnbroker's assistant to concentrate on sculpture.
Continued working with leather and zips.
First casts *Zip 1* (bronze and aluminium), *Zip 2* (aluminium) and *Zip* (bronze) were executed at a local North London foundry. The two latter works were abandoned for lack of casting quality. Being short of funds to continue with casting objects, Barker turned to working on the subject of the zip using silkscreen on canvas as well as on metallic paper, and continued the series of leather-upholstered objects.
July - September: two works included in '118 Show' at the Kasmin Gallery, London.
Two Palettes for Jim Dine, a homage to the American whose paintings Barker had seen at the Robert Fraser Gallery, marked the beginning of the use of chrome-plating.
Introduced to Robert Fraser by art collector Alan Power, who by that time owned *Two Palettes for Jim Dine* (1964).

1965 Tutor at Maidstone School of Art.
Continued experimenting with painting, using aerosol paint to transfer

images of his underpants and vest onto canvas, and making screenprints of zips. Sufficient funds enabled Barker to cast the contents for *Pencil Box* and *Pencils*, first examples of objects related to art materials.

Silver Zip concluded the use of leather.

The Arts Council selected two screenprints for its 'New Prints 2' show. Fraser expressed interest in exhibiting Barker's sculptures.

November: moved with Ro to Dartmouth Road, London, NW2.

December: storage unit in Old Street, London, EC1 burned down, destroying several objects.

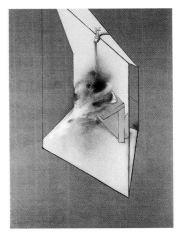

Fig. 29
Invitation to exhibition at Robert Fraser Gallery, from 25 Jan. 1967

1966	Started working with Morris Singer Foundry (London).

With the support of Robert Fraser (contract during November) Barker realised his first works in chrome-plated bronze. With *Van Gogh's Chair*, *Table with Drawing Board*, *Morandi Still Life* and *Art Box I* Barker obtained a sudden maturity. *Palette for Rose* was the first in a series of paint palettes.

April-May: first visit to the United States; spent three weeks in New York with Gerald and Jenny Laing. Met Tom Wesselmann, Roy Lichtenstein, Jasper Johns and Andy Warhol, whose show 'Andy Warhol: Wallpaper and Clouds' at the Leo Castelli Gallery (2 - 27 April) he visited. Saw work by Jasper Johns and perspex objects by Robert Watts at the Bianchini Gallery. Warhol's silver clouds and the work of Jasper Johns confirmed Barker's direction.

May: Ro gave birth to their first son, Tad, which prompted Barker to make *Coke with Teat*, the first of his celebrated Coke bottle sculptures.

June: introduced by Richard Hamilton to Marcel Duchamp at his Tate Gallery retrospective 'The Almost Complete Works of Marcel Duchamp' (18 June - 31 July).

August-September: Robert Fraser included *Van Gogh's Chair* (1966) in 'New Idioms', a group show with Derek Boshier, Richard Hamilton, Roy Lichtenstein, Craig Kauffman, Eduardo Paolozzi, Claes Oldenburg, Colin Self, Bridget Riley and Andy Warhol. Barker's exhibit won him instant fame, and invitations to show internationally followed soon afterwards.

1967 January: first visit to Paris to attend the 'Salon de la Jeune Peinture' (1 - 25 Jan.), where *Van Gogh's Chair* and *Table with Drawing Board II* (1966) were most favourably received.

Other international invitations included the 'Biennale d'Arte' in San Marino (10 July - 30 Sept.) and Bruno Bischofberger's 'Englische Kunst' in Zürich.

Participated in 'Tribute to Robert Fraser' (from 5 July), the gallery artists' initiative to keep the Robert Fraser Gallery open whilst Fraser was jailed.

Fig. 30
FRANCIS BACON (1909-1992)
Water from a Running Tap, 1982
oil on canvas, 198 x 147.5 cm
(Private Collection): Bacon's interpretation of Barker's *Splash*, 1967

Working towards his first one-man show at the Robert Fraser Gallery, Barker started utilising a broad spectrum of metals, including bronze, brass, steel, aluminium, chromium, silver and gold. Made *Bucket of Raindrops*, *Splash* and *Drips*. Continued the theme of painter's materials, creating *Art Box II* and more variations of paint palettes. The 'Van Gogh' subject matter was continued with *Van Gogh's Ear*.

Dartboard and *Painted Dartboard*, reiterated this icon of Pop Art imagery.

3 Cokes Study anticipated a group of Coke bottle sculptures executed in 1968.

1968 First one-man show at the Robert Fraser Gallery (17 Jan. - 14 Feb.). Francis Bacon's visit to the show marked the beginning of a life-long friendship between the two artists.

Joseph Hirshhorn purchased *Morandi Still Life* (1966), *Zip Mouth Organ* (1966) and *Spill* (1967), now part of the Hirshhorn Museum and Sculpture

Fig. 31
Clive Barker at chrome-platers, Barell and Clerkenwell, 1968
(Photograph Keith Morris)

Fig. 32
Clive Barker with his eldest son, Tad,
London, 1969
(Photograph Keith Morris)

Fig. 33
Ro with Tad and Ras,
photographed by Jean Shrimpton,
London, 1973

Fig. 34
Clive Barker with David Hockney
burning one of Hockney's paintings
for 'Cremated David Hockney Painting'
London, 1973

Garden (Smithsonian Institution), Washington, D.C.
Three works were shown in 'British Artists: 6 Painters, 6 Sculptors', an exhibition circulated by the Museum of Modern Art, New York (until 26 Oct. 1969).
November: anticipating the closure of the Robert Fraser Gallery, Barker was approached by Erica Brausen of the Hanover Gallery. Whilst Barker was officially still represented by the Fraser Gallery at the 'Mostra Mercato d'Arte Contemporanea' in Florence (16 Nov. - 9 Dec.), he was now in effect working under the patronage of the Hanover Gallery, starting with a series of ten Coke bottle sculptures.
An introduction to Marlon Brando inspired *Cowboy Boots* and *Rio – Homage to Marlon Brando*.

1969 March-April: moved with Ro to Heath Street, London, NW3.
A temporary separation followed shortly afterwards.
August: Robert Fraser, after his release from prison, closed his gallery; Barker was now represented exclusively by the Hanover Gallery.

Completed *Homage to Magritte. Van Gogh's Sunflowers* and two variations of *Van Gogh's Hat with Candles* paid further tribute to his favourite painter. Homages to Soutine, Picasso and Morandi followed.
Cast *Life Mask of Francis Bacon*, his first portrait of the painter. Began the casting of bakery products. The series of 'Hand Grenades' were Barker's first references to the subject of war.
Summer: the Hanover Gallery showed *Homage to Magritte* (1968-69) in 'Poetic Image' (July - Aug.), a Surrealist show including work by René Magritte, Salvador Dalí, Man Ray and Roland Penrose.
Mario Amaya selected six chrome-plated works for 'Young and Fantastic', ICA, London (9 July - 3 Sept.).
October-November: one-man show at the Hanover Gallery; exhibition reviews consolidated his previous success.

1970 The Tate Gallery, London, purchased *Splash* (1967).
Commenced *Portrait of Madame Magritte* (1970-73), a life-size bronze cast of a Chesterfield sofa.
Art Box concluded the series of painting-related objects begun in 1965-66.
A Lovely Shape was the last of the early Coke bottle sculptures.
Van Gogh's Chair (1966) and *Van Gogh's Sunflowers* (1969) were shown at 'British Sculpture out of the Sixties', ICA, London (6 Aug. - 27 Sept.).
Van Gogh's Chair and *Homage to Magritte* travelled around Europe as part of 'Métamorphose de l'objet. Art et anti-art 1910-1970'.

1971 Visited Paris where 'Métamorphose de l'objet. Art et anti-art 1910-1970' had its last showing at the Musée des Arts Décoratifs. Following a visit to the Louvre, made *Chained Venus* and *Roped Venus* (destroyed), his first references to classical sculpture, with which he became preoccupied.
March-May: travelled through 22 American States, making a series of drawings. In New York, spent time with Jasper Johns and visited Warhol again.
Back in London made 'cremated paintings', for which artist friends were asked to burn an important painting. Richard Hamilton and Joe Tilson contributed; David Hockney contributed in 1973.
Anticipating the closure of the Hanover Gallery (December 1972) Barker

accepted a teaching position at Croydon School of Art, Surrey, but unwilling to make the commitment attached to a teaching job, left after one term. *Chained Venus* (1971) was shown at 'Der Geist des Surrealismus' at the Baukunst-Galerie, Cologne (4 Oct. - 20 Nov.), which brought Barker to Germany for the first time.

Fig. 35
DAVID HOCKNEY (b.1937)
Clive Barker, ink drawing
executed in Paris, January 1975
430 x 357 mm

1971-1974	Further international showings of his work led to the creation of sculptures relating to the crating and transporting of art works: *Object to be Shipped Abroad* (1971-73) and *Small Object to be shipped Abroad* (1973), *Tang Chariot* (1973), followed by *Chariot* (1974) and *Charioteer* (1974).
1972	The classical theme was continued. Inspired by finding his father's wartime gas mask, made *Aphrodite* (1972) and 'War Heads' (1973-74), a series of six gas masks and skulls.
1973	Further reference to the subject of Venus was made in *Portrait of an Unknown Beauty*. February: Ro gave birth to their second son, Erasmus (Ras). One of the edition of *Homage to Magritte* was lost during transport to Chile. The Baukunst-Galerie, Cologne included 23 works in 'Künstler aus England' (13 June - 8 Sept.), which Barker attended.
1974	Made *Head of Jean*, a portrait of his friend the model Jean Shrimpton, and the first of a group of portraits in which a cast of the lips is the only feature revealing the identity of the sitter. One-man show 'Heads and Chariots', including the series of 'War Heads' (1973-74) at Anthony d'Offay, London (2 - 26 July).
1975	January: visited David Hockney in Paris, where Hockney drew his portrait. Made *Torso of Marianne Faithfull* and *Tits (M.F.)*, alluding to his intimate relationship with the pop singer. A cast of her lips was not used until later in *Head of Marianne Faithfull* (1981). Fraser returned to London and started dealing privately with the works of his former gallery artists, including Barker's sculptures.
1976	At the invitation of Peter Blake, showed in the Summer Exhibition at the Royal Academy of Arts, London. *3 Cokes* (1968) and *Homage to Magritte* hit newspaper headlines when sold at Sotheby's Contemporary Art Sale (1 July) for £420 and £900 respectively. Mannheim Kunsthalle purchased *Portrait of Madame Magritte* (1970-73). Barker completed one work only.
1977	The search for a new family home halted the creation of new work. Ended his working relationship with Morris Singer Foundry. *Splash* was included in 'British Artists of the '60s' at the Tate Gallery (1 June - 18 Sept.).
1978	Bought a house in Malvern, Worcestershire, which Ro and the boys moved into permanently. Barker then divided his time between Malvern and London. Started having works cast by Burleighfield Arts (High Wycombe). Made a series of 12 bronze and brass studies of Francis Bacon. This series, together with the three portraits of Barker painted by Bacon, was promoted by Robert Fraser for an exhibition held at the Felicity Samuel Gallery, London.

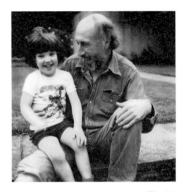

Fig. 36
Richard Hamilton with Ras Barker, 1977
(Photograph Clive Barker)

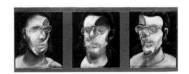

Fig. 37
FRANCIS BACON (1909-1992)
Three Studies for a Portrait of Clive Barker, 1978
triptych, oil on canvas
each panel 35.6 x 30.5 cm

Fig. 38
Scene from one-man show at Felicity
Samuel Gallery, London, Oct. - 1 Dec. 1978
(Photograph Rodney Todd-White)

Fig. 39
Clive Barker with HRH Princess
Anne, 1983

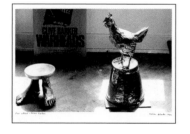

Fig. 40
Foot Stool (1983) and *Cockerel on Bucket* (1983), photographed by Peter Blake, 1984

Fig. 41
Marianne Faithfull photographed by Peter Blake, at Barker's home in 1984

The Arts Council purchased *Study of Francis Bacon, No. 1* (1978).
The Aberdeen Art Gallery purchased *Study of Francis Bacon, No. 6* (1978).

1979-1980	Preoccupied with overseeing building work on the house in Malvern, Barker made little progress with sculpture. Production amounted to three works only.
1980	Barker completed only one work. *Helen* is the first in a group of works in wood executed during 1980-81. The Imperial War Museum, London, purchased *German Head '42* (1974).
1981	Made a group of portrait heads of friends, including Eduardo Paolozzi and Marianne Faithfull.
1981-1982	A retrospective exhibition, comprising sculptures, drawings and prints, was organised by the Sheffield City Art Galleries, touring to Stoke, Eastbourne and Cheltenham, (28 Nov. - 29 May 1982). Graves Art Gallery, Sheffield, purchased *Helmet* (1973). Mappin Art Gallery, Sheffield purchased *Exit* (1963-64). The Imperial War Museum acquired the 'War Heads' (1973-74) series.
1982	Barker completed no work. The acquisition of *Study of Francis Bacon, No. 9* (1978) by the Wolverhampton Art Gallery was met with disapproval by some members of the City Council. The local newspaper, 'Star and Express', became the forum of a five-month long written debate between defenders and opponents. Mappin Art Gallery, Sheffield included *Van Gogh's Chair* in 'Milestones in Modern British Sculpture' (9 Oct. - 7 Nov.).
1983	Robert Fraser opened a gallery in Cork Street. Here, Barker's work was shown in group shows of British Pop Art. With *Cockerel on Bucket*, *Rooster Head*, *Black Vase of Flowers*, *Roses* and *Crucifixion on a Red Hill*, Barker turned to more traditional subject matter. Started a series of portrait drawings and paintings.
1984	Marianne Faithfull was living with Barker in London; his marriage with Ro started to break down. Production of sculpture came to a halt again. Ended his working relationship with Burleighfield Arts.
1985	Won the Elephant Trust Award. An exhibition of the 'Boxes', a series of 25 sculptural scenes placed in wooden boxes (executed 1972-85) was hosted by the Wolverhampton Art Gallery (13 April - 18 May). Separation from Ro. Their house in Malvern was sold, along with their collection of art works. Barker moved back to the flat in Heath Street. Affected by the separation, Barker lost interest in working. *Man from U.S.A.* was the only work completed. Contributed a work to 'Visual Aid', part of Bob Geldof's initiative 'Band Aid'.
1986	*Splash* was included in 'Forty Years of Modern Art', Tate Gallery, London (19 Feb. - 27 April). The sole work executed was *Candle Stick*, commissioned by 'Le Caprice' restaurant. Started working with Red Bronze Studio Fine Art Founders (London).

The Contemporary Arts Society purchased *Study of Francis Bacon, No. 7* (1978), for donation to the Ferens Art Gallery, Hull.
Following Robert Fraser's death, the gallery closed. The combined effects of Fraser's death and the separation from Ro led Barker to withdraw from the art scene.

1987 Fell in love with American artist Linda Kilgore and resumed work. With *Venus Escargot* Barker returned to the classical theme. Cast *Self-Portrait with Bananas*, his only self-portrait sculpture. Whilst still working with Red Bronze Studio Art Founders, Barker now also employed Livingstone Art Founders (Tonbridge, Kent).
Marco Livingstone selected *Art Box II* (1967) and *Venus Escargot* (1987) for 'Pop Art U.S.A. – U.K.: American and British Artists of the '60s in the '80s', Tokyo (24 July - 18 Aug. and tour), an exhibition co-curated with Lawrence Alloway.
The National Portrait Gallery, London, hosted a one-man show of Barker's portrait drawings (executed 1983-87) and sculptures (24 July - 18 Oct.).

Fig. 42
Clive Barker photographed
by Don McCullin, 1987

1988 Summer: travelled to Arizona and to the South of France, visiting Antibes, Biot, Nice, Monaco and Saint-Paul de Vence.
Started working with sheet steel, resulting in a series of 'Cubist Violins'. Made a group of very personal works referring to Linda Kilgore and her home in Arizona.
The National Portrait Gallery expressed a wish to purchase the gold leaf version of *Life Mask of Francis Bacon* (1969), after which Barker donated the work.

1989 Forced by external circumstances, Linda returned to the United States for an indefinite period of time, but never returned. Barker's only work that year, *The Red Violin for Linda Kilgore*, stands out as a reminder of his love for his American companion.

Fig. 43
Clive Barker with Linda
Kilgore, South of France, 1988

1990 The use of the Venus head continued. Completed a commission for an ice-bucket-stand for 'The Ivy' restaurant, London.
Linda's absence left another gap in his life. *Little Bird in His Nest* and *Twins* reflect the artist's introspective mood.

1991 Barker made no work. In London, 'Objects for the Ideal Home: The Legacy of Pop Art' (11 Sept. - 20 Oct.), at the Serpentine Gallery, and 'Pop Art' (13 Sept. - 15 Dec.), at the Royal Academy of Arts showed Barker's and Jeff Koons's chrome-plated works simultaneously. Koons's debt to Barker was pointed out in exhibition reviews as well as by Richard Hamilton at the Pop Art symposium (Royal Academy of Arts, London 12 Sept.).

1992 Commenced a group of still lifes presented on cast iron tables.
Showed in the Summer Exhibition at the Royal Academy of Arts, London.
With *Gold Coke*, Barker returned to the theme of the Coke bottle, intending to produce a large commercial edition for the first time (not completed).
The death of Francis Bacon prompted *Study for a Monument to Francis Bacon*. Barker left Red Bronze Studio Fine Art Founders, and started employing The Luton Casting Company (Luton).

1993 The City of Luton commissioned a monument. *Elephant for Luton* was never executed due to lack of funds.
Work was shown in group exhibitions in England and overseas. David Mellor

selected *Cremated Richard Hamilton Painting* (1971) for 'The Sixties Art Scene in London', Barbican Art Gallery, London (11 March - 13 June).
Showed in the Summer Exhibition at the Royal Academy of Arts, London.
Barker started working with Roseblade Foundry (London).

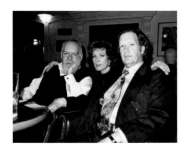

1994 One-man show of works on paper at the Independent Gallery, London.
Showed in the Summer Exhibition at the Royal Academy of Arts, London.
Production was limited to one work only.

1995 Met Adrian Mibus of Whitford Fine Art, London, who included work in 'Post War to Pop'.
Barker returned to the subject matter of Cubism with two Cubist still lifes.
Further reference to painting was made in *Vase of Flowers in a Frame 1* and *2*.

1996 The Berardo Foundation acquired *Homage to Soutine* (1969) for the Sintra Museum of Modern Art, Sintra (Portugal).

1997 Work was shown in 'Pop Art' (1 Feb. - 6 April) at Norwich Castle Museum, and in 'Les Sixties: Great Britain and France 1962-1973, The Utopian Years', Brighton Museum and Art Gallery (23 April - 29 June). Marco Livingstone selected four works for 'The Pop '60s: Transatlantic Crossing', Centro Cultural de Belém, Lisbon (11 Sept. - 17 Nov.).
Repeated the classical theme in *Torso* and *Things of Beauty Arrive Broken in the Box*.

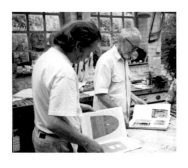

1998 The production of 43 works heralded a creative outburst which would last for two years. Further reference to classical sculpture is found in *Helmet 1-5*.
In a new series of still lifes Barker worked with fruit, shells and breads.
Following *Box Camera* (1990), *Box Camera and Flash* announced a group of eight camera sculptures executed in 1999. *Space Pilot X-Ray Gun, Dalek, Head of Darth Vader* and *Light Sabre* highlight Barker's love of science fiction.

1999 Began work on larger scale projects such as *Fridge*, *Van Gogh's Bed* and *Alphabet*. A group of guns alluded to Barker's childhood love of gangster movies and Westerns. Continued the science-fiction theme as well as the series of cameras.

2000 With *MM* (12 variations), returned to the Coke bottle theme to mark the millennium. *Torches* echo the early Coke bottle sculptures. *Tom and Jerry*, *Mickey Mouse*, *Mickey Mouse 2* and *Minnie Mouse* revive Barker's interest in cartoon figures and children's toys.
With *The Last Coke Bottle*, Barker drew a line under this very popular and seminal subject of his visual vocabulary.
Exhibition of recent sculpture at Whitford Fine Art, London (7 Nov. - 7 Dec.).

2001 David E. Brauer included *Two Palettes for Jim Dine* and *Van Gogh's Chair* in 'Pop Art: U.S./U.K. Connections 1956-1966', The Menil Collection, Houston (Texas).
The Berardo Foundation acquired *Fridge* (1999) for the Sintra Museum of Modern Art. Peter Blake selected *Fridge* for the Summer Show, Royal Academy of Arts, London.
Commenced a new series of still lifes and continued work on *Alphabet* and *Van Gogh's Bed*.

Clive Barker lives and works in London.

Exhibitions

** Exhibitions accompanied by a catalogue.*

Where traced, the number of works included in each exhibition is given in parentheses.
Precise dates, if they have proved impossible to confirm, are not given for certain exhibitions.

SOLO EXHIBITIONS

1968
Clive Barker: Recent Works, Robert Fraser Gallery, London, 17 Jan. - 14 Feb. (15).*

1969
Clive Barker, Hanover Gallery, London, Oct. - Nov. (37).*

1974
Clive Barker: Heads and Chariots, Anthony d'Offay, London, 2 - 26 July (11).*

1978
Clive Barker: 12 Studies of Francis Bacon. Francis Bacon: 3 Studies of Clive Barker, Felicity Samuel Gallery in collaboration with Robert Fraser, London, Oct. - 1 Dec. (12).

1981
Clive Barker: Sculpture, Drawings and Prints, Retrospective Exhibition, Mappin Art Gallery, Sheffield, 28 Nov. - 3 Jan. 1982, touring Stoke, Eastbourne and Cheltenham (92).*

1983
Clive Barker: War Heads, Imperial War Museum, London, 30 Sept. - Jan. 1984. (7).

1985
Clive Barker: Boxes, Wolverhampton Art Gallery, Wolverhampton, 13 April - 18 May (25).*

1987
Clive Barker: Portraits, National Portrait Gallery, London,

24 July - 18 Sept. (58)*, touring Luton, Wolverhampton, Eastbourne, Folkestone and Hull (1988).

1994
Works on Paper, Independent Gallery, London.

2000
Clive Barker: Recent Work, Whitford Fine Art, London, 8 Nov. - 8 Dec. (27).*

GROUP EXHIBITIONS

1962
Young Contemporaries, RBA Galleries, London, Feb. (3).*

1964
About Round, Leeds University, Leeds, 14 - 28 June (1).*

118 Show, Kasmin Gallery, London, 30 July - 19 Sept. (2).

1965
New Prints 2, Arts Council of Great Britain, touring exhibition.

1966
New Idioms, Robert Fraser Gallery, London, Aug. - Sept. (1).

1967
Salon de la Jeune Peinture, Musée d'Art Moderne de la Ville de Paris, Paris, 1 - 25 Jan. (3).

Works from 1956 to 1967 by Clive Barker, Peter Blake, Richard Hamilton, Jann Howarth and Colin Self, Robert Fraser Gallery, London, from 25 Jan.

Ventures, Arts Council of Great Britain, Arts Council Gallery, Cambridge, 25 Feb. - 18 March, touring exhibition (6).*

Tribute to Robert Fraser, Robert Fraser Gallery, London, from 5 July.

Nuove Tecniche d'Immagine, Sesta Biennale Internazionale d'Arte, San Marino, 10 July - 30 Sept. (1).*

Drawings and Prints, Robert Fraser Gallery, London, from 24 Oct.

Englische Kunst, Galerie Bruno Bischofberger, Zürich (2).*

1968
Contemporary British Painting and Sculpture, Museum of Modern Art, Oxford, 23 June - 30 Aug.

British Artists: 6 Painters, 6 Sculptors, exhibition circulated by the Museum of Modern Art, New York, 1 July 1968 - 26 Oct. 1969 (3).*

Mostra Mercato d'Arte Contemporanea, Palazzo Strozzi, Florence, 16 Nov. - 8 Dec. (5).*

Tout Terriblement Guillaume Apollinaire, ICA, London, Nov. (1).*

1969
Poetic Image, Hanover Gallery, London, 8 July - 30 Aug. (1).*

Pop Art, Hayward Gallery, London, 9 July - 3 Sept. (4).*

Young and Fantastic, ICA, London, 13 July - 17 Aug., touring New York and Toronto (6).*

Play Orbit, Royal National Eisteddfod of Wales, Flint and ICA, London, 28 Nov. - 15 Feb. 1970 (1).*

1970
Métamorphose de l'objet. Art et anti-art 1910-1970, Palais des Beaux-Arts, Brussels, 22 April - 6 June, touring Rotterdam, Berlin, Milan, Basel and Paris (1971) (2).*

Kelpra Prints, Arts Council of Great Britain, Hayward Gallery, London 17 June - 7 July (2).*

British Sculpture out of the Sixties, ICA, London, 6 Aug. - 27 Sept. (2).*

Alice, Waddington Galleries, London.

3 ∞ : New Multiple Art, Whitechapel Art Gallery, London, 19 Nov. - 3 Jan. 1971 (3).*

1971
Der Geist des Surrealismus, Baukunst-Galerie, Cologne, 4 Oct. - 20 Nov. (1).*

1972
XI Premi Internacional Dibuix Joan Miró, Barcelona, 23 May - 15 June.*

Third British International Print Biennale, Bradford City Art Gallery and Museums, Cartwright Hall, Bradford, July - Sept. (1).*

British Figurative Art Today and Tomorrow, Nova-London Fine Art, Copenhagen (2).*

Clive Barker/David Oxtoby/ Norman Stevens/ Michael Vaughan/ David Versey/ Roy Tunnicliffe/John Loker, Studio 4 (Vivien Lowenstein and Pat Sonabend), London, 4 - 10 Dec. (5).*

1973
11 Englische Zeichner, Staatliche Kunsthalle, Baden-Baden, 4 May - 17 June, touring Bremen and Antwerp.

Künstler aus England, Baukunst-Galerie, Cologne, 13 June - 8 Sept. (21).*

1974
Zehn Jahre Baukunst, Baukunst-Galerie, Cologne, 14 Oct. - 23 Dec. (2).*

Small is Beautiful, Angela Flowers Gallery, London, 10 Dec. - 5 Jan. 1975 (1).

1975
Desenhos Britânicos Contemporâneos, XIII Bienal de São Paulo (3).*

Der Ausgesparte Mensch, Städtische Kunsthalle Mannheim, Mannheim, 13 Dec. - 8 Feb. 1976 (2).*

1976
Schuhwerke, Kunsthalle Nürnberg, Nuremberg, 28 May - 26 Sept. (1).*

Summer Exhibition, Royal Academy of Arts, London, 8 May - 1 Aug (1).*

Small is Beautiful. Part 2: Sculpture, Angela Flowers Gallery, London, 7 - 31 Dec. (1).*

1977
British Artists of the 60's, Tate Gallery, London, 1 June -
18 Sept. (1).*

*Ivor Abrahams/ Clive Barker/Peter Blake/Barry Flanagan/
Richard Hamilton/ Jann Haworth/ Gordon House/ Eduardo
Paolozzi and Colin Self,* Kinsman Morrison Gallery,
London (2).
1978
The Museum of Drawers by Herbert Distel, Kunsthaus, Zürich.*

1979
Furniture Sculpture, Ikon Gallery, Birmingham.

*... A Cold Wind Brushing the Temple. An Exhibition of Drawing,
Painting and Sculpture purchased by George Melly for the Arts
Council of Great Britain,* Arts Council of Great Britain,
touring exhibition (1).*

1980
Nudes, Angela Flowers Gallery, London, 10 Dec. -
31 Jan. 1981 (1).

1981
13ª Biennale Internazionale del Bronzetto Piccola Scultura,
Padua, 22 Nov. - 31 Jan. 1982 (3).*

British Sculpture in the 20th Century, Whitechapel Art Gallery,
London, 27 Nov. - 24 Jan. 1982 (2).*

1982
Kunst der Klassischen Moderne bis zur Gegenwart, Galerie
Kunsthandlung Roche, Bremen, from 29 Jan. (1).

Milestones in Modern British Sculpture, Mappin Art Gallery,
Sheffield, 9 Oct. - 7 Nov. (1).*

1983
Black White, Robert Fraser Gallery, London (2).

Small is Beautiful. Part 3, Angela Flowers Gallery, London,
1 - 24 Dec. (1).

Art-Hats, Harlekin Art, Wiesbaden, Germany.

1984
*Nine Works of Art from the Contemporary Collection of
Wolverhampton Art Gallery,* The Mayor Gallery, London,
7 - 24 Jan. (1).

British Pop Art, Robert Fraser Gallery, London, 10 Jan. -
3 March.

Barrier 1977-80 and Contemporary Acquisitions, Imperial War
Museum, London, 29 June - 7 Oct. (1).

Look! People, St. Paul's Gallery, Leeds and National Portrait
Gallery, London, 24 Nov. - 13 Jan. 1985 (4).

1985
The Irresistible Object: Still Life 1600-1985, Leeds City Art
Galleries, 18 Oct. - 8 Dec. (1).*

Visual Aid Print and Original Works, Royal Academy of Arts,
London, 9 - 15 Dec. (1).

1986
Forty Years of Modern Art 1945-1985, Tate Gallery, London,
19 Feb. - 27 April (1).*

*Faces for the Future. New Twentieth Century Acquisitions at the
National Portrait Gallery,* National Portrait Gallery, London,
11 July - 5 Oct. (1).

*The Flower Show. An Exhibition on the Theme of Flowers in
Twentieth Century British Art,* Stoke-on-Trent City Museum
and Art Gallery, Hanley, 26 July - 7 Sept., touring York,
Southampton and Durham (1).*

Design, Redfern Gallery, London.

Contrariwise: Surrealism and Britain 1930-1986, Glynn Vivian
Art Gallery, Swansea, 20 Sept. - 15 Nov., touring Bath,
Newcastle and Llandudno, 1987 (1).*

1987
British Pop Art, Birch and Conran Fine Art, London.

19de Biënnale Monumenta, Openluchtmuseum voor beeld-
houwkunst Middelheim, Antwerp, 28 July - 11 Oct. (1).*

*Pop Art U.S.A.-U.K.: American and British Artists of the '60s in
the '80s,* Odakyu Grand Gallery, Tokyo, 24 July - 18 Aug., tou-
ring Osaka, Funabashi and Yokohama (2).*

1988
Summer Selection: Contemporanea, Achim Moeller Fine Art,
New York, 12 July - 12 Aug.

Contemporary Portraits, Flowers East, London, 21 Sept. -
12 Nov. (1).

Modern British Sculpture from the Collection, Tate Gallery,
Liverpool, 7 Sept. - 12 Jan. 1992 (1).*

1990
Birch and Conran (February Exhibition), London, Feb.

1991
Objects for the Ideal Home: The Legacy of Pop Art, Serpentine
Gallery, London, 11 Sept. - 20 Oct. (1).*

Pop Art, Royal Academy of Arts, London, 13 Sept. - 15 Dec.
(2) *, Museum Ludwig, Cologne (2) *, Centro de Arte Reina
Sofia, Madrid (2) * and The Montreal Museum of Fine Arts,
Montreal, 1992 (4) *.

1992
Summer Exhibition, Royal Academy of Arts, London,
7 June - 16 Aug. (1).*
Pop Art, Galerie Michael, Darmstadt (2).*

Summer Exhibition, Redfern Gallery, London,
14 July - 20 Aug. (2).

Summer Exhibition, The Piccadilly Gallery, London (1).

1993
Declarations of War: Contemporary Art from the Collection of the Imperial War Museum, Kettles Yard, Cambridge, 9 Jan. - 28 Feb. (1).

The Sixties Art Scene in London, Barbican Art Gallery, London, 11 March - 13 June (2).*

The Fab Year Show, Independent Editions, Business Design Centre, London (1).

The 1960's, England & Co., London, 8 April - 8 May (3).

Summer Exhibition, Royal Academy of Arts, London,
6 June - 15 Aug. (1).*

Drawing Towards Sculpture, Isis Gallery and Art Institute, Leigh-on-Sea, Essex, July - Aug.*

Art in Boxes, England & Co., London, 17 July - 22 Sept. (1).*

Reflet-Restitution. La Sculpture pop et hyperréaliste, Abbaye Saint-André, centre d'art contemporain, Meymac,
18 July - 10 Oct. (6).*

No More Heroes Anymore: Contemporary Art from the Imperial War Museum, Royal Scottish Academy, Edinburgh,
11 Aug. - 12 Sept. (1).

Imitation Goods, Gilmour Gallery, London.

The Portrait Now, National Portrait Gallery, London,
19 Nov. - 6 Feb. 1994 (1).*

Art in Boxes, Nottingham Castle Museum and Art Gallery, Nottingham, 20 Nov. - 2 Jan. 1994 (1).

1994
Worlds in a Box, City Art Centre, Edinburgh, 28 May - 16 July, touring Sheffield, Norwich and London, 1995 (2).*

Summer Exhibition, Royal Academy of Arts, London,
5 June - 14 Aug. (1).*

1995
Works on Paper, Duncan R. Miller Fine Arts, London.

British Surrealism 1935-1995, England & Co., London,
5 - 27 May (1).

Post-War to Pop, Whitford Fine Art, London, 20 Sept. - 31 Oct. (5).*

Treasures from the National Portrait Gallery, Koriyama City Museum of Art, Fukushima, 7 Oct. - 23 Nov., touring Nagoya, Kitakyushu, Hiroshima and Tokyo, 1996 (1).*

1996
Works on Paper, Duncan R. Miller Fine Arts, Glasgow.

1997
Pop Art, Norwich Castle Museum, Norwich, 1 Feb. - 6 April (1).*

The Berardo Collection, Sintra Museum of Modern Art, Sintra, from 17 May (1).*

Les Sixties: Great Britain and France 1962-1973, The Utopian Years, Brighton Museum and Art Gallery, Brighton,
25 April - 29 June (1).*

The Pop '60s: Transatlantic Crossing, Centro Cultural de Belém, Lisbon, 11 Sept. - 17 Nov. (3).*

1998
Twin Images, The Fine Art Society, London, 23 - 28 Feb. (1).*

30th Anniversary of Mr Chow: Portrait Collection, Pace Wildenstein, Beverly Hills, 14 - 28 Feb. and Mayor Gallery, London, 27 Oct. - 17 Nov. (1).*

Modern British Art, Tate Gallery, Liverpool, museum display until 2001 (1).

1999
A Cabinet of Curiosities from the Collections of Peter Blake, Morley Gallery, London, 8 Oct. - 11 Nov. (4).*

Portrait Collection of Mr Chow, Galerie Enrico Navarra, Paris, Nov. - Jan. 2000 (1).*

2000
Things: Assemblage, Collage and Photography since 1935, Norwich Gallery, Norwich, 12 Jan. - 12 Feb., touring Edinburgh and Sheffield (1).*

D' Après l'Antique, Musée du Louvre, Paris, 16 Oct. - 15 Jan. (1).*

2001
Pop Art: U.S./U.K. Connections 1956-1966, The Menil Collection, Houston, Texas, 26 Jan. - 13 May (2).*

Summer Exhibition, Royal Academy of Arts, London,
5 June - 13 Aug. (1).*

Public Collections

Great Britain

Aberdeen Art Gallery, Aberdeen
Arts Council Collection, Hayward Gallery, London
British Council
British Museum, London
Contemporary Arts Society
Graves Art Gallery, Sheffield
Hull City Museum and Art Gallery (Ferens Art Gallery)
Imperial War Museum, London
Mappin Art Gallery, Sheffield
National Portrait Gallery, London
Tate, London
Victoria and Albert Museum, London
Wolverhampton Art Gallery, Wolverhampton

Europe

Berardo Collection, Sintra Museum of Modern Art, Sintra
Städtische Kunsthalle, Mannheim

United States of America

The Hirshhorn Museum and Sculpture Garden, Smithsonian
Institution, Washington, D.C.

Selected Bibliography

ARTIST'S STATEMENTS
In chronological order

BARKER, Clive. 'Clive Barker's Zips', *ICA Bulletin*, no.159, June 1966, p.14.

BARKER, Clive. Statement, *Ventures*, exhibition catalogue, Arts Council Gallery, Cambridge, 1967.

'Young and Fantastic: Fragments of a Conversation with Clive Barker', *ICA Eventsheet*, Institute of Contemporary Arts, London, August 1969.

BARKER, Clive. Statement, *British Sculpture out of the Sixties*, exhibition catalogue, Institute of Contemporary Arts, London, 1970.

BARKER, Clive. Unpublished catalogue introduction (c. 1976) and excerpt from unpublished interview by Marco Livingstone (10 July 1989), *Pop Art: An International Survey*, exhibition catalogue, Royal Academy of Arts, London, 1991, pp. 154-155.

SELECTED BOOKS

BONN, Sally. *L'Art en Angleterre: 1945-1995*. Paris, 1996.

COMPTON, Michael. *Pop Art: Movements of Modern Art*. London, New York, Sydney and Toronto, 1970, p. 176.

COMPTON, Michael. 'Pop Art in Britain', *Pop Art*, edited by Andreas C. Papadakis. *Art and Design*, vol. 6 11/12 90, Profile 24, London and New York, 1992, pp. 63-73.

FINCH, Christopher. *Pop Art: Object and Image*. London and New York, 1968, pp. 65-67.

FINCH, Christopher. *Image as Language: Aspects of British Art 1950-1968*. Harmondsworth, Middlesex and Baltimore, Maryland, 1969, pp. 134-139.

FULLER, Peter. *Art and Psychoanalysis*. London, 1980, p. 120.

FULLER, Peter. *Marches Past*. London, 1986, pp. 39-40, 81.

LIVINGSTONE, Marco. *Pop Art: A Continuing History*. London and New York, 1990, pp. 168-172.

LUCIE-SMITH, Edward. *Thinking About Art*. London, 1968, pp. 235-237.

LUCIE-SMITH, Edward and Patricia White. *Art in Britain 1969/70*. London, 1970, p. 153.

OSTERWOLD, Tilman. *Pop Art*. Cologne, 1989, p. 228.

PIERRE, José. *An Illustrated Dictionary of Pop Art*. London, 1977 and Woodbury, CT, 1978 (originally published in French, Paris, 1975).

ROTZLER, Willy. *Objekt-Kunst: Von Duchamp bis Kienholz*. Cologne, 1972, pp. 170-171.

RUSSELL, John, and Suzi Gablik. *Pop Art Redefined*. London and New York, 1969, p. 233.

VYNER, Harriet. *Groovy Bob: The Life and Times of Robert Fraser*. London, 1999, pp. 136-138, 170-171, 273-274 and 287-288.

WALKER, JOHN A. *Van Gogh Studies: Five Critical Essays*. London, 1981, pp. 41-46.

WALKER, JOHN A. *Cultural Offensive: America's Impact on British Art Since 1945*. London and Sterling, Virginia, 1998, pp. 101-102, 153-154, and 186-187.

WOLFRAM, Eddie. *History of Collage: An Anthology of Collage, Assemblage and Event Structures*. London, 1975, p.160.

ONE-MAN EXHIBITION CATALOGUES

For exhibition catalogues of group shows refer to the exhibitions list.

Clive Barker: Recent Works. Robert Fraser Gallery, London, 1968. Introduction by Christopher Finch.

Clive Barker. Hanover Gallery, London, 1969.

Clive Barker: Heads and Chariots. Anthony d'Offay, London, 1974. Introduction by Roland Penrose.

Clive Barker. Unpublished catalogue introduction by Peter Fuller, (London, 1975).

Clive Barker: Sculpture, Drawings and Prints. Retrospective Exhibition. Mappin Art Gallery, Sheffield and tour, 1981-82. Text by George Melly.

Clive Barker: Portraits. National Portrait Gallery, London, and tour, 1987. Introduction by Norbert Lynton.

Clive Barker: Recent Work. Whitford Fine Art, London, 2000. Introduction by An Jo Fermon.

SELECTED ARTICLES AND REVIEWS

Reviewed shows are quoted in parentheses

1962

SUTTON, Keith. 'Round the London Art Galleries', *The Listener*, vol. LXVII, no. 1716, 15 February 1962, p. 306. (Young Contemporaries, RBA)

1966

MULLALY, Terence. 'Exhibition of Work by Spoilt Darlings', *The Daily Telegraph*, 1 August 1966. (New Idioms, Robert Fraser Gallery)

LUCIE-SMITH, Edward. 'Aesthetic objects: the drunk and the lamp-post again', *The Times*, 2 August 1966. (New Idioms, Robert Fraser Gallery)

LUCIE-SMITH, Edward. 'Mixed Shows and Feelings', *Studio International*, vol. 172, no. 881, September 1966, pp. 148-151. (New Idioms, Robert Fraser Gallery)

MELVILLE, Robert. 'Art: Paraphrases', *New Statesman*, 5 August 1966. (New Idioms, Robert Fraser Gallery)

1967

LACOSTE, Conil. 'La 'jeune peinture' dans l'opposition', *Le Monde*, 6 January 1967. (18ème Salon de la Jeune Peinture)

PLUCHART, François. 'Le Salon de la Jeune Peinture confirme la vitalité anglaise', *Combat*, 10 January 1967. (18ème Salon de la Jeune Peinture)

FINCH, Christopher. 'British Sculpture Now', *Art and Artists*, vol. 2, no. 2, May 1967, pp. 20-23.

WYKES-JOYCE, Max. 'Praising Fraser's Friends', *The International Herald Tribune*, 11 July 1967.

MELVILLE, Robert. 'Art: The Case for Fraser', *New Statesman*, 14 July 1967.

AMAYA, Mario. 'Tribute to a dealer, Robert Fraser', *The Financial Times*, 15 July 1967.

AMAYA, Mario. 'Tribute to Robert Fraser', *Art and Artists*, vol. 2, no. 5, August 1967, p. 13.

COUTTS-SMITH, Kenneth. 'Clima mentale nell' arte britannica d'oggi', *D'Ars*, VIII, no. 36, September 1967, pp. 48-49. (Nuove Tecniche d'Immagine, San Marino)

1968

LYNTON, Norbert. 'A Double Game with Irony', *The Guardian*, 27 January 1968. (One-man show, Robert Fraser Gallery)

A correspondent. *The Observer*, 28 January 1968. (One-man show, Robert Fraser Gallery)

A correspondent. *The International Herald Tribune*, 30 January 1968. (One-man show, Robert Fraser Gallery)

FINCH, Christopher. 'Clive Barker', *Art and Artists*, vol. 2, no. 10, January 1968, pp.16-19.

'On exhibition', *Studio International*, vol. 175, no. 896, January 1968, p. 45. (One-man show, Robert Fraser Gallery)

A correspondent. *The Sunday Telegraph*, 4 February 1968. (One-man show, Robert Fraser Gallery)

A correspondent. 'Metaphors in Steel', *The Times*, 14 February 1968. (One-man show, Robert Fraser Gallery)

BURR, James. 'London Galleries: Barren Belligerence', *Apollo Magazine*, vol. LXXXVII, no. 72 (new series), February 1968, p. 148. (One-man show, Robert Fraser Gallery)

LYNTON, Norbert. 'London', *Art International*, vol. XII, no. 3, March 1968, p. 65. (One-man show, Robert Fraser Gallery)

1969

DALEY, Janet. 'Pop Vulgarism', *Art and Artists*, vol. 4, no. 4, July 1969, pp. 44-45. (Pop Art, Hayward Gallery)

RUSSELL, John. 'Pop Reappraised', *Art in America*, July-August 1969, pp. 78-89. (Pop Art, Hayward Gallery)

BRETT, Guy. 'Modern Revival of Fantasy', *The Times*, 8 August 1969. (Young and Fantastic, ICA)

MELVILLE, Robert. 'Art: Wild Excesses', *New Statesman*, 8 August 1969, p. 191. (Young and Fantastic, ICA)

WOLFRAM, Eddie. 'Pop Art Undefined', *Art and Artists*, vol. 4, no. 6, September 1969, pp. 18-19. (Pop Art, Hayward Gallery)

DUNLOP, Ian. 'Clive Barker - when all that shimmers is not silver', *The Evening Standard*, 6 October 1969. (One-man show, Hanover Gallery)

BRETT, Guy. 'Coated in Chrome', *The Times*, 13 October 1969. (One-man show, Hanover Gallery)

RUSSELL, John. 'London: Barker's Chrome Echoes', *Art News*, vol. 68, no. 7, November 1969, pp. 46-51. (One-man show, Hanover Gallery)

RUSSELL, John. 'Arts: Independent Ideas', *The Sunday Times*, 12 October 1969. (One-man show, Hanover Gallery)

DENVIR, Bernard. 'London', *Art International*, vol. XIII, no. 9, November 1969, pp. 58-61. (One-man show, Hanover Gallery)

FULLER, Peter. 'Art Scape: Clive Barker', *Harpers Bazaar*, December 1969, pp. 19-21. (One-man show, Hanover Gallery)

A correspondent. 'New Sculptures', *The London Magazine*, December 1969, pp. 52-53.

1970

FULLER, Peter. 'The £sd of Art', *New Society*, no. 406, July 1970, pp. 64-66.

SPURLING, Hilary. 'Arts: The Gravest of Jokes', *New Statesman*, 21 August 1970, p. 218.

PACKER, William. 'London Exhibition and World Gallery Guide: British Sculpture out of the 60's', *Art and Artists*, vol. 5, no. 6, September 1970, p. 30. (British Sculpture out of the Sixties, ICA)

McLEAN, Bruce. 'Not Even Crimble Crumble', *Studio International. Journal of Modern Art*, vol. 180, no. 926, October 1970, pp. 156-159. (British Sculpture out of the Sixties, ICA)

1971

ANDREWS, Rena. 'The Fine Arts', *The Sunday Denver Post*, May 1971.

OHFF, Heinz. 'Der Gegenstand als Kunstobjekt. Das Kunstobjekt als Gegenstand', *Magazin Kunst. Das Aktuelle Kunstmagazin*, no. 42, 1971, pp. 2248-2277.

1974

STEIN, Jenny. 'Gallery Reviews: Clive Barker', *Arts Review*, vol. XXVI, no. 14, 12 July 1974, p. 434. (One-man show, Anthony d'Offay)

WYKES-JOYCE, Max. 'Around Europe's Galleries', *The International Herald Tribune*, 13-14 July 1974. (One-man show, Anthony d'Offay)

GOSLING, Nigel. 'Art', *The Observer*, 17 July 1974. (One-man show, Anthony d'Offay)

BURR, James. 'Round the Galleries: Art Stains', *Apollo Magazine*, vol. XCV, no. 149 (new series), July 1974, pp. 71-72. (One-man show, Anthony d'Offay)

FULLER, Peter. 'Galleries: Clive Barker', *The Connoisseur*, vol. 187, no. 751, September 1974, p. 73. (One-man show, Anthony d'Offay)

OILLE, Jennifer. 'London', *Art and Artists*, October 1974, pp. 44-45. (One-man show, Anthony d'Offay)

CRICHTON, Fenella. 'London Letter', *Art International. The Lugano Review*, vol. XVIII, no. 9, November 1974, p. 38. (One-man show, Anthony d'Offay)

1975

FULLER, Peter. 'The Venus Pin-Up', *New Society*, vol. 35, no. 681, October 1975, pp. 222-223.

A correspondent. 'Schatten und Schablonen. Ausstellung in Mannheim', *Neue Zürcher Zeitung*, 22 December 1975. (Der Ausgesparte Mensch, Städtische Kunsthalle Mannheim)

1976

A correspondent. 'It's the real thing … for £140 a bottle', *The Evening News*, 1 July 1976.

A correspondent. 'On the day two musicians went cuckoo… the wellies throwers were in full fling and a coke bottle sold for £250. What's got into Britain? It must be the weather!', *The Daily Mail*, 2 July 1976.

A correspondent. 'The Real Thing!', *The Guardian*, 2 July 1976.

WALKER, John A. 'The Van Gogh Industry', *Art and Artists*, vol. 11, no. 5, August 1976, pp. 4-7.

RYDON, John. 'No Cutting Remarks, Please', *The Daily Express*, 3 December 1976.

1977

HEARD, James. 'London Reviews: Small is Beautiful. Part 2 - Sculpture, Angela Flowers', *Arts Review*, vol. XXIX, no. 1, 7 January 1977, p. 7. (Small is Beautiful. Part 2: Sculpture, Angela Flowers)

LUCIE-SMITH, Edward. 'The Way We Were', *Art and Artists*, vol. 12, no. 4, August 1977, pp. 14-17. (British Artists of the 60's, Tate Gallery)

MORGAN, Stuart. 'British Artists in the Sixties at the Tate', *Artscribe*, no. 8, September 1977, p. 47. (British Artists of the 60's, Tate Gallery)

1978

BLAKESTON, Oswell. 'London: Bacon, Barker. Felicity Samuel', *Arts Review*, vol. XXX, no. 21, October 1978, p. 582. (One-man show, Felicity Samuel Gallery)

KULTERMANN, Udo. 'Sculpture in the Image of the Past', *Scultura*, October-November 1978, pp. 8-9. (One-man show, Felicity Samuel Gallery)

McEWEN, John. 'Painstaking', *Spectator*, vol. 241, no. 7844, 4 November 1978, pp. 25-26. (One-man show, Felicity Samuel Gallery)

MELLY, George. 'Exhibitions: Creating a Convincing Imagery', *Art Monthly*, no. 21, November 1978, pp. 12-14. (One-man show, Felicity Samuel Gallery)

TALBOT, Linda. 'Barker's Dozen', *Hampstead and Highgate Express*, 3 November 1978. (One-man show, Felicity Samuel Gallery)

BLAKE, John. 'Ad Lib', *Evening News*, 8 December 1978.

FEAVER, William. 'Art', *The Observer*, 29 October 1978.

1979

A correspondent. 'Boycott planned when £2700 'monstrous' bronze is shown', *The Glasgow Herald*, 19 March 1979.

KULTERMANN, Udo. 'Clive Barker's Portraits of Francis Bacon', *Scultura*, April-May 1979, pp. 6-9.

1981

JANUSZCZAK, Waldemar. 'Art as a Floor Show', *The Guardian*, 9 December 1981. (British Sculpture in the 20th Century, Whitechapel Art Gallery)

VAIZEY, Marina. 'Clive Barker: homage to the commonplace', *The Sunday Times*, 27 December. (Retrospective Exhibition)

1982

A correspondent. 'Teeth and Smiles', *The Sheffield Morning Telegraph*, 15 January 1982. (Retrospective Exhibition)

SPALDING, Frances. 'Regional Reviews: Clive Barker', *Arts Review*, vol. XXXIV, no. 2, 15 January 1982, p. 22. (Retrospective Exhibition)

A correspondent. 'Sculptor with an ironic Midas Touch', *The Evening Sentinel*, 8 January 1982. (Retrospective Exhibition)

A correspondent. 'Paddy puts the bite on Bacon', *Express and Star*, 6 May 1982.

'Impressive Pop item', letter by Tom Jenkins, *Express and Star*, 12 May 1982.

'Council childish over Sculpture', letter by Andy Harrison, *Express and Star*, 31 May 1982.

'How long must they justify art?', letter by A. Birch, *Express and Star*, 5 June 1982.

'Save the Bacon', letter by Ron Dutton, *Express and Star*, 8 June 1982.

A correspondent. 'Pop art teeth ridicule slammed', *Express and Star*, 9 June 1982.

'Sculpture grant up by £200', letter by Nancy Balfour, *Express and Star*, 11 June 1982.

'Please buy sculpture', letter by Lois Hall, *Express and Star*, 16 June 1982.

A correspondent. 'False teeth sculpture is to be bought', *Express and Star*, 18 June 1982.

'Art dispute an insult', letter by Jesse Bruton, *Express and Star*, 18 June 1982.

'Leave art to the experts', letter by Peter Ling et al., *Express and Star*, 22 June 1982.

A correspondent. 'Brass study for gallery', *Express and Star*, 3 August 1982.

1984

PHILLPOTTS, Beatrice. 'London: British Pop Art, Robert Fraser Gallery', *Arts Review*, vol. XXXVI, no. 3, 17 February 1984, pp. 71-72. (British Pop Art, Robert Fraser Gallery)

SPALDING, Frances. 'Regional: Look! People, St. Paul's Gallery, Leeds', *Arts Review*, vol. XXXVI, no. 13, July 1984, pp. 348-349. (Look! People, St. Paul's Gallery)

1985

SIDEY, Tessa. 'Regional: Clive Barker, Wolverhampton Art Gallery', *Arts Review*, vol. XXXVII, no. 9, 10 May 1985, pp. 232-233. (One-man show, Wolverhampton Art Gallery)

1986

SEWELL, Brian. 'Headmaster, here's your chance', *The London Standard*, 27 February 1986. (Forty Years of Modern Art, Tate Gallery)

SELIGMAN, Patricia. 'Tate Gallery 3', *Arts Review*, vol. XXXVIII, no. 5, 14 March 1986, p. 14. (Forty Years of Modern Art, Tate Gallery)

BEAUMONT, Mary Rose. 'London: Faces for the Future, National Portrait Gallery', *Arts Review*, vol. XXXVIII, no. 15, 1 August 1986, p. 422. (Faces for the Future, National Portrait Gallery)

1987

A correspondent. 'Clive Barker', *The Times*, 24 July, 1987. (One-man show, National Portrait Gallery)

A correspondent. 'Clive Barker: Portraits', *The London Evening Standard*, 24 July, 1987. (One-man show, National Portrait Gallery)

SHEPHERD, Michael. 'International: Antwerp', *Arts Review*, vol. XXXIX, no. 15, 31 July 1987, pp. 538-539. (Monumenta, Antwerp)

TALBOT, Linda. 'Facial Expression', *Hampstead and Highgate Express*, 7 August 1987. (One-man show, National Portrait Gallery)

LIVINGSTONE, Marco. 'New! Improved! Varieties of British Pop Sculpture from the 1950's to the 1980's', *Art & Design*, vol. 3, no. 11/12, 1987, pp. 5-12.

A correspondent. 'Briefly…', *Time Out*, 2-9 September 1987. (One-man show, National Portrait Gallery)

1988

MELLY, George. 'On Sitting for One's Portrait', *Jazz News*, vol. 2, no. 1, 1988, pp. 7-8.

1991

LISTER, David. 'Post-war images of fun and rebellion', *The Independent*, 9 May 1991. (Pop Art, Royal Academy of Arts)

HILTON, Tim. 'Why Pop went Bang', *The Guardian*, 13 September 1991. (Pop Art, Royal Academy of Arts)

LIVINGSTONE. Marco. 'L'héritage du Pop Art anglais. Leurres: voir double'. *Art Press*, no. 160, juillet-août, 1991, pp. 18-25 & cover.

DAGEN, Philippe. 'Leçon d'ironie à Burlington House', *Le Monde*, 26 September 1991. (Pop Art, Royal Academy of Arts)

TALBOT, Linda. 'Chrome, steel, leather and irony', *Hampstead and Highgate Express*, 11 October 1991. (Pop Art, Royal Academy of Arts)

LIVINGSTONE, Marco. 'Excerpts from an Unpublished Interview', *Pop Art*, exhibition catalogue, Royal Academy of Arts, London, 1991, p.155.

1992

'The Pop Art Symposium: General Discussion', *Pop Art*, edited by Andreas C. Papadakis, *Art and Design*, vol. 6 11/12 90, Profile 24, London, New York, 1992, p. 60.

1993

MELLY, George. 'Pop Record', *Art Review*, April 1993, pp. 34-38.

1994

LOPPERT, Susan. 'Clive Barker', *Galleries*, vol. XI, no. 8, January 1994, p. 14. (One-man show, Independent Gallery)

1998

DAVIES, Peter. 'The Diversity of The Everyday', *World Sculpture News*, vol. 4, no. 4, Autumn 1998, pp. 28-32.

1999

BLAKE, Peter. 'The Sitter's Tale', *The Independent on Sunday*, 2 May 1999.

STEWART, Clare. 'Art for the Millennium', *The Times*, 11 December 1999.

2000

GARLAKE, Margaret. 'Exhibitions: Things, Assemblage, Collage and Photography since 1935', *Art Monthly*, 235, April 2000, pp. 31-32. (Things, Assemblage, Collage and Photography since 1935, Norwich Gallery)

GLEADELL, Colin. 'Art Sales: Object of the Week', *The Independent*, 10 July, 2000.

MONCRIEFF, Elspeth. 'On the Loose in London. British artists plaster London Galleries', *The Art Newspaper*, no. 108, November 2000. (One-man show, Whitford Fine Art)

TAYLOR, Tanis. 'Clive Barker', *Metro*, 8 November 2000. (One-man show, Whitford Fine Art)

DALBY, Stewart. 'Popping back into fashion', *The Guardian*, 11 November 2000. (One-man show, Whitford Fine Art)

A correspondent. 'Chrome Truth', *Time Out*, 8-15 November 2000. (One-man show, Whitford Fine Art)

GLEESON, David. 'Clive Barker', *Time Out*, 29 November - 6 December 2000. (One-man show, Whitford Fine Art)

A correspondent. 'Clive Barker, Recent Work', *Blueprint*, no. 177, November 2000. (One-man show, Whitford Fine Art)

PERMANENT COLLECTION CATALOGUES

The Tate Gallery 1970-72, Tate Gallery, London, 1972.

The Hirshhorn Museum and Sculpture Garden, Smithsonian Institution, New York, 1974.

Arts Council Collection. A Concise Illustrated Catalogue of Paintings, Drawings and Sculpture Purchased for the Arts Council of Great Britain between 1942 and 1978, Arts Council of Great Britain, London, 1979.

Kunsthalle Mannheim Skulptur - Plastik - Objekte, Mannheim, 1982.

The British Council Collection 1938-1984, British Council, London, 1984.

Modern British Sculpture from the Collection, Tate Gallery, Liverpool, 1988.

The National Portrait Gallery Collection, National Portrait Gallery, London, 1988.

The Berardo Collection, Sintra Museum of Modern Art, Sintra, Lisbon, 1996.

Index

Acknowledgements

My deepest gratitude goes to Clive Barker for his unfailing support and patient assistance during the preparation of this book. I am thankful for his help towards the location of works, for making available his notes and correspondence, for spending long hours responding to my many questions, and for giving a helpful and critical reading of the draft manuscript.

I am greatly indebted to Adrian Mibus for initiating this project. His enthusiasm, encouragements and patience helped bringing this book to fruition.
My special thanks go to Marco Livingstone for his insightful essay. His contribution has been a motivation throughout the preparation of the catalogue. I am equally grateful for all his advice and criticism in proofing the manuscript.

All collectors who have granted me access to the objects in their collections or supplied me with relevant information, have helped my research in an invaluable way. In the same way instrumental were all museum staff that have made an effort in locating relevant material and conducted research on my behalf, in particular Victoria Lane (Tate Gallery Archive, London) and Angela Weight (Imperial War Museum, London).

Paola Gribaudo, project coordinator, has been more than accommodating and, with Silvia Migliazzi of Litho Art New, worked with great enthusiasm on the design of the book.
I am indebted to Giancarlo Zampollo of Litho Art New, Turin and to Achim Moeller of Achim Moeller Fine Art, New York.

Finally, without the generous support from Whitford Fine Art and an anonymous individual this book would never have come into being.

An Jo Fermon, June 2002

Photographic Credits

Art-Wood Photography Cat. 72-75, 117, 122, 126, 130-133, 136, 140, 141, 145, 147-151, 153, 155, 157 and 162

Beth Phillips Cat. 156

Bonhams London Cat. 314

Brompton Studio/John Webb Fig. 1; Cat. 1-15, 17-21, 24, 26, 31, 35, 36, 38-41, 45, 47-49, 54, 55, 60-62, 68-70, 72-75, 78, 79, 84, 88, 102, 103, 108, 121, 127 and 170

Christie's London Plate 12; Cat. 83, 113 and 363

Eileen Tweedy Fig. 20; Cat. 220, 226, 227, 432 and 433

Frank Guttierrez Cat. 105, 174, 229, 255, 277, 322, 374 and 387

Hirshhorn Museum and Sculpture Garden, Smithsonian Institution, Washington, D.C. Cat. 56

Imperial War Museum, London Plate 21; Cat. 152

Keith Morris Figs. 3, 31 and 32; Cat. 66, 67, 95-97, 100, 105, 109, 110, 116, 118, 120, 128, 158, 168, 182, 185, 186, 189, 190, 198, 214, 217, 218, 221-223, 228, 233, 235, 236, 238-240, 244, 249, 254, 256, 260, 261, 266, 267, 271-274, 280, 286-288, 290, 291, 293, 304, 305, 308, 310, 311, 313, 316, 319, 320, 323-325, 328-332, 334-336, 338-340, 344-346, 348-351, 353-360, 362, 364-371, 375-378, 381, 382, 384, 390, 425, 426, 428, 435 and 438-440

Margita Wickenhäuser, Kunsthalle Mannheim Plate 16

Metropolitan Museum of Art, New York Fig. 6

Miki Slingsby Plates 2, 8, 9, 15, 25 and 27; Cat. 28-30, 37, 42, 64, 76, 77, 80, 81, 87, 111, 114, 119, 125, 129, 137, 138, 142, 169, 183, 184, 191, 193, 194, 196, 204, 208, 209, 224, 225, 230, 231, 234, 237, 243, 248, 250, 252, 253, 257, 259, 262-265, 268-270, 275, 276, 278, 279, 281, 283-285, 295-302, 306, 307, 309, 312, 315, 317, 321, 326, 327, 337, 341, 343, 347, 352, 361, 373, 379, 380, 383, 385, 386, 388, 389 and 391-423

National Gallery, London Fig.7

National Portrait Gallery, London Plate 14; Cat. 86

Noel Allum Plate 20; Cat. 143

Norman May's Studio Cat. 176, 179 and 181

Peter Blake Figs. 40 and 41; Cat. 205 and 207

Philadelphia Museum of Art Fig. 11

Prudence Cuming Associates Ltd. Plates 1, 3, 4, 9, 22 and 28-30; Cat. 27, 32, 33, 44, 71, 187, 200, 210, 211, 215, 219, 251, 258, 289, 436 and 437

Rodney Todd-White, London Fig. 38; Cat. 173

Royal Academy of Arts Cat. 241

Tate, London Plate 5; Figs. 12-14; Cat. 46

Vauxhall Motors, Luton Fig. 15

Wolverhampton Art Gallery, Wolverhampton Plate 23; Cat. 178